Front Cover Image:

Set Design by Afsoon Pajoufar, *The Silence*
Directed by Jay Scheib
Photo Courtesy of Jay Scheib
Performers (Left to Right): Ayesha Jordan, Lacey Dorn

Back Cover Image:

Set Design and Photography by Marsha Ginsberg, *L'Orfeo*
Directed by Lydia Steier
Performer: Uwe Stickert as Orfeo

First published 2023
by Routledge
605 Third Avenue, New York, NY 10158

and by Routledge
4 Park Square, Milton Park, Abingdon, Oxon, OX14 4RN

Routledge is an imprint of the Taylor & Francis Group, an informa business

© 2023 selection and editorial matter, Maureen Weiss and Sibyl Wickersheimer; individual chapters, the contributors

The right of Maureen Weiss and Sibyl Wickersheimer to be identified as the authors of the editorial material, and of the authors for their individual chapters, has been asserted in accordance with sections 77 and 78 of the Copyright, Designs and Patents Act 1988.

All rights reserved. No part of this book may be reprinted or reproduced or utilised in any form or by any electronic, mechanical, or other means, now known or hereafter invented, including photocopying and recording, or in any information storage or retrieval system, without permission in writing from the publishers.

Trademark notice: Product or corporate names may be trademarks or registered trademarks, and are used only for identification and explanation without intent to infringe.

Library of Congress Cataloging-in-Publication Data
A catalog record for this title has been requested

ISBN: 978-0-367-70834-4 (hbk)
ISBN: 978-0-367-63876-4 (pbk)
ISBN: 978-1-003-14819-7 (ebk)

DOI: 10.4324/9781003148197

Typeset in Sofia Pro by Josh Worth

Assistant Editor: Nelia Miller
Conversation Coordinator: Katie Fitch
Copy Editor: Katrina Posner
Book Designer: Josh Worth
Proofreader: Ruth Bourne

SCENESHIFT

U.S. SET DESIGNERS IN CONVERSATION

Conceived, Curated, and Edited by
Maureen Weiss & Sibyl Wickersheimer

Contents

Program Note
Introduction — 1
Questions — 2
Answers — 3
Transition — 14

1 Dialogue Between Decades
Career as a Shifting Landscape — 41
Teacher / Student Relationships — 53
Early Career Designers — 64
Transitioning Forward — 72

2 Patterns & Systems
Balancing Act 1 — 88
Balancing Act 2 — 102
Devil in the Details — 112
Selfish Selflessness — 122

3 Perspective

| International Perspectives | 135 |
| Regionalism & Micro-climates | 149 |

4 Space

Creating the Space to Work	171
Finding New Spaces	187
Leading the Storytelling	206
Shifting the Narrative	216
Designers on Design	224

5 Navigating Boundaries

| Intersection of an Arts Practice | 239 |

Coda

Contributors	255
Image Index	260
Acknowledgments	268

INTRODUCTION

Between June 2020 and January 2021, Maureen Weiss and Sibyl Wickersheimer convened a group of U.S. set designers for weekly, and sometimes bi-weekly, conversations. In each conversation we examined our careers, our juggling act, and the state of theatre as the landscape shifted and unfolded before us. The designers we initially spoke with were selected from cities across the country, designing in a wide variety of spaces, situations, and communities. Many of them arrived at set design unconventionally, others have moved beyond set design. But until now, most of these designers have not been included in textbooks. After a series of initial conversations, the core group expanded to include the voices of designers from younger generations who are in the beginning stages of their careers. What follows is a curated journey through challenging discoveries. There are no absolutes here, but there are insights and possible revelations. Ordinarily, designers remain behind the scenes, but here we find ourselves shifting our presence further onstage.

Set Design by Sibyl Wickersheimer, *The Happiest Song Plays Last*

QUESTIONS

To initiate momentum, we sent a preliminary fifty question survey to the designers. Though instructed to answer questions only if they were so compelled, many of their responses were deeply analytical and their responses helped shape the agendas for the actual conversations. Below is a sampling of questions from the original outline. We are also eager to continue to collect and share answers in an online format for all who are interested.

Join us at www.scene-shift.com.

- What are three productions or artworks that influenced you?
- What is the guiding force behind your design work? Is there a specific approval that you were after? And if not, how did you know whether the work was up to your standards?
- Is there a recent design that you have seen that has made you happy with the current direction of set design?
- Do you think set design gets relegated to the margins?
- How has the focus of your design practice evolved? Have there been dramatic shifts over time?
- Are you first a collaborator or first a designer?
- What does mid-career mean to you? If you could graph your career what shape would it take?
- Where do you step outside of the boundaries of theatre? How did you know how to do this?
- What are the avenues you have with which to create? Can you produce the work that you want to produce?
- Do you find it difficult to describe what it is you do?
- Who leads the storytelling? Who do you want to lead the storytelling? What is the balance of the visual in visual storytelling?

- Do female-identifying designers collaborate differently than their male-identifying counterparts?
- How tied are you to the text?
- How are you connected to the actual build of the set? Are you emotionally connected to the details?
- How and when do designers feel they have best used their given resources?
- How do you balance your individual instincts within the collaboration?
- What are your hopes for American theatre?
- Is our community growing or shrinking? How does inclusion play a role? What role can you play to diversify American theatre culture?
- What inequities do you witness in your work? How should/could this be changed?

ANSWERS

Set designers arrive at a collaboration with questions and leave with questions. It's not that we don't find answers, but that we are never satisfied even when answers are achieved. Questions consistently lead to more questions. Each design brings with it a process of many steps and decisions, and each decision brings more steps, thus more questions. We are on an endless quest: hunting, digging, investigating. Through the process of creating this book, the discovery is that set designers thrive in this continuum. We are "working" all the time. There was an instant joy in discovering this commonality and sharing our practice and experiences with one another.

What follows are a few of the responses that seeded our conversations...

I have had a lot of conversations with collaborators over the past few years about how we really just need to dismantle the industry and start over, and I wonder if the pandemic is our opportunity to do that, although my hopes aren't super high. I have seen so many safe, bad, easy plays filled with an audience of older, upper middle-class, or just rich, white people, and a creative team that looks about the same, and it does make you question what the point is of doing this job. But then, of course, you have moments of really exciting work that gets exposed to people who leave asking big questions and feeling changed, and that is what makes it all feel worthwhile. So, I guess my hope is that after we all take a couple years off, we create affordable theatre for a diverse, younger audience that can actually contribute and respond to important discussions happening in our city and nation. I do think the medium can be really powerful and can contribute to change, but that is happening in such a tiny percentage of the actual work."

—LAURA JELLINEK

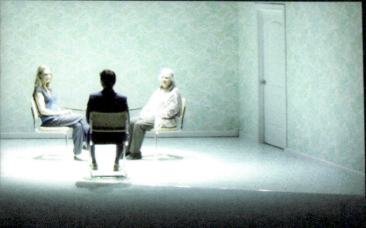

"If anything, I have a full-time job at a university and I don't take that for granted. I always wanted to be a designer and artist, and also teach. Growing up, I had incredible teachers who I used to assist in a variety of ways; I was their apprentice in an atelier environment and I cherished that. So, I knew that education was going to play an important part in my life. I try to be a better educator and master artist and model best practices, especially on the collaboration side of things, which was not really a part of the fine arts world but is a key element in theatre."

—REGINA GARCÍA

Set Design by Regina García, *Between Two Knees*

"I can't remember if we talked about this earlier on. Because I have been so visible lately, because of *What the Constitution Means to Me,* I've gotten a lot of email from young women who are wanting to go into this field, and it is fascinating. I've had girls as young as ten write me and be like, I just have these six questions. And they're the six most brilliant [questions] and I'm like, I'm so sorry. We're just going to have to talk. I can't answer those in writing. But,

Set Design by Rachel Hauck, *The House of Bernarda Alba*

you know, to get an email from a young woman in Kansas who says, My high school teacher tells me to pick something else, another career, because women don't do set design. It was amazing to write her back and be like, Your teacher is wrong, which I've never said in my life but, Your teacher is just wrong. Here [are] twenty [female set designers], check them out. They're pretty good."

—RACHEL HAUCK

"I always tell people [that] if I wasn't a stage designer, I wouldn't be any other kind of designer. I am not in this for how it looks, I am in it for how it feels. I think, like athletes, you can tell when you are in the flow and you get there by putting your whole self in. Designing is about turning an emotional and intellectual response into a physicalized space for people to play in. You have to build it out of air, but it has to carry the weight of the world you made. It needs muscle, both of the heart and the hands."

—CHRISTINE JONES

Collage by Christine Jones, *American Idiot*

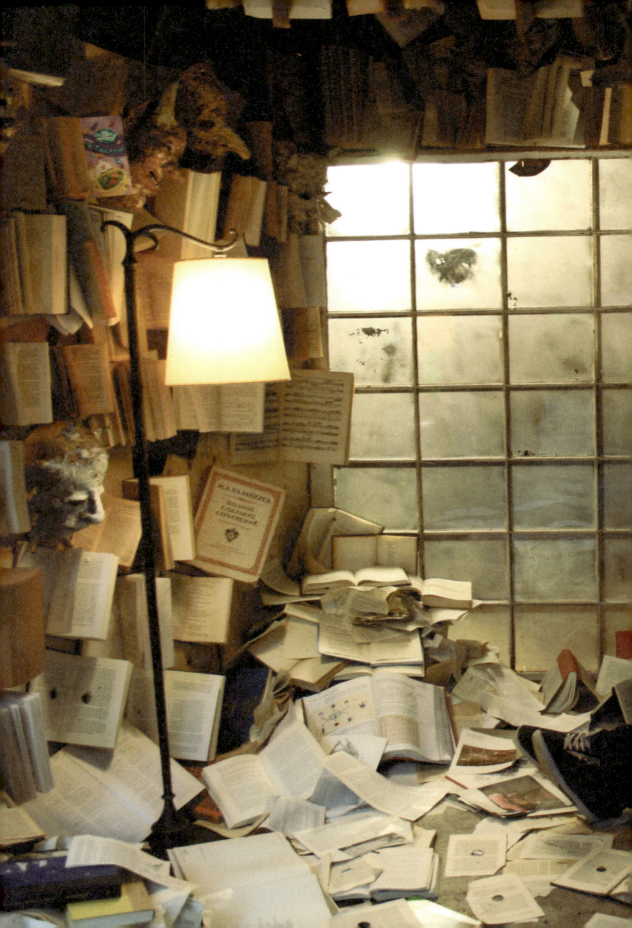

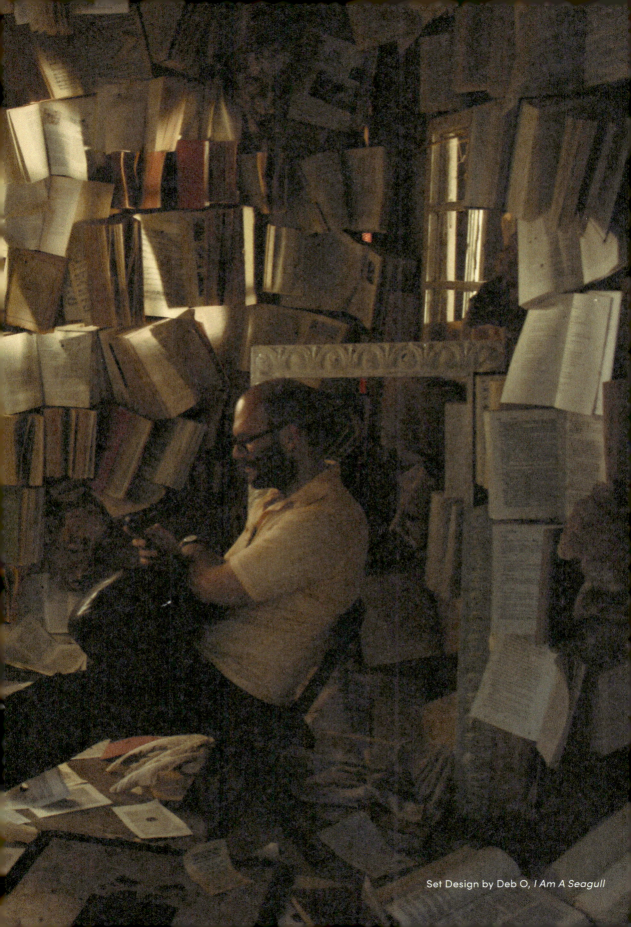

Set Design by Deb O, *I Am A Seagull*

Abigail DeVille, *The New Migration*

TRANSITION

Abigail DeVille / Andromache Chalfant / Deb O / Hana Kim / Markéta Fantová / Marsha Ginsberg / Maureen Weiss / Narelle Sissons / Shing Yin Khor / Sibyl Wickersheimer / Tanya Orellana / You-Shin Chen / Yvonne Miranda

January 19, 2021
(day #321 of the global pandemic and the day prior to US president #46, Joe Biden, taking office)

SIBYL WICKERSHEIMER The question on our minds is about transitions—not just the transition about to take place in the country tomorrow, hopefully [the inauguration of the 46th US president], but also the transitions that we deal with on a day-to-day basis in storytelling mode. Those moment-by-moment conversations about transitions that have real impacts in our practices.

DEB O In the beginning of Covid, I had this show that I was doing. I was trying to make the producers think differently on how we pay people, how we think about the people who are working with us, and how we include all people of color in the group. I was forcing them to talk and think about all these things, and then getting the whole show designed. And I mean, seeing the space, everything, all the protocol, and then quitting because they didn't follow through paying people and treating people well. I have this whole design that I was so excited about. There were no actors in there. It was twelve stories that twelve playwrights wrote. I created an eight-by-ten-foot room for each one of the dreams that they wrote. I was the director and the designer. It was so exciting. And I quit. I said, You either pay my assistants and pay everybody, and let's have people of color in the room with us or I'm gone. They said, No, we're not going to do it. So, I had to leave. It was a really strange place to be.

MAUREEN WEISS I wondered what happened to that show, Deb.

DEB O They never put it up. They're going to do it after Covid now.

SIBYL WICKERSHEIMER Well, I can see a change over the last several months—that our understanding of where we were at the beginning of the summer and where we are now as designers is really different. Do you feel good about making that choice and walking away from it?

DEB O Yes and no. Now I'm like, Well, fuck them. I'm just going to do some installation art on my own.

ABIGAIL DEVILLE I did a public art commission for a DC Arts Commission [DC Commission on the Arts and Humanities], 5x5 in 2014. They invited me to come pick a place in DC that I wanted to respond to. I picked this neighborhood called Anacostia, which is a Black residential neighborhood in southeast DC. All the places that they took us to before that had just been leveled with new glass structures on top. It was fresh erasure, right? The things had been freshly whitewashed. I wasn't interested in responding to any of those sites.

You know how sometimes as creative people we get compromised in strange political situations that you don't realize how politically charged they are when you're coming in on the outset, right? You are just coming with your project, your ideas, thinking you're going to have a dialogue with the community. There was this component to the 5x5 project where they wanted it to be provocative.

The thing that did happen out of it was the procession at the opening, which happened from Frederick Douglass' home, the place where he passed away, to the storefront installations that I did on, I think, Martin Luther King Jr. [Avenue]. And where these stores had been, they were technically protected. I didn't know

that these are the buildings that the government has shuttered to the local community for the last ten years. These are the buildings I selected to make my installations in. The community wants to know, How did I have access to it and why didn't they? And me, as an outsider, Why am I coming here and doing this art project? They can't have access to stores in their own community. I thought it was messed up. It ended up being this whole big public conversation. There were multiple news articles that came out in that moment where people were talking about the injustice of the federal government holding these things from the community access. It was really a mind-opening moment for me in terms of the ways that you can sometimes be co-opted by being naive or [by] not doing enough research, and the ways people use art as an hors d'oeuvre.

SIBYL WICKERSHEIMER Did it change any of your next collaborations?

ABIGAIL DEVILLE I was never that dumb again. I was really looking at the language of an email and someone offering me an opportunity. You can see when something is genuine and it's coming from a real place or when someone is just trying to use you. I think that happens a lot with artists of color where people are just making a space for you in that particular moment because there's a box for them to check, but not actually having any real investment in anything that you could bring to it.

I talk about larger systemic things and do not want to be co-opted as a Black person to being a Black representative for the embodiment of the whole Black experience when that's not possible.

TANYA ORELLANA The transition I landed on was a set design for the Mexican premiere of *Angels in America*. The idea behind this set was a space that was inspired by Masonic halls that felt like general historical, institutional spaces. The idea of the Masonic hall came from conversations we were having around the connection between Reagan and Roy Cohn and how he mentored Donald Trump. The idea of these terrible men handing the keys of power to other terrible men and how all our lives are suffering from the consequences of those conversations happening in these spaces of exclusion and male power. I am unraveling the power that is in a lot of spaces, unraveling the power that is in a lot of the architecture of the United States and the idea of the symbols of white dominant power that are in our architecture and our federal buildings. That transition was really impactful to my understanding of space.

MARSHA GINSBERG I had a female-centric autumn. There were two things that were pretty significant for me. The shift that I have been trying to make, or a kind of addition in my own work, is being the originator of projects. I'm really interested in contemporary classical music. I wanted to spearhead this project over a few years starting from a visual and urban mystic prompt. I was working with a director/writer who is based in Germany and a composer who is also based in Germany, and they're all women. One of the things I was also trying to do in this collaboration was to imagine a way that we could develop this piece not in a hierarchical manner. Traditionally with new opera works, a libretto or the music comes first. We were scheduled to finally do a version of this piece in Berlin

at this remarkable place called the [Haus der] Kulturen der Welt. The HKW is an interdisciplinary, global platform that tends to thematic curation. We were supposed to do our thing as an outdoor performance, we had picked all these spaces. Of course, because of Covid, I couldn't get there. I started working in the fall making these videos. That was a big transition for me—I had never shot video before, although I have a background as a photographer. The whole festival shifted into a digital platform. I was working with this performer and I was filming in Hudson, New York. We really shifted mediums. At the same time, I teach at NYU Abu Dhabi, and I was teaching my design class in the fall and all of my students were female, and they were all from all over the place. I'm really encouraging them to do all this exploration and take risk in their work. A lot of work that they were doing with site was quite interesting because I had students in Dubai, I had students in Ho Chi Minh City, I had students in Abu Dhabi. This interesting mixture, of all these different sites, starts to penetrate your consciousness. The things that I'm filming and thinking about, the things that I'm seeing from my students—that's been getting me through this moment.

NARELLE SISSONS As I listen and think of transitions or productions, **I also want to include that we have to broaden our definitions of what a performance designer is because we are caught up in a very narrow definition of what we do.** This pivot into remote worlds, and isolating and keeping our distance, has forced us to think about ourselves more as artists in a in a larger context. You know, perhaps we did think of ourselves as artists before, but it was very specific for me. I've been doing this for, gosh, like thirty years at least, and then suddenly having no support system, economically or artistically, we kind of launched off into this massive unknown ocean to try and survive and to figure out what we're doing. It has forced many people to really dig deep inside and have a serious conversation with yourself and other people in the industry; redefining gender, race, artform, the way we have a voice, the way we collaborate, the expectations, the way that we get paid. All of that has to be scrutinized so maybe the end will be positive. To me, that's a big part of this transition. I'm hoping that there will be a positive outcome to this [pandemic].

I also hope that we have the flexibility to move in and out of all the different mediums more often. I think they feed our souls in a way that when you get so focused on being a set designer it relegates all the other things needed to feed myself to one side.

I challenged myself this year and over the last however many months since March; doing a lot of painting and trying to be a better painter, on canvas with oil paint. I ended up in two exhibitions, both in California, two pieces of art that I made are now in exhibitions. I'm excited about that. Where that goes to next, I don't know. I've kind of cracked open something that I really love to do and I'm just collaborating with myself.

In terms of patriarchy in this conversation, I really felt I've had access to things. But with the Me Too movement the door opened. I was the first female set designer on the main stage at the Goodman [Theatre] in 2019. That's terrible that

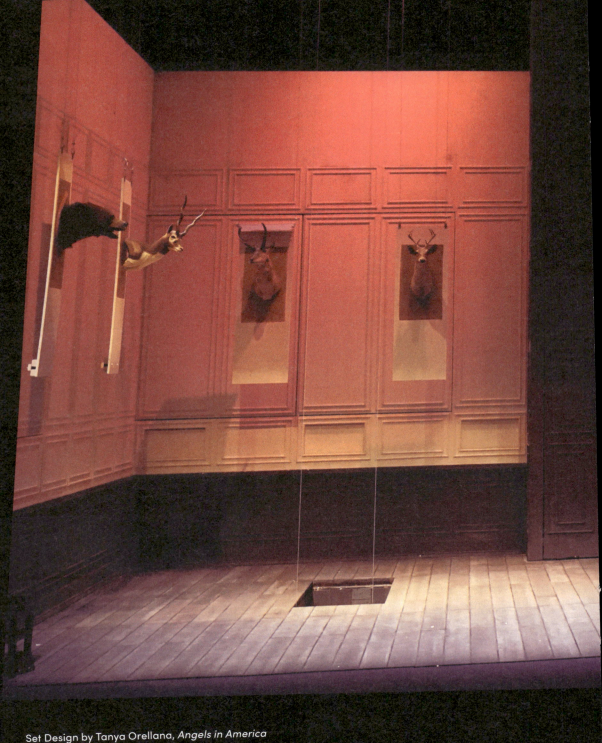

Set Design by Tanya Orellana, *Angels in America*

Set Design by Narelle Sissons, *Mabou Mines DollHouse*

they haven't had women designers on the main stage at the Goodman. It was an all-women team, so it was a bit of a softball that they threw us. Suddenly I realized I was invited to all these different theatres—that I've been hitting this glass ceiling for years, and suddenly I was invited to all these theatres to work at. I realized that you don't know that you don't have access until suddenly you have access. Invitations flew in and I thought, Wow, you know, these are all the jobs our male counterparts have been doing. Well, I have nothing against any of them, but we need to share. Also talking in terms of anti-racist theatre, we need to share. And, so, it's really essential that we talk about this and actually act upon it.

In terms of [an example of] transition of a show—and then I'll stop! I remember doing the *Mabou Mines DollHouse* years ago, and there's a transition in that play towards the end, where Nora becomes aware of what she's done and she's about to leave. In that production, the men were played by little people and the women were not little people. We get to the end of the play and suddenly the artifice of the house goes away, and we're in the theatre. We had a puppet designer, and all the curtains opened and there were all these hundreds of little, tiny boxes with little characters—puppets in other people's productions. Nora is there in one of the boxes, she takes her wig off and she's naked. This is the moment of, like, I've removed all the artifice and I'm a woman. Then right after that, she leaves and Torvald goes [out] to the audience calling her name, completely depleted, looking for her like he's a child. That moment is a transition in the theatre. It was just so powerful. Every time that moment happens, because we took that show all over the world, that final image always hit me and moved me.

It's so essential for us, as women working—we must empower ourselves to remove that artifice and to insist on change and insist on a voice and a place.

YOU-SHIN CHEN I've prepared to talk about the transition for a show I designed at Bushwick Star, a small theatre in Brooklyn. That same production we also brought to a different theatre in Seattle, Washington. The original design was built to this space [Bushwick Star]. They had an old loft and all these corners and architecture that you have to deal with. Then we had to bring that show to a new black box theatre.

We really redesigned the entire thing while still trying to keep the [original] idea. The entire structure around the audience is totally different. They have a different experience entering the space, and the ceiling is eighteen feet. The scale is different. It's not something you can just proportionately expand. Everything feels longer. When I arrived at the theatre, I cut the slit from ten feet to twelve feet, trying to approximate the original design. But then they built it totally wrong. They have the slits from the ground from zero to plus-eighteen feet. Basically, there's just the entire gap. The lighting designer didn't have enough lighting instruments to fill the gap because the light shines through the gap. We went back and forth and between trying to keep the old design, the concept, and then struggling, trying to build it anew in the new space. At the end, we actually kept that door at eighteen feet, and it was amazing to see a version of the design in that scale and how a human body reacts to something so big. The feeling is so different.

This entire time, we were just trying to capture the first experience of the show. But then there is this mistake and we kept it. Yeah, the transition is more of how we accept something that was built wrong but make the most [of it]. **I didn't want to give up what my original design was, but it was about letting go of personal ego to see this thing in a totally new perspective.**

MAUREEN WEISS I love that because you set us up to really love the first image of your set. I was also holding on to your set and wanting to fit it into this new space also.

YVONNE MIRANDA As far as transitions, there's one that comes to mind on the last set that I designed. Sometimes you have directors that come in that have no idea what they want and then some that are like, This is what's happening. Unfortunately, that sometimes doesn't really leave room for the rest of the

Set Design by You-Shin Chen, *UGLY (Black Queer Zoo)*

designers to figure out what that is. You have to make it what you want it to be. The director wanted to dissect what *Così fan tutte* was, because at face [value] it's, like, a really sexist opera, so he set it in the guise of a privileged school, a private, predominantly white institution in a really affluent neighborhood where professors of color have been pulled over by cops and asked, like, What are we doing in this area? I did a lot of research. I was like, Why don't we set this in a library? Why don't we make everything just white to tell the story? As it goes along with the unraveling of [the story], them being very culpable in their actions and [increasingly] have more color come in until the end, and it's like a blast of color. The costumes and the set, everything started out white and black and it would be up to lighting and projections to help assist with the color transition. Being a scenic designer and creating a world and having a vision—it is really hard when you create this world and you try to be

Program Note

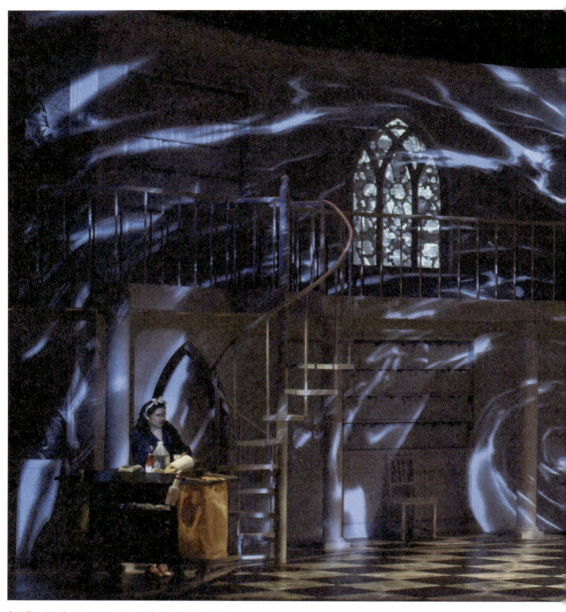

Set Design by Yvonne Miranda, *Così fan tutte*

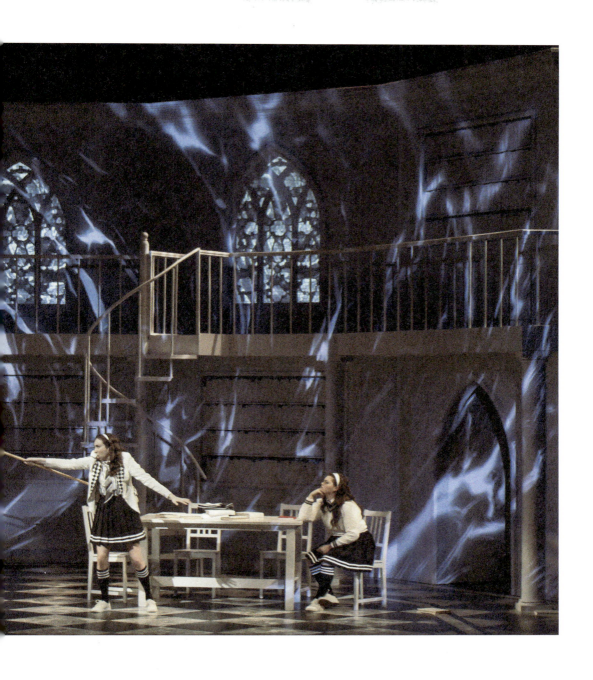

collaborative with your fellow designers and it still doesn't come close to your vision because you're relying on others.

How do you remedy that? That's something I'm really looking forward to when I work professionally as a scenic designer and get to witness. There [are] a lot of dynamics and you don't want to step on anyone's toes, but at the same time it's like, This is my work that I've done that I'm proud of. I put a lot of hard work in and then it looks totally different when those other attributes—lighting, costumes, projections—come into play.

ANDROMACHE CHALFANT **Even the idea of transition to me—as I was thinking about the question—it's a place for designers to sort of take over as narrator.** And, so, I'm always excited about transitions when I'm reading the script, even if they're not indicated. Early on in my career I saw it more through the lens of light and sound as taking us from one moment to the next. But in this case that I'll tell you about, it was the first time I understood that the set could be this kind of kinetic event that could also join in this transitional storytelling. And once I had that experience, it impacted all of my design moving forward. But—some success, some failures. And again, to sort of piggyback on what Yvonne was saying, so much of it has to do with whether or not the team, the entire team—directors, actors, designers, technical department—are all in because of the coordination that is required, as we all know, to have all of this happen in time and bring meaning to the story. It all must be coming from the same place. So, in this case, it was *Endgame*. Marcus Stern was directing. And I was working with Scott Zielinski [lighting designer]. And he was pivotal in terms of bringing the [visual] idea forth, it was essentially just an interior within a black space. But it was a complex construction of fabric-covered walls and the set was elevated about six feet, so it was really floating. And the cinematic trick was at the end, when Clov leaves Hamm but doesn't really leave him. He gets into the sort of threshold, his door, and the set just very, very slowly starts to separate. The walls separate from the floor. And it had a profound new meaning to that moment where Beckett hasn't written any words, you know. And I was thinking about this idea. What does it mean for us as artists to be able to speak in those liminal spaces, you know? So then if I were to relate it to my own life, I've been thinking a lot about time [during Covid]—and reflecting on how little time we really have when we're in the throes of our design careers. And then I connected it to research and cultural competency and—recognizing that if we're given the opportunity to glimpse into the world of another person, the ways in which many of us don't take the time to understand other people's experience and other people's lives. I've loved all of the comments, especially Narelle, when you said broadening culture, and we don't give it the time to really understand who these people are—it's not an authentic expression. I was struck by how that relates so much to the conversation definitions. That also connects for me.

MARKÉTA FANTOVÁ This is so incredibly wonderful to hear and it is very inspiring for me because one of my transitions was, I think four or five years ago now, which was moving from being a designer and educator to flipping into somebody who is trying to figure out how to exhibit scenography. And that is insanely difficult.

Set Design by Andromache Chalfant, *Reverberation*

How do we capture a moment [of performance] which is past and then show it somehow to others? I had a huge moment of waking up. Moving from [the] United States where, for the same reasons as we heard Yvonne say, I started doing lighting design because I thought, Okay, if I can't say some of these things, I'm just going to do it. There were moments where I just couldn't imagine how I can separate the set. I never separated things. I was trained as a scenographer, so I never understand the divisions between different disciplines. So, it was difficult for me. Those moments that she just talked about were very hard to understand—why everything has to be so separate.

I went and just started lighting design, which I really love as a profession. And then coming back to [the] Czech Republic, I realized that here it's not even recognized as a profession in some cases. Because this whole term scenography—which I thought is great to look at as this universal thing—it actually also has a somewhat complicated past where it's often about a man who does everything and is revered for his imagination while everybody else does the partial things. There is something like, I don't know, it's a little higher position than a master electrician, but it's essentially a designer who helps the scenographer.

When I came to Prague and took the position of artistic director of PQ [Prague Quadrennial], I thought, Okay, let's just do a project because there's a voice

Program Note

Curated by Markéta Fantová and Jan K. Rolník, *36Q*

I can use. So let's do a project which is specifically for non-tangible forms of scenography, which is lighting, sound, and such others. And we did something that is called *36Q*. It happened at PQ 2019 and it was a fairly large installation where there was lighting, sound, different kinds of sound, different kinds of lighting. Altogether it was around ninety people [that] participated in [it]. I have learned a lot about teamwork. And just a day before we opened this really large installation, we had an interesting moment similar to what Yvonne was saying, but a different angle. And that was we added into the installation an element of tangible territories. We had an artist who had created tangible particles of this large installation that we as a team created together. And the installation was primarily visually driven, which we didn't realize until we were about to open. And one of the artists, who is the visual projection artist also from the visual arts world, said, Well, I don't like the tangible territory. I don't think that's aesthetically pleasing. And we have this giant, I don't want to say it wasn't a fight, but it was a very strong discussion between the artist who created the tangible territories and the artist who created the visual overlay of the world. Especially now, in the in the time of Covid, we miss tangible. We just miss things that are tactile. We miss tactile stuff. We miss the touch. And I realize that sometimes the touch is far more important in these installations than is the actual visual. So, it was sort of my transition realizing, Okay, maybe we just need to stop thinking about scenography constantly so much from the visual point of view because it really is

an immersive art. And the touch, the tangible, is just so, so important in it. Now being in the midst of Covid, working on the vision for 2023, I'm wondering how much the touch or the tactile is going to be part of the next exhibition. If we are done with this terrible pandemic, people will be so ready to see each other and come to one place and share, or will we be still stuck in some sort of an onscreen life, I don't know. But that's definitely going to be another transition—waiting for all of us to see where we get from here.

SHING YIN KHOR I feel like my entire career has been a transition away from the institution of theatre, not theatre as a whole, but theatre as an institution. And so much of that, especially now, I don't feel that most theatre institutions serve marginalized communities or people—it tolerates, but it doesn't serve or center them. This was basically the moment I started moving away from scenic design. My central question was, How do I make a living without begging to be taken seriously by all these white men and deal with daily microaggressions that are just held up by sexism and white supremacy? Ultimately, what I decided on is that I didn't want to be hired. What I wanted was power. I wanted access and I wanted resources. And none of that was going to happen by me slowly climbing up the scenic design ladder where the standards were clearly different. I had to think of what that meant for my career, because I wasn't willing to spend ten years of putting up with it or ten years of wading through the slog—how do I make design-led theatre and how do I make work that is directly connected to and relevant to my own community?

If anything, I'm more of a set designer now. I feel like I'm making work using all my set design skills, using set design theories and practices to make work that finally, finally feels right.

I'll actually talk about a work example. One thing I've always been interested in is the rituals and traditions of immigrant diaspora communities and, specifically, how those rituals have differed and evolved from the traditions in the home country. Because diaspora rituals are like a whole different thing in and of [themselves]. And in a broader sense, it's about how humans are always creating rituals and traditions to make sense of a world that doesn't [make sense]. An installation I've worked on for several years now has been this thing called *The Gentle OracleBird*, which was initially a very large room installation and has become a more performer-led project. It's essentially a fortunetelling cart. But in pandemic times, I've had to transition that to something mediated by screens and I'm really excited for it to happen. It's currently a thirty-minute interactive experience. This is also my transition into adding performance into my work, which is weird because I've spent like a decade of my career removing performers from it. It actually has become a lot smaller and more intimate every time.

ANDROMACHE CHALFANT I like the way you put it that you've made transitions away from set design, and yet you're using more of your set design skills every time you make a transition away. I just think that's really smart.

Shing Yin Khor, *The Gentle OracleBird*

SHING YIN KHOR It feels like I'm actually coming back to set design more and more and maybe I could just build a full-on set again; might actually be kind of fun.

ANDROMACHE CHALFANT But on your terms.

SHING YIN KHOR Yes, exactly. I'm also just more confident as a person and all my other projects have given me "fuck you" money, like in a way that you don't have when you're twenty-two or twenty-three. I created the ability to walk away from something that doesn't serve me.

HANA KIM Really interesting to hear about—thinking [of] theatre as an institution more than like an art form. Because I definitely feel that sentiment of like, Oh, I'm the only one who is not white in this room. I feel like that's been kind of like a model. It's getting better, of course, but I think I kind of had that moment since I was in school for theatre. I'm still unpacking that because I think the flip side of it is also like being a token diversity, especially in this really heated kind of environment. I do feel like you get calls that otherwise you may not get. I know there is certain value to it, but, yeah.

SHING YIN KHOR What people are doing these days is they are hiring people of color, but they are not creating room for them to thrive and are expecting people that have been marginalized for a very long time to instantly enter an institutional environment and know what's going on. And they get paid for not getting it, for not fitting into the culture. It's like, well, maybe your culture was bad.

HANA KIM Another side of it is that most projects that are really focused on diversity tend to be underfunded, or [they're] not funded in the same way.

ANDROMACHE CHALFANT There's an opportunity for solidarity in this conversation. I'm thinking about what Narelle said and where she and I are. We're kind of the same age and I think the experience of being given work—maybe we can connect it to the Me Too movement or something like that but also recognizing that you couldn't fuck up, too. The hopeful side [is] that the world is changing and that things will open up and more voices will be heard and they will be more equitable.

NARELLE SISSONS I agree with what you've just said, Andromache, Hana, and Shing Yin. You know, we are in such a competitive field and there's such a fight on right from the beginning. I came from England and I hadn't been to school here. And I just kind of dropped in, having had no professional, no sort of student connections or professional connections except for one when I got to this country thirty years ago. Just to add into this mix, there were very few women who were scenic designers, like Marjorie Kellogg, like Andromache, probably other people who remember that there were so few people who are women who are doing this work. So there was kind of this fight on every day to get the jobs.

I had to prove so much more than my male counterparts who had graduated [at] the same time to get the jobs or to stay on the jobs. You know, the amount of condescension that came from a lot of the shops or the producers, the lack of trust, having to prove constantly that I could actually do this and the fight that I've had as a female set designer and a lot of us had to keep forging that path.

Marsha Ginsberg, *Hauch – A Sonic Horror Show*

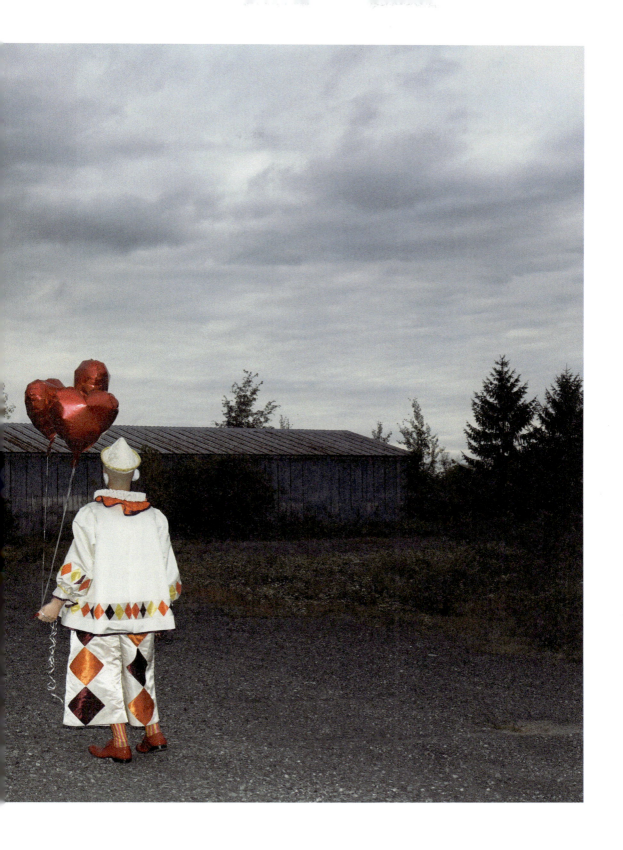

It's exhausting, and that's one of the things that I've been thinking about [during the] pandemic—is that level of exhaustion that I've had my whole life just to hang on. So, I'm going to get swept out, you know, and it really came to roost when suddenly the Me Too movement happened and I started to actually be given access as a white woman to a world of scenic design that mostly my white male counterparts had full access to. They were calling the shots. I think it's really complicated. I don't want to just reduce it to the simplicity of race or gender or competition, but I think it is worth continuing to push. It's worth continuing to kind of crack open these opportunities. And I think that, in solidarity, we have to work together to make sure that we are there to catch each other and to bring people up who are coming up in the industry.

MARSHA GINSBERG I've gone through the struggles of aesthetically not fitting in and [as] a woman not fitting in. And that that's really a huge thing as well. Often my instincts of how to work are not in sync. And so, my wishes for American theatre would be that there's a multiplicity of practices and that the work that is pushing boundaries of form, or just having a different aesthetic, is not always marginalized. Because there are so many levels of being marginalized and part of the thing of being on second stages is that your work is not in this kind of dominant aesthetic. And we could also talk about the dominant aesthetic and what that means on so many different levels—whether it's patriarchal, whether it's very white supremacist, etcetera, of what constitutes American theatre.

HANA KIM Yeah, I agree that it's not just about even race or gender; the aesthetic part is really resonating with me as well. I'm so encouraged to just listen in for a very short period today. There [are] so many of us that have solidarity and a similar mind. Expanding the notion of the aesthetic and the definition of scenic design is really encouraging.

TANYA ORELLANA I was thinking about one of the transitions that I'm going through is just being more honest about what my perspective is to people I'm working with. My work has always come from my perspective. **There is no neutral perspective. If it's a white perspective, that's considered neutral?** But that's not true—we're all coming with a specific cultural perspective when we're making work. I have found that if I talk about it with some directors they get afraid or I'm seen as like I'm going to turn everything into some something that's not neutral. So, the transition is [me] starting to say, It's my job. And what Narelle said earlier about fighting for our voice—it is my job to be honest. This is my emotional in, and yet I'm still going to design something that can speak to us all, because that's—we're all doing that.

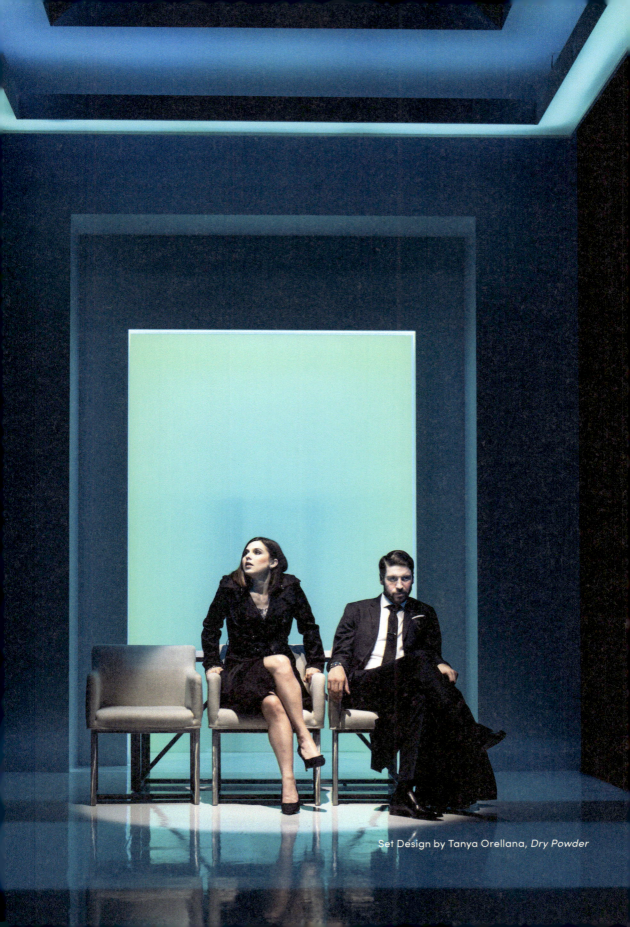
Set Design by Tanya Orellana, *Dry Powder*

Video and Projection Design by Hana Kim, *Sweet Land*

Program Note

It's almost five-o'clock.

yeah, thanks.

I am teaching those, yeah.

...faculty member stand in for me, and I somehow found his lecture on a Google Drive and was horrified by the history of set design put forth. And I was—I vowed to change that history.

But anyway, I think we all probably need a bathroom break.

I hate to say this is our last conversation because I likely will want to reach out to so many of you again, because it's just been awesome.

So we'll just try to continue doing that and supporting each other.

Set Design by Deb O, *Selkie*

And already I've had the benefit of being able to either bring in a couple of people to work with me or be able to suggest other designers from the group at large to others around.

And it's been so amazing.

—call this person.

I just think it's a great, great group. So thank you.

And thank you for introducing us all. Thanks for the— Stay safe tomorrow, please. Oh, right, Okay. The real world, right.

Thank you so much. I'm going to.

Everyone. Thank you so much for coming in. And.

But your kids.

Okay, I got to pee. I know I'm going to—do you want me to stay on? I got to get the kids food.

CHAPTER 1

Dialogue Between Decades

CAREER AS A SHIFTING LANDSCAPE

Ed Haynes / Linda Buchanan

July 22, 2020

MAUREEN WEISS From your perspective, this lack of live theatre that might continue for quite a while, do you think that this gap is going to change how we enter back into the theatre as designers?

ED HAYNES Hope so. I think there's a lot of—there was a lot of abuse going on in terms of the way things were set up. I hope that people are going to revisit the way designers are dealt with.

SIBYL WICKERSHEIMER And how do you think that the change will take place?

ED HAYNES I've heard rumors about theatres trying to reduce the amount of travel by hiring local designers, which would be wonderful considering I live in Los Angeles, which is the furthest Off Broadway market in the world. The regional theatres here all tend to hire New York designers before California designers, but you know I could drive to most of the theatres around here. I live in Temple City, which is a Pasadena suburb, and I've only ever done one show at The Pasadena Playhouse which is the closest LORT [League of Resident Theatres] theatre to my house.

LINDA BUCHANAN Also, it's a scheduling issue. I've been doing this a pretty long time. It used to be very normal to have many, many face-to-face meetings that were long, long meetings.

Decrease, decrease. And then it starts being, Oh, we're going to have meetings, one at a time because people are so busy. You rarely have the full team there. I understand why that happens, but I really hate it, especially for the very first meeting with a director and the very first meeting of a project. It's just very hard to have the buy-in, you know.

ED HAYNES The other thing I've noticed with the directors particularly is that they have what I like to call "decision-making disorder." Building models has become painful because the process—it used to be that when I do designs, I give them versions. And every time I would alter it significantly, I give it a new version. So yeah, a theatre show probably opens on version ten or eleven for me. I've had corporate shows that have opened on version forty/forty-one and at that point, doing models is out the window and it's all about 3-D and virtual reality and turning around renderings and VRs—three different concepts. Well, let's see it with this, this, and this and let's get that from all the angles and can I have that in two days? Can I have it tomorrow morning?

LINDA BUCHANAN It's supposed to be called directing, not shopping. I used to give three options. And now I find that I know which is right and I don't want to present the other stuff anymore. I just try to sell the thing that I think is right.

ED HAYNES There are two kinds of directors out there. There are the ones who have already blocked the show in their heads and they're the ones that have absolutely no idea how to block the show.

LINDA BUCHANAN Yeah.

ED HAYNES And you know when they've already blocked the show in their head. It's so easy to design the show if they can communicate that blocking, it just flows. But if they haven't blocked that show in their head and they can't think spatially—

LINDA BUCHANAN That's the issue.

ED HAYNES That's the hard way.

LINDA BUCHANAN Don't you think that you're often blocking the show?

ED HAYNES Always.

SIBYL WICKERSHEIMER Can you speak to how you've been able to get the trust of a director who you had challenges with? I think that's the biggest thing, as you do more and more work and get more experience, that's what you hold and feel the most confident about, no?

LINDA BUCHANAN I mean, I do know that I'm pretty straightforward.

ED HAYNES Usually I try to get there before. So, you know, maybe a designer run-through or something. I'll say, Okay, well, this is very interesting, but remember we had structured this whole moment like this [gestures to an unseen model or drawing]. Do we want to try to push closer to that or do we want to try to take the moment that we rendered closer to what you've actually discovered in rehearsal? Some directors are very much rehearsal-based and it is sometimes hard once they are in rehearsal, they may stray a long way from where you had visually storyboarded the show.

MAUREEN WEISS You said that really well, Ed, putting it in their lap. Do you want to get there or do you want to go in the direction you're heading?

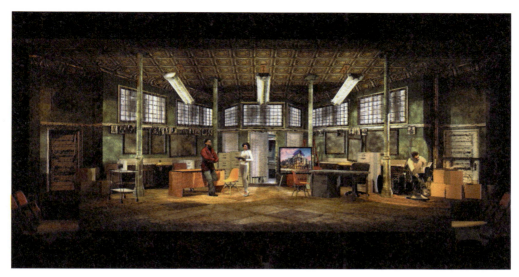

Set Design by Ed Haynes, *Radio Golf*

ED HAYNES Right. Right.

MAUREEN WEISS I'd never thought of it that way.

LINDA BUCHANAN You can sometimes see the production in rehearsal veering away from the stated concept or style that everyone said they were going for. And that is hard for us because our stuff is built.

ED HAYNES Yes. Nothing like going to a designer run-through and going, Well, that was nice. But that's certainly not what's on stage.

LINDA BUCHANAN If I'm in rehearsal and I see that, stylistically, it is going in a different direction I bring it up right away to see what, if anything, I can do. Maybe they are just not aware that they're deviating from what was discussed. But yeah, it's really hard on us.

ED HAYNES That's when a good stage manager can sort of really save your bacon. It's odd, because when I when I started in this business I was known for insane detailed models and I have completely gotten away from finished models. I do white models, but then all my detail is done in virtual reality now because it changes so much. And also, this is probably my anal retentiveness more than anything else as I'm getting feedback from, say, the prop people and such, then I will change the virtual models.

LINDA BUCHANAN Wow, pretty impressive.

ED HAYNES Um, no, it's exhausting.

LINDA BUCHANAN Impressive and exhausting.

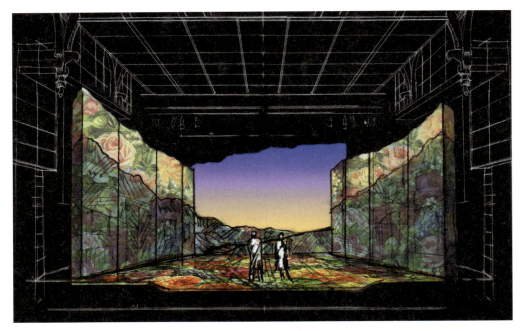

Set Design by Linda Buchanan, *Boleros for the Disenchanted*

ED HAYNES Making sure that that they recognize what they're going to see before they see it, it just saves a lot of time in tech. I did a TV show for a while, called *Culture Clash*. It was on Fox. This is years ago, but it was crazy—twenty-six to twenty-eight sets every two weeks for twenty-six episodes. And we discovered that we just had to lock everything down just because the timeline was so crazy that everything had to be locked down and everybody had to know what they were going to see when they walked in the door and that sort of stuck with me.

MAUREEN WEISS It's different than theatre, working that quickly.

ED HAYNES I remember, I had a line producer, a guy named Jimmy Vilardi. He was really wonderful and always had his cousin, who was this really big guy, next to him. I was very young at the time, and he took me aside and he said, You know, on shoot days I carry $60,000 cash. And I said, Well, why the hell do you do that? He says, Well, when all the departments are here it's [costing] $75,000 an hour, do you really want to wait fifteen minutes for me to get a check cut so that I can buy a $200 chair that we need for the scene?

SIBYL WICKERSHEIMER Have you worked with TV-directors-gone-theatre-director, where they want that same speed and efficiency?

ED HAYNES Yeah, usually the TV directors are slumming when they're in theatre and we usually have that conversation early on. I always say, Money, time, and quality—pick two. And in television, it's money and quality and usually in theatre, it's time and quality.

SIBYL WICKERSHEIMER And with the 3-D modeling work that you do, do you find the directors have trouble with it, or is that why you do the white model?

ED HAYNES That's why I do the white models. Most directors are pretty good with it and I can [also] do it in 3-D. The other thing I found going virtual—a lot of directors, this is a horrible secret I think, a lot of the younger directors have absolutely no idea how to read plans. And by giving them a bird's-eye view of the set, it takes away that sort of fear that they have of reading blueprint.

I have a theory of design, you know, depending on your budget, you always work from the actor outward. So obviously, the most important thing on stage is the actor and the second most important thing is what they're wearing, and then the next important thing is the things that they're touching, and so forth and so on to the things that are well on the periphery that they can't touch, that are just simply visual.

MAUREEN WEISS Yeah. How about you, Linda. Do you find that's the case also, or do you have another [way]?

LINDA BUCHANAN Absolutely, yes. **The actor is the point. And that's the grounding point** and then you're moving out from there. I mean, we need the most detail and the most time spent on what's closest to the actor and that can become much more abstracted or loose on the periphery.

ED HAYNES Eugene [Lee] taught me some of the most important lessons that I've ever used in theatre. My favorite lesson that he taught me was [to] always threaten to cut the thing they love the most.

LINDA BUCHANAN Why, why?

ED HAYNES Because then you get the thing you want the most.

LINDA BUCHANAN Oh, I see.

ED HAYNES He always suggested that what you did was when you presented a show and you had to read your audience, your producers, and your directors to figure out what element they love the most. And then he said, Invariably, it's not the thing you [the designer] love the most. And then when they want to cut the thing you love the most, you threaten to cut the thing they love the most in order to get the thing you want the most kept [in].

LINDA BUCHANAN How do you justify your threat, it has to usually be based on cost or something, you know what I mean?

ED HAYNES Oh no, no Eugene—I don't know if you've ever worked with Eugene. He's nuts. [laughs] We don't need the barber chair in *Sweeney Todd*, I really want *this*. We'll cut the barber chair just so we can have [it] and the producers would inevitably go, Oh, no, no, no, no, no. We'll figure out a way to have both.

SIBYL WICKERSHEIMER I'm curious to know if there were times where you thought I am done with this career and / or that you always sort of pushed yourself forward within it.

LINDA BUCHANAN There was a time when I thought about leaving and actually becoming a therapist, a counselor, a social worker or something like that, which

partly had to do with my past interests. But also, I just got to a point where I think I hit a bit of a ceiling and the work was not—I felt like I was just reinventing the wheel all the time. It was the same thing over and over and I was getting kind of bored with that. And then something happened. I'm not sure exactly why, but I seem to have broken through and started working at different theatres on different kinds of projects. Also, that might have been about the same time that I did a bunch of corporate work.

I worked at Chicago Scenic Studios heading their design area for a while, and I did everything there. I did the opening of the state of Illinois building, and I built hats on the Picasso statue, and designed some restaurants and parade floats—everything. I think that experience of working with corporate people made me see myself more as an expert or the authority on the spatial representation of an idea. When I started to bring that into my theatre work in a way where I was more authoritative like, You've come to me with this problem, and I'm going to give you the solution to it. And not like, Tell me what you want and I'll produce that. I think that got me through a boring place where I thought about leaving and doing something else. Since then, I've never had that.

SIBYL WICKERSHEIMER Do you find that the authoritative approach as a woman is more difficult?

LINDA BUCHANAN Yes, it depends on the director. Some directors are absolutely fine with it and some I have to do what I call the "scenery wife approach" where I go, What would you think about doing or trying this idea? Or, I had this idea, but I don't know. You know, where you have to kind of back into the idea which I really hate. There's the inevitable story of the ideas that you throw out that are horrible and then three weeks later, when it's the director's idea, it's genius. You know, that's happened so many times [I] actually one time said, Yeah, I really liked that idea three weeks ago when I first brought it up.

ED HAYNES That's why I do version numbers. Oh, so you mean, like, version sixteen?

SIBYL WICKERSHEIMER Ed, how about you?

ED HAYNES Well, I took a break. A sort of forced break when CTG [Center Theatre Group] laid off all the designers when they closed the Taper [Mark Taper Forum] for renovation. I gave up theatre and pretty much from 2007 to 2011, didn't do much theatre at all. And then, I don't know what happened, but people started calling me again. In that time, I was doing events work: concerts, restaurant, and nightclub design. I was working for an event company. The first thing I found was that the way the people approached me—I had this depth of knowledge that nobody else seemed to have. And so, my word was the final word. Which was something that had not happened in the theatre. I always had a director and I always had an artistic director who were there and even a TD [technical director] was telling me what I could and couldn't do. The other thing I found was that, to be perfectly blunt, the event world and the corporate world are far less racist

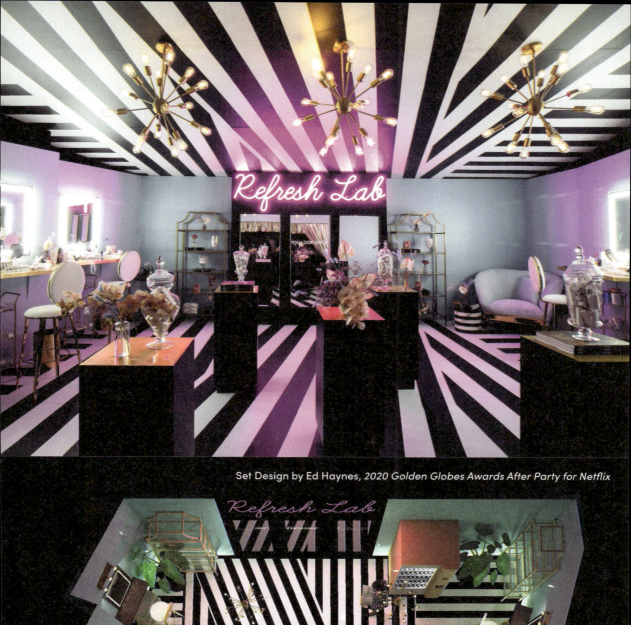

Set Design by Ed Haynes, *2020 Golden Globes Awards After Party for Netflix*

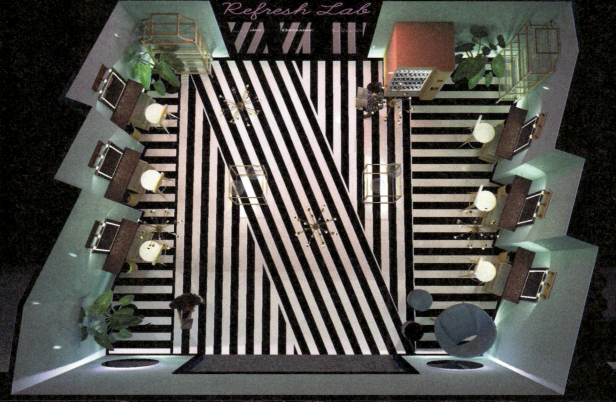

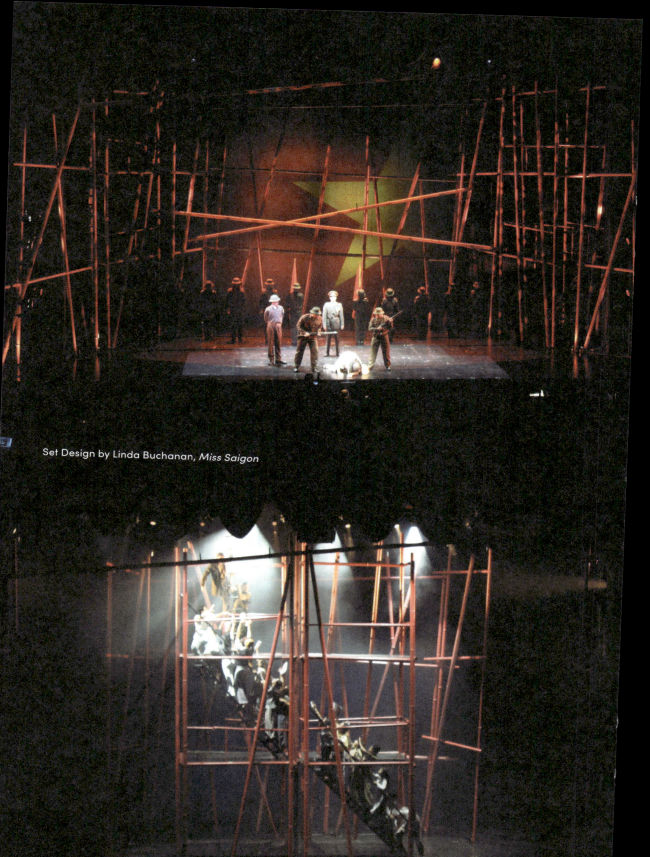

Set Design by Linda Buchanan, *Miss Saigon*

than the theatre world. In the theatre world it was assumed that I always did the Black shows and in the corporate world, they didn't care.

LINDA BUCHANAN It's interesting that we both, through that corporate side of event design, blossom into the next level of theatre design.

ED HAYNES There was something freeing about the corporate world because they literally didn't care as long as you made them money. As long as you could bring it in on budget, bring it in on schedule, and effectively create what they were looking for they didn't care who you were or what your politics were. They had very little politics on their own side. There was something absolutely freeing about that. There were fewer egos to deal with as well.

SIBYL WICKERSHEIMER So interesting. What is an approach that can be taken in order to achieve a similar balance in the theatre world and in the theatre structure—that of less racism, more support, and less authorship in terms of less pretension or ownership over the ideas?

ED HAYNES It's good question. Initially, it starts off with ego. When you think about a theatre production there are a lot of egos that have to be stroked, starting with the artistic director or starting with the board of directors.

LINDA BUCHANAN Bottom line, it's not meant to be art. No one thinks that they're producing great art. They're telling a story. That's not to say that they don't take their skill and their artistry seriously. There is very serious storytelling work, but there is not the pretense that this is some kind of art. I mean, I used to say to myself, Take your work seriously and yourself not [seriously]. What we do doesn't cure cancer. I mean, it might be an important piece of art and an important message, [but] we have to take it with a certain level of humor.

The other thing that could happen is that every area could really learn to believe that the people who work in the other areas are the experts in their area. A little respect for the other areas would be helpful. I'm not talking about just directors to designers, I'm talking about designers between the fields of design. I think there could be more respect for people's expertise.

ED HAYNES I remember I did a thing for T-Mobile for E3 [Expo; gaming convention] and we wanted to do this sort of fifties style. So, we created a diner and I actually storyboarded how the patrons would walk through to the booth and what their experience would be. They were blown away by this. They had not contemplated sort of scripting a person's pathway through the booth, and I think that helped make it more successful. It made the whole process more magical from a corporate side than they were expecting it to be. I made it more successful. Also, being able to put that sort of art into things that people aren't usually used to having an art framework was valued more than in theatre. In theatre, everybody's like, Oh you're doing your artsy thing. Here they were like, Oh my god, this is, this is art and I was expecting a billboard. And I got art instead.

1. Dialogue Between Decades

SIBYL WICKERSHEIMER It's funny because now I often get the comment, What are we doing, an art installation?

LINDA BUCHANAN I didn't know that was an insult. Is that an insult that it's supposed to be an art installation? Is that supposed to be an insult?

SIBYL WICKERSHEIMER Well, I don't know, I think it kind of goes back to what you were saying about us being theatre designers or theatre artists. Are we artists? Are we making art? And what is that distinction? Actually, the answer might be yes and yes, right?

MAUREEN WEISS What brought you back into theatre or what keeps you there? Or maybe you don't want to stay there anymore which is understandable.

LINDA BUCHANAN **What brought me back was really the relationships with collaborators. That's the part that I enjoy the most and it's not just collaborating with the team, [but also] with the shops, the technical director, the scenic artist, all of that. That's just what I love to do and I love the final product.**

ED HAYNES I don't know what brought me back to the theatre. It always was my first love. And it was what got me into this, and I always have loved the collaborative process. I love the live audience experience—putting something on tape is very controlled but also there's something that's not exciting about it because it is so controlled. What ultimately brought me back to the theatrical experience was, at some point, a light switch got flipped and I became a senior designer. All of a sudden people aren't asking me to justify my design choices anymore. It's like, Okay, well, this is less frustrating. And the opportunities were all suddenly bigger. I always tell people: I do the corporate stuff so I can afford to do my theatre habit. Because you just can't, and particularly in this town, you can't live off of theatre alone. The larger projects started rolling in, and that sort of helped, and that got me back into the theatre world. I actually did a ninety-nine-seat theatre show last year. It was incredibly painful, but it was fun. And I was building flats.

LINDA BUCHANAN Oh my god. Oh my god. Did anybody take pictures?

ED HAYNES No, no, no. I made sure nobody took pictures. You never let the producers know you can build anything.

"There's this beautiful little scribble that came out of a Stanford d.school exercise a couple of years ago about what education should really look like. And it was this beautiful loop of, like, you come back and sometimes you're a student and then you come back and sometimes you're a teacher and then you are working and then you come back and you're a teacher again and then you actually need to be a student again. And it was just porous and so intelligent and so accurate to how life actually works."

—SHANNON SCROFANO

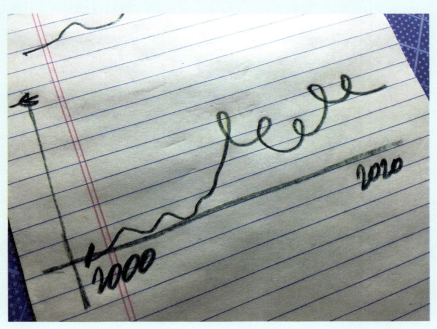

Regina García, *Career Arc Illustration*

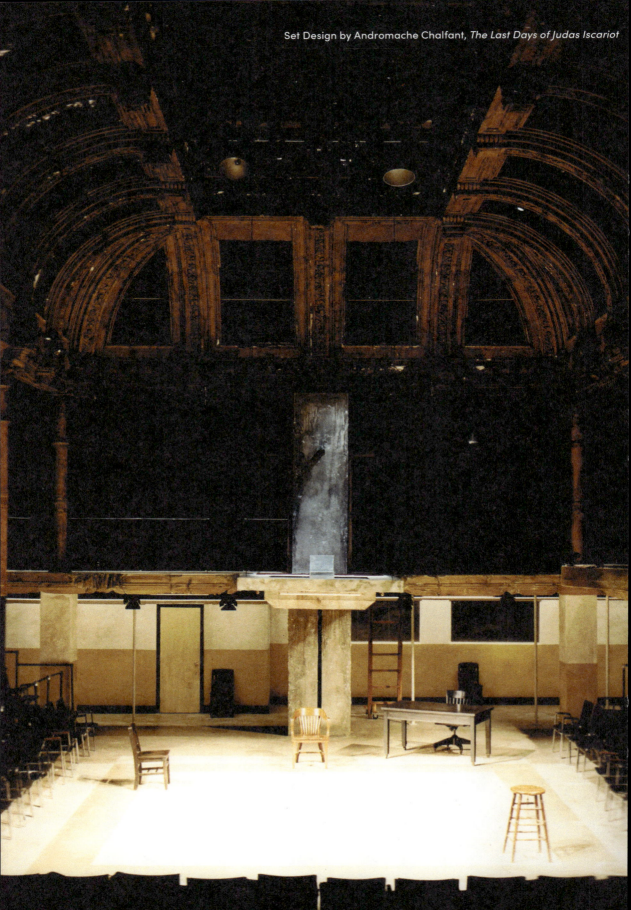
Set Design by Andromache Chalfant, *The Last Days of Judas Iscariot*

TEACHER / STUDENT RELATIONSHIPS

Andromache Chalfant / Marsha Ginsberg / Regina García

July 18, 2020

MARSHA GINSBERG <u>I think that one of the huge issues about American theatre is that it's really monolithic.</u> And there's this idea that [theatre is] musicals or this well-made play thing—I was a person who never identified with any of that. I went to art school and I had a really hard time at NYU. I was kicked out of my first-year design class. I found these different outlets in [the] performance studies and experimental theatre wing within NYU. If I didn't have those outlets I wouldn't have graduated because I got A's in those but not in my design program. And, I'm a white woman inside this institution that has a very monolithic idea of what theatre is. I felt that [difference] when I taught at [SUNY] Purchase and I taught at Fordham [University]—when I taught at NYU that monolithic idea of what theatre is still exists.

We don't have a kind of multiplicity of practice, whereas the art world is just wide open. We're all hearing about all the grievances that people have with American theatre; it's an environment that doesn't care about artists at all. That's a huge, huge issue.

ANDROMACHE CHALFANT I think the thing that makes me uncomfortable right now teaching is there's this idea that we are in the service of preparing these students with skills for that monolith, which I've never felt comfortable with. It even gets us into a question about technology and what our responsibility is [in] teaching that technology. And when you track that to the 1 percent billionaires who are sending out this technology for us to be using, I start to have big questions about it. It's coming up right now, especially with this remote [schooling] thing. What are the values and skills that don't have anything to do with the economy that we're trying to teach theatre designers? To bring it back to the art world question, it isn't about economy. I mean, you go, you do your performance art, you go be a painter, you're not really thinking about it from an economy point of view or a financial point of view, you're doing your art.

MARSHA GINSBERG I kind of always feel like you have to be really entrepreneurial about your own education. But I also think that going to art school teaches you to

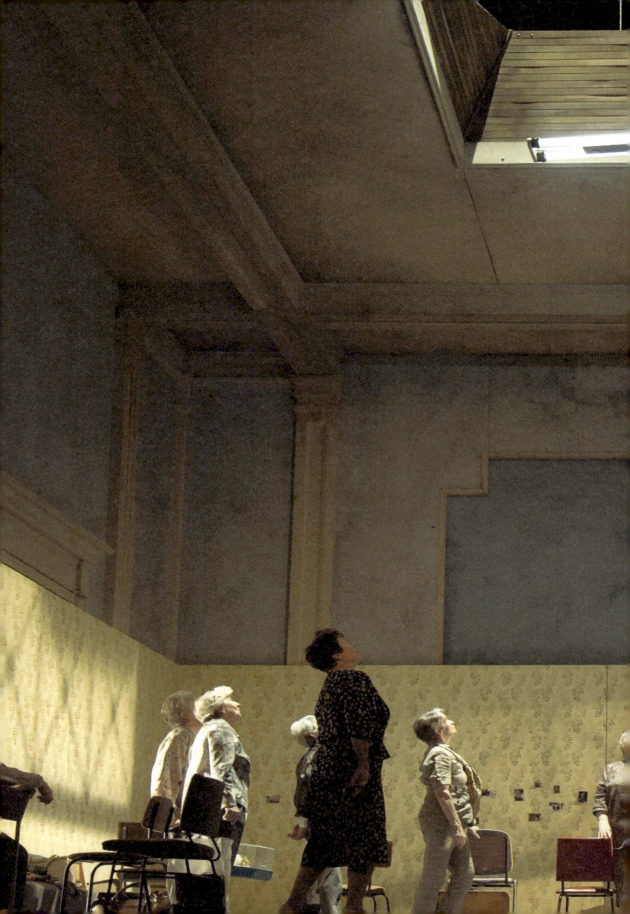

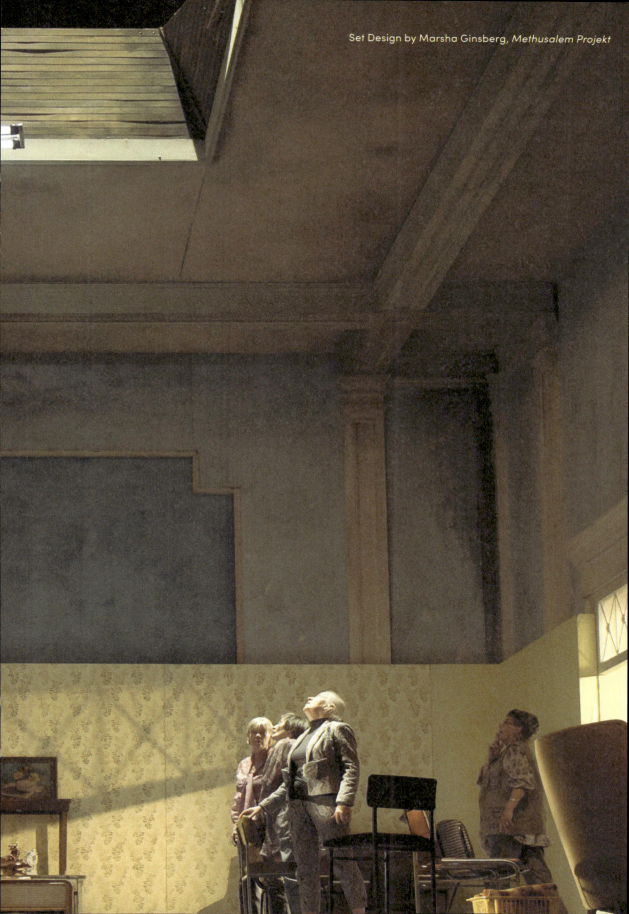

Set Design by Marsha Ginsberg, *Methusalem Projekt*

Set Design by Andromache Chalfant, *Il Combattimento di Tancredi e Clorinda / I Have No Stories to Tell You*

1. Dialogue Between Decades

be kind of a radical and invent your own ways of doing things. And I think that theatre is actually quite a conformist medium and, especially, I think that probably we all struggle in our own work lives finding the sweet spot between what we're interested in investigating about a piece and how we integrate that into the collaborative team.

REGINA GARCÍA I was a painting major, not a sculptor, but I did take some sculpture classes and in terms of understanding what I brought into theatre—also valuing inquiry and valuing voice—the specificity and uniqueness of your voice is something that I present and discuss with my students at the same time. We're also studying some of these things that we are passing on from generation to generation. I don't see the obsession with inquiry and observation and testing and challenging us as clearly as I see it in the students in the allied fields. My students in the conservatory—their questions are about the grading rubric.

ANDROMACHE CHALFANT It's generational.

SIBYL WICKERSHEIMER I love that term, Marsha: the monolithic. You know, theatre—there's something connected to the conformist culture where it's like the group has to decide on a way to do the show and it has to be unified some way.

I'm adamant about creating a personal practice, and I look to artistic practices for guidance. I don't look to theatre artists as much as I look to [visual] artists because their process of working is more focused on the individual.

ANDROMACHE CHALFANT **You use the word "artist," too, because I think in recent years, that word has become overused to some extent. There are a lot of definitions flying around here that have to be kind of unraveled and untangled and—**

SIBYL WICKERSHEIMER Andromache, you wrote in the survey about teaching, One force would be the guiding principles of designing for the theatre that were ingrained in me from my studies at NYU. Can you talk about what force of the guiding principles? And, do you focus on those principles?

ANDROMACHE CHALFANT I think it's actually incredibly hard to teach theatre design because you have this text, and you have to learn how to break the text down in two different ways. One is from a sort of literary perspective, understanding the story and the themes and all of that. And then there's a technical aspect to the text where you're breaking it down in particularities to your discipline. Then you somehow have to translate that spatially and visually.

SIBYL WICKERSHEIMER Marsha was one of the teachers that made the most sense to me. And Marsha, when we met, you taught the model-making class in my graduate program. You taught me to really look at something at such a minute scale, model-making, and keep looking back saying, It's still not right; it's still not the right proportion. The model is so important, but it doesn't translate fully to digital. I studied with Robert Israel and he would come in and he would just move one thing over.

REGINA GARCÍA I've heard stories before about Mr. Israel.

Set Design by Regina García, *The Rembrandt*

1. Dialogue Between Decades

SIBYL WICKERSHEIMER He would be talking to you in a conversation [and] then he would just be fascinated by the crack on the wall behind your head. And then that was the conversation.

ANDROMACHE CHALFANT But that's performance.

SIBYL WICKERSHEIMER It is performance, but it's also like what you're saying is actually not important, but this crack here is really important to look at and again it goes back to looking.

ANDROMACHE CHALFANT Yeah, that's right. Observation and seeing—are we teaching the students to see?

Site-specific work is great for people to engage in partly because of this connection to architecture. Every design is site-specific, you know, because you're responding to the theatre space and you're interacting and engaging with it.

If there's anything we can do to get the students to make these links and, for me, I make the links with space and with architecture and it evokes enormous amounts of emotion depending where I am and what space I'm in. It may be different for other designers and why we're drawn to [scenic design]. But, that link between that [space] and text or storytelling—

SIBYL WICKERSHEIMER We were wondering about balancing your time between teaching and designing.

REGINA GARCÍA I appreciate and value the conversation when you bring the students into the process. **I'm very well known for bringing more than one rough model to the conversation and I try to have those conversations with my students on why, on this particular production, I'm looking at it from a couple of different angles.**

But balance, it's hard. I've had to structure my evenings differently from just a transactional way—like three hours for this, two hours for this. I sometimes have to work with a little, I hate to share this but, egg timer. But to be able to keep going at a certain pace and be able to be ready for the next day, since I do have a full-time job.

SIBYL WICKERSHEIMER I like that you use an egg timer rather than, you know, your phone.

MAUREEN WEISS Do you teach because you wanted to teach or is it a way to supplement the designer income?

REGINA GARCÍA I would say that I started taking drawing classes when I was ten in the studio of Andy Bueso. The structure of master artists and apprentices really makes sense to me; it's been very important, the intergenerational dialogue.

MAUREEN WEISS Right, and so what's feeding your desire to be in education is within those two things.

REGINA GARCÍA Absolutely. That's really why I have moved from one university to another. We keep growing. We keep kind of shifting and changing as we get older, so when I joined the faculty at DePaul [University], it was time.

MAUREEN WEISS Andromache. How about you?

ANDROMACHE CHALFANT Okay, I was just thinking as Regina was talking—I feel like I'm in the research phase and more academic phase of my life right now and I'm working on a project of my own. I feel like there's an exchange happening with education. It's more of trying to put language to what it is I do and what I'm interested in. The engagement with students is a way for both of us to feed off each other in a way. But none of this was conscious.

REGINA GARCÍA Just want to say that I find myself being harder, and perhaps less tolerant, with the women in my design class than the men. I kind of tracked it down to this moment. I did an internship at [a scene shop] because I didn't really know anything about technical theatre, how to build a flat, none of that. I knew that I was going to have a TA-ship and my class was huge. I spent a lot of money on my education and the chair at the time was giving me an opportunity for some funds but I had to run a little shop upstairs and I didn't know anything. I decided to go work in a shop over the summer. I remember one day when I arrived, I see all these guys around the table saw talking about this "woman designer" and, Who is this woman designer and, You know we're building a show and it's this woman designer's work. No names ever, it was, *This woman designer.* And I said, Holy shit, this is unacceptable. But I was in no position to say anything out loud.

I remember the laughing, the comments, and that just kind of broke me a little bit for the rest of the summer, but it also said to me that, yeah, we have to work twice as hard and that we have to cross our Ts and dot our Is when it comes to drafting, and that our models have to be impeccable. It's not the same for my male counterparts when I'm looking at their work. That had kind of a deep impact into how I look at my students' work and how I give them feedback and critique. Of course, I am not an asshole. I think they understand that I am first and foremost their champion and if they don't [know that], I work hard at it.

ANDROMACHE CHALFANT I do think our generation of women and that era of feminism was about this idea of equality, and moving into a male profession meant a certain performance of masculinity on our parts and just taking it and being tough and all that stuff. So, what I recognize in myself with certain students is that if I detect that they are being—they're giggling or being coquettish or something as they're arguing their points, I'm totally triggered by that. You know, immediately like, What are you doing? If I'm nice to a white young man, I would have to say it must be an internalized patriarchy. You know, Regina, you brought up the women today who are like, Fuck this shit. No way. But I definitely come from an era where we—I tried to make it work in the men's way but as a tough girl or something, starting with "paint girl."

MARSHA GINSBERG I definitely had the same experience and it was definitely like a modulation of my personality and stuff. I recently saw this term "charm privilege"

1. Dialogue Between Decades

[and] it was a big "aha" moment because I was like, Oh, I've never had charm privilege because the men were comfortable with power. I would not tell things all at once that I didn't like when I went to a shop visit because I thought, Oh, I'm telling them too many negative things, they're going to hate me. And then I realized, No, actually, you have to slam it all at once. But it made me feel like, as a woman, because I had to get tough that I had no charm privilege at all.

Lord knows what people say about me behind my back. Some of us who have experienced that in the Me Too moment—I think that it's not like we were unsympathetic, but I think some people had to really toughen up. We've dealt with sexual hurt, you know, sexual harassment in terms of men being assholes to us or so many condescending things. And yet, at the same time, we just had to have blinders on and plow through.

I'm very pro-women in my teaching. I really try to empower women. A lot of it has to do with not having women edit themselves. Are we preparing students to go into American theatre or are we supporting them to have individual voices that may have to actually struggle a bit to find their place? I think that thing is like a really huge question in terms of what the mission of each individual teaching environment is.

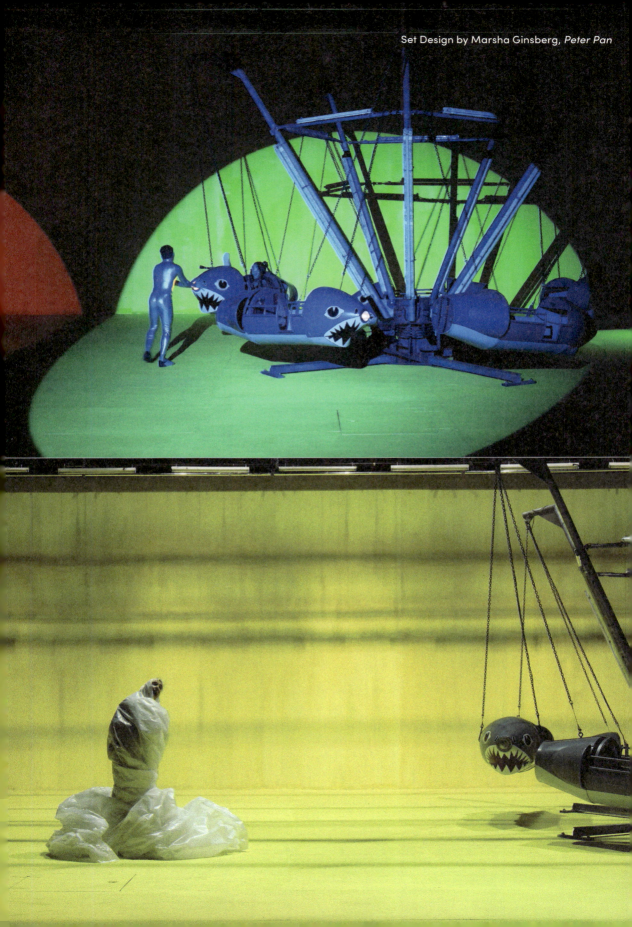

Set Design by Marsha Ginsberg, *Peter Pan*

Set Design by You-Shin Chen, *News of the Strange*

EARLY CAREER DESIGNERS

Chen-Wei Liao / Sara Outing / You-Shin Chen

August 11, 2020

CHEN-WEI LIAO I think it was two weeks ago, I visited Narelle [Sissons] and her place is really nice. You look outside [at] the Hudson. It's really nice to still be in a city, or close to the city, but you have a touch of nature.

SIBYL WICKERSHEIMER It's been amazing to get to know Narelle and her perspective. She's got a really strong sense of who she is and how she operates as a designer. As a student of hers, how have you managed to stay in touch with Narelle?

CHEN-WEI LIAO At school, it was [a] teacher–student relationship, but we get along pretty well and we chat sometimes. I would say that maybe we are friends, maybe. Actually, my first job after I graduated was as her assistant for the production with the Primary Stages in the city. We just chat sometimes. She's cool.

YOU-SHIN CHEN Yeah, I studied under Christine Jones for the first year, and Andrew Lieberman the second year, and third year Paul Steinberg. Every year we have a different structure. **When I was searching for grad school, I tried to find the program that has different professors with a different style.** [With] Christine Jones you learn the more emotional aspects, like how you as a designer connect with the project you get assigned to and then find a connection between you and the subject. Which I think is more our artistic approach.

MAUREEN WEISS From your grad school, was there some information that you wish had been imparted to you that was not?

YOU-SHIN CHEN So two out of three of my professors were male designers and they are well established. I feel like sometimes they have more leeway [in] asking for things. Something that I found hard once I graduated—to talk with [the] scene shop or even being someone's assistant and how do you talk with them? It's a totally different world.

I found it really helpful being supported by them. But at the same time, that's not the real world. So, I was just hoping that I had a class where we sat in the design meetings of the more established designers and, also, [be able to] follow them to the shop and talk about things, just listening. It would be super helpful and see how they navigate this world that's more dominated by male [designers].

SIBYL WICKERSHEIMER You almost need to role play, to practice how to respond when someone in a shop answers you in the way you're not expecting as a woman? So, probably following around the more experienced male designers isn't the way to do that, but to follow around the experienced female designers, just [to see] how they get themselves out of it. I've found myself many times trying to figure out what I did or said wrong, because I know that my male counterpart would not have had that response in the shop.

SARA OUTING I've been, honestly, on a run for most of my career of having availability of jobs. The challenge has always been to have enough time to do well on them, and to get enough pay that I can do one or two at a time instead of six or seven, which has been, honestly, my greatest downfall—trying to do too many things at the same time.

MAUREEN WEISS Yes, assess all things. How do you figure out how much you want to be paid for the small theatre gigs?

SARA OUTING Yeah, that's been an interesting new development for me. In the past year or so I've started developing payment proposal sheets where I map out how many hours I think I would work on a project and what kind of work it would be. Then I follow that with developing an hourly rate for that work. I've been setting this Excel spreadsheet where I estimate my hours and then I try to pay myself well for those hours. Of course, estimating the hours is its own weird trick. It's usually not very accurate because no one knows what a project is going to look like until it's up and running.

The past year has also been really interesting for me because I've actually taken a gap year, like a break from doing scenic productions.

I've noticed that my scenic work doesn't pay for my scenic work expenses but part-time work pays for my part-time work expenses, if that makes any sense. By not generating income from scenic work, I'm also not having to pay for gas to go down to the theatre every night or parking in Philly, which is wild, or train tickets, or that extra prop that I bought that I thought we would need but that I decided to keep for myself, or late-night snacks on the way back from techs. There [are] all these extra expenses that I discovered that I've just been pouring my paycheck into. It evened out when I stopped doing scenic work.

MAUREEN WEISS I like when you describe working in the small theatre and those drives back and forth, all of that life—it feels joyful and it fills me, but it can't actually fill me. I hear it and I miss it. But I couldn't pay rent on it.

SARA OUTING Yeah. That's going to pay rent in a different way. It's a really important discovery. There are different ways that kind of work is sustaining different parts of you, but not your actual survival. You have to be surviving in order to have joy or to have creativity or to have friends, you know. I mean, as a little baby anti-capitalist myself, which I'm still learning a lot about, like Black radicalism.

I've been really focused over the pandemic period about figuring out nourishing structures for myself that do happen in theatre so that I can hold on to those if and when it comes back. So that I can hold onto them in the meantime through Zoom programming, because they're there. It does have a creative value to me that is not monetary, but the monetary thing is still a fact of our lives.

There's some radical work being done about sustaining designers and cast members and tech though, not monetary, but tangential things like, We're a tiny company so we can't give you a huge paycheck, but we will feed you a big awesome meal at every single rehearsal. And it's home cooked and we're going to take care of each other. Those kinds of structures really are interesting to me and all too rare, unfortunately.

YOU-SHIN CHEN I do wish for a bigger change to happen. For instance, like, change Ten-out-of-Twelves. That kind of life, it's taxing your body. That lifestyle is not sustainable. A lot of projects that I've worked on are mostly with people of color and the pay is not very good.

I had to do a lot of [set] installing myself, which I enjoy actually. They also need to pay for my labor. I feel like I can't say no because a lot of projects I took on [were stories] about people of color. And I like that environment. I want to support it with my artistic concepts and my set, and to be fully supported. That story is important. I need to participate and I need to help to tell the story.

SARA OUTING **It tears me apart because there's this binary where we can either do passion projects for the people we want to support, or we can make money. That's not a fair binary.**

Set Design by Sara Outing, *Tilda Swinton Adopt Me Please*

Puppet Design by Sara Outing, *Gregor*

1. Dialogue Between Decades

The battle to keep the art form and to keep control of the art form, to keep agency within the art form is a real one. At the same time, it's very clear within my art making community in Philly—people are going to keep it scrappy enough, people are going to keep doing what they are doing regardless.

CHEN-WEI LIAO So, during the quarantine, I've been thinking a lot about our theatre. Are we going to keep surviving— [is] watching things on TV enough? Like, **what is the difference of watching TV and being in the theatre or being in a live show?** And I think the biggest difference is the time when you are in the live show, you've got no control of time. You don't know what's going to happen. Maybe someone will fail, and maybe something will happen on the stage. And there are people around you. And that's a pretty solid reason why theatre, probably, will keep existing.

This is another thought I've been pondering, but it's kind of too complicated. It's the two words interaction and Internet. So, Internet is meant two way[s], right. Interaction is into action, it's a two-way action where, Now we are having interaction because I'm taking some action. I'm talking and you are also having an action, which is listening. So, we are having that interaction—action, action, two-way. And Internet is kind of the same thing.

I call it an "internection" because [of the] World Wide Web. It's a web and it's also a net. It's [the] same thing, and maybe there is reason why Internet is called Internet because we are interacting through these [gestures] invisible things. Nowadays, we all have access to digital equipment, digital devices, where that world is very powerful, very scary and no control and you don't know what is going to pop out somewhere at some corner.

Set Design by Andromache Chalfant, *Henry V*

Set Design by Chen-Wei Liao, *Mr. Marmalade*

1. Dialogue Between Decades

Collaborative Installation by Naomi Kasahara, *Rooms: Tiny Openings*

TRANSITIONING FORWARD

Afsoon Pajoufar / Kimie Nishikawa / Naomi Kasahara / Yuri Okahana

January 19, 2021

KIMIE NISHIKAWA Well, what's happened in the past year? I've now created a company with two other set designers called dots design collective. I'm not designing under my own name anymore. All three of us have decided to not do that. It's our way of changing how designers should offer ourselves to institutions. Since then, it's actually been a great silver lining to Covid. I'm very happy with what we've done and hopefully theatre does come back. We can do some theatre, but also it's just been a great year. Time to reflect [on] what the theatre industry is going through right now, every industry.

Set Design by Afsoon Pajoufar, *The Silence*

AFSOON PAJOUFAR I'm based in Brooklyn, New York, and I'm a freelance designer. And I design for any kind of performative pieces or gallery performances. Doesn't matter. I graduated from Boston University in August 2019 and I was in the middle of exploring New York City when everything got shut down and I was like, Okay, now I get to explore new ways to develop muscles.

MAUREEN WEISS Sibyl and I thought for today we'd start with specifics on shows you've worked on that had a transition in them that impacted you personally.

I've been thinking a lot about the show I did, and I bet Naomi was working on it with me. I had to create sort of like a suitcase, and it opened and closed. The whole idea was that when it opened, the performers would be stuck inside of it. After you've designed enough you understand dimension and space and measurements to such a clear degree, yet explaining that and having a director trust those instincts can be difficult. The box got built and the director looked at it, opened it and was like, No way. My actors are not going to fit in there. It's not going to work. And this was an elaborate build. She was ready to cut the box, We'll just open it, but there doesn't need to be anybody in it. And we'll have them walk in front of it. Those moments are really hard because you don't want to immediately say, You have to do it. But you also realize that you're correct, but you don't know how to say that either. That was the first time I really stuck to my guns and said, We have to do this. Not one time. Not two times. Three times. I want you to watch it. I want you to see if you think they fit. And by the third time, it was this magical thing. And she understood that the story was about how stuck they were in this box and because there wasn't enough space, that was the story.

Set Design by Kimie Nishikawa, *Gnit*

But I needed to get her there. Otherwise, it would have been cut. It was after finding that confidence to stick to my instincts [that] I felt more confident as a designer.

AFSOON PAJOUFAR I've been through so many experiences as a designer—when you are grappling with numbers, scale, and dimension on your paper [and] on your model. **Definitely, there are some kinds of standards that you're being taught by a school or your mentors. You're always struggling to meet those standards. Sometimes, as you said, it's about breaking those rules.** You can help this story to make sense, to become much more clear, or to feel [it] in a way that is true. That is the moment that it's a story—it's going to start to talk to the audience as truthful, as opposed to just meet some standards like, Three feet wide or three feet clearance. These are the standards we all know, but sometimes you have to go against the rules to help this story to be much more truthful to the audience.

NAOMI KASAHARA Okay, so this is about my very first show after school which, actually, Maureen forwarded to me and I was really excited. And then at the first production meeting, I [knew] why I got this job. They told me [that] before me eight designers said no to the show because there were too many scene changes and they told me the budget was $700. And, okay, but I was still excited so I pretty much decided to put 150 percent of my time and effort and everything into it. Just so many dramas in the production—too many producers and the director, he kind of got sick and he wanted to quit the last minute. But because I committed myself, I created eight different scenes. A producer came and said, I have a friend [who] works in the movie industry who said I can borrow this humongous monster face [prop]. Then he showed me, and okay, that will help with my time but doesn't fit my set. I could say yes to save my time and effort, but I just thought it was really wrong and it doesn't fit the world [of my design]. I decided to say no and basically finish everything by myself. It was really hard but in the end, I became confident in myself. I can deal with this situation and I know how to say no for the things that I don't feel are right. That was my experience of a particular job that has transitioned into my own experience.

YURI OKAHANA At the beginning of my career, right after school, I just really wanted to start working. I took everything that came my way—all the projects, all different theatres, and films as well. I had a time that lightning struck me, and I was like, Oh no, this is where I teach myself to say no to certain things.

I remember which show it was. I was asked super last minute through one of my friends, and I took it because it fit in my schedule at the moment. I didn't know how difficult the producer and director could be on the show. They already had very specific ideas and I didn't know that. When I went to the first meeting with them I had my own ideas from the script. I had design ideas like a few sketches, but no, their answer was very firm, No. I had to start talking to them about a few things that I could still try to incorporate from my end, but I ended up not having the design that I wanted to deliver because they actually decided to go behind my back and they repainted the whole space. That happened too late in the

Set Design by Yuri Okahana, *Jupiter Moon*

process. I wanted to fight for that, but I didn't. At the same time, I didn't have enough energy to fight. That was a hard experience for me. Then, **I started choosing the show instead of letting the project choose me.** That was a major shift in my mindset. When you start working you just really want to get a lot of projects done and expose yourself but, at some point, you have to learn to pick for yourself.

KIMIE NISHIKAWA I so agree with what you said, Yuri. It's such a thing that you have to learn the hard way—kind of get broken by it a little bit and then try not to do it again.

The show I did right before the pandemic was a very good example for me. The set is still in the theatre. I did a show at Theatre for a New Audience in Brooklyn called *Gnit*, which was based on *Peer Gynt* by Ibsen and has twenty-five separate scenes. The question of transitions—**I always start with, Who says we need a transition? There's always a world where you don't need a single set piece, you really just need the actors and a light to see. Then whatever we add to it has to be better than nothing.** It was a great exercise for me because I think this was the show that I thought that I'm just going to do it the proper way, meaning what I think is the proper way. I'm not saying that there is a proper way, but for me that meant just making [a] half-scale physical model for every scene and doing a full storyboard [and] just going through the script with the director and writer over and over again. The show was in March, but we started talking in June of the year prior. That, to me, was great. Of course, financially, it didn't make any sense to me. I was basically losing money. For me, I thought, No, this is the show that I'm just going to do and do my best. And it did pay off. We found a great container for

1. Dialogue Between Decades

Collage by Naomi Kasahara, *Leaf Journal*

where the whole play can take place with minimal transitions, and the transitions were not just about changing the scene. It really added to the story because the theatre didn't have a fly system, but we still did want to fly some things. It was all designed so that the crankiness of the flying in, and how long it took, was adding to the story. We saw the lines that were like thick ropes and, because it was a human actually doing it, the sound designer added that [noise] of the flying pieces going in. It just became part of the story. That was a really successful transition for me. We were shut down on fifth preview [because of Covid]. I was sad that people didn't get to watch it, but I wasn't that sad because I thought I'm just doing this for me, as a great exercise as a designer. For the first time, it was a set that I thought was close to a piece of art. I don't know how else to say it, really.

It's something that I'm very proud about. Then, it's also kind of great that it got shut down. Looking back, spending all those hours on it, basically free labor, being a wage slave in a way, and then it getting shut down by Covid. It just became, Wow, you know what? What we do doesn't really matter in a way. It just made me think that I was so connected to my life being my work. But that's not true—it's such an unhealthy relationship to have with your work, I think. It was kind of great that that was the last show that I did before the pandemic happened, because I could prove to myself that I was able to do it. But then I was also ready to just kind of let go of theatre. That doesn't mean I'm not going to produce, I probably will do it again, but not to the same extent. Having one show a year like that for me is great. It was a great transition for me.

SIBYL WICKERSHEIMER I feel like the world is constantly in transition. As set designers it's not just what we're doing on stage, but the reimagining of how every show changes. The group dynamic is so different with every production that we continue to learn how to collaborate with each other. You have to figure out what is your next transformation. For me, it was coming out of graduate school thinking someone forgot to teach me how to do this as a profession. What, where is it? I don't see it, I can't find it. Okay, I'm on my own. What am I going to do? So, I learn software and became an animator. And I was suddenly making money. I put that money into an art studio someone offered me to rent for a few months and I started casting stuff. I made this rubber case. I still have a piece of it. And I remember walking into this architecture firm and I slap this case on the table, which is jiggling because it's silicone. I used it as my portfolio and I pulled out my sheets and was showing them some very random stuff. But I got hired that day because that thing was so cool. I worked there for six months or a year, worked as an art director for some questionable TV and films, taught at Pepperdine [University]. I slowly started picking up design work, starting at a forty-seat theatre. I got back into doing theatre. That's when I felt proud of myself because I was able to reimagine myself along the way and just dive into whatever opportunity was in front of me. That taught me [that] we have to keep reimagining ourselves and the way we design. I turn to that again now during the pandemic: What can I do with my creative energy?

So, hearing you talk about your experiences, those moments build your confidence to make the next transition. And we're just going to keep doing that as designers.

Set Design by Afsoon Pajoufar, *Lathe Of Heaven*

1. Dialogue Between Decades

MAUREEN WEISS Yeah. This is making me think about those moments where directors assume there's a transition. And in my head, I haven't thought that was going to be a transition. They're like, Well, don't you want to build this thing to do this huge thing? And there [are] these awkward conversations where I don't think anything's needed, which sort of goes back to what Naomi and Kimie were talking about. Kimie, I love when you said that you start from really nothing—maybe there doesn't need to be a transition. For me that just blew my head because I was like, wait, maybe that's all it is. Why are we thinking things are changing? Maybe everything is a flat line always. I'm just curious if you've had those moments where you didn't assume there was a transition, and the director was saying that it has to go from day to night and that means you have to do this large shift.

KIMIE NISHIKAWA I've been lucky, especially recently, that I haven't had that. Meaning, the directors always wanted to help. They understood that it's not really their job to be the problem solvers of everything. That's the beauty of theatre: it's a collaborative art form and it doesn't matter who has the best idea. I do remember doing this play called Plenty by David Hare. That also has many transitions. But in the end, we had to go to the fields of France. I agreed with the director who had thought there had to be some huge gesture. And he was saying, Well, do flowers suddenly appear? I think of my role as taking whatever the director wants and distilling it, and trying to get to the core of what's actually making them describe it that way because I don't think they actually want flowers all over the set. Where we landed on is actually wind. We mounted a lot of fans in the grid and the set was basically just one huge curtain that split the whole stage and it was there the whole time. In the end, [about] fifteen fans went on. The sound designer did amazing sound design so that the fan noise was okay. Then this huge curtain was billowing— the fields of France. It was that feeling of, We're outside now and there's nature here. I think whatever the director wants I always, in a way, ignore it, but also try to understand why they want that.

MAUREEN WEISS Because a lot of us have had to move into digital media, does that mean we can do transitions quicker? Are there more transitions that are asked for?

AFSOON PAJOUFAR The way that I'm seeing these digital performances—it's not only the set designer's job anymore. It's not expected only from the scenic designer to make this magic happen—the video designer has a very important role in these works and obviously it is a collaboration of set designer and video designer. **The way that I'm seeing this transition, I prefer to call it more of a film edit or a jump cut. I prefer to use film terminology when I collaborate with other designers because I think once we are dealing with the element of camera, we cannot ignore it as a reality. Camera is the most important element in digital performances.** Once we open this shutter to the whole world, we are dealing with a different kind of work, with all its own components, its own terminology. Sometimes it's easier to create those transitions, or those cuts between scenes, but it requires more collaboration between video editors or video designers and set designers.

The other thing that I was going to add to our discussion, which is mainly about transition, is being with the director and actors as they're rehearsing is really helpful. It really helps both sides—the director and the designer—to understand each other better, what they're going to create, and what are their expectations from creating this story.

One unsuccessful experience that I had as far as transitions was a couple of years ago with a director. We were working on a piece which was a sci-fi piece. It was called *Lathe of Heaven*. And we were traveling between so many locations—from a laboratory, to Afghanistan, to the Matrix. We came up with the idea of using a very large-scale piece of scenery which relied heavily on automation. But the lack of communication—we both, director and designer, didn't look at that automation in the same way. I thought by bringing this element on the stage, it can just stay there. I don't need to do anything else to travel to other locations. Once we create the big shift in the middle of the piece, then we are there. It's fine. But that was not the way that the director was thinking about the piece. She ended up suggesting bringing [in] these gigantic elements which became a comic moment for me. Yeah, that was a failed experience that I had. I don't know if it was lack of communication or just different perspective.

SIBYL WICKERSHEIMER Yeah, that big automation scene change—I'm so terrified of it.

YURI OKAHANA I think I'm in the middle of that right now. I'm working on an adaptation of *A Winter's Tale*. It's called *A Winter's Tale Interrupted*. We're working with the film minors as well. We're trying to work with an interdisciplinary project for this one. The script has gone through so many different versions. One thing that was interesting that Afsoon mentioned was the communication, the level of communication changing. This digital format needs a lot more attention from everyone that's involved. I ended up creating storyboards that were forty pages long. It is interesting to see the shift in how we communicate. I've been in meetings so much more now. People want to see each other's faces, even on screen, because everything has been remote for the past ten months. Everyone's kind of longing for whatever communication that they can get. Theatre people, designers, and directors are really trying to make that shift right now because this digital format is not a theatre, but it's kind of a third form. Designers might have a little bit of an easier time making this transition than the directors.

SIBYL WICKERSHEIMER It's an interesting world that we're in. We're going to be changed by this. It is a real benefit that there's a revolution going on, both politically and in our art form. I think that's what needed to happen. It maybe didn't need to happen with also hundreds of thousands of people dying. I think that that sadness and that realization will just make us better humans, perhaps, and more thoughtful I hope.

NAOMI KASAHARA We went to Griffith Park on a walk the other day and we found some actors doing this performance together at the park. It was in a hidden wooded area. My daughter really got excited—Hey, there's a performance going on! —and she decided to stay there. I realized so many people are waiting to see something live. I thought there's a hope, and I was glad these actors decided to

1. Dialogue Between Decades

do something together, although kind of secretly. There's a hope that performing theatre itself will be back and the audience will be back as well.

MAUREEN WEISS I love that.

SIBYL WICKERSHEIMER I wonder if it's something to come back to again, to your new company Kimie, which is that perhaps there's a strength in a group. Where the name of the individual or the artist as an individual are not important?

KIMIE NISHIKAWA Yeah, I mean, absolutely. To be honest, I don't think the industry will change. I think it's actually going to get a little worse.

SIBYL WICKERSHEIMER Can you say why?

KIMIE NISHIKAWA Because what is happening now, like Design Action [Collective] and of course, We See You, White American [Theatre]. The documents were amazing. I agree with everything that should be done. And it's great that is out there. But also, at the same time, those documents are very easy for institutions to ignore. As long as there is that individual-to-institutional relationship, we are always going to be taken advantage of. I did a show at Lincoln Center and my fee was $3,000. It's insane. And I don't want to put everything back into material conditions and money, but we do need that to live. So, my way of activism is just refusing that individual connection to the institution, because even when I get a job offer, I could say, Well, let me go back to my team and I'll get back to you. That is such a blessing. For the first time, I have control over the work I'm doing.

Some people are going to have to take orders for the industry to really change—for the artists that are actually making the art to be compensated equally—because the people who work in the institutions that house the arts get health care and benefits and for that to change there has to be a bigger movement. Which I just don't think will happen because I think we're all eager to get back to work, you know? But I do have hope. I do have hope. I want to set a precedent and a new way of working, so I believe in the collective power.

SIBYL WICKERSHEIMER It's interesting because I could see it going two ways. It could go where the theatres themselves hire a team of designers to work with them for a season or seasons. That may actually be smarter—to then house them and everybody who works at the institution gets the same health care and the same fee, right? What if the artistic director and the designers for the whole season get the same fee for the year? I think there's a potential model. Then there's also the model where you're suggesting that the theatres reach out to a group to do the work. I don't know. I feel like I'm trapped in this same world being offered many jobs with very little support.

KIMIE NISHIKAWA I'm very sympathetic to the institutions. It's that we're in a country where there is no government funding for the arts. Of course it's hard, but then we don't need a budget of $80K. Why is my fee $3,000? Why can't it be redistributed? That's all. That's our job, to be creative, to make something out of nothing. We're so good at that. We don't need more budget. We need more time, and a place where we are allowed to do our best. That's all.

Set Design by Kimie Nishikawa, *Ain't No Mo'*

AFSOON PAJOUFAR But as long as we do not share our fees, our thoughts, our troubles that we had with previous companies or artistic directors, we are always leaving these opportunities open for institutions to take advantage of new designers.

CHAPTER 2

Patterns & Systems

"I find that I am in a better position now than ten years ago for many reasons. I have grown as an artist and learned from mistakes. I am a better communicator, collaborator, and have more confidence in leading a conversation about the world of the play with my director and collaborators. I better understand limitations and budgeting and have learned to take things less personally. I am also making a living, where the hours I put into something are better met with an hourly compensation. Whereas before it was too depressing to do the math of what hours I put into the work for compensation that was far less than minimum wage."

—COLLETTE POLLARD

Set Design by Collette Pollard, *Hunter and the Bear*

BALANCING ACT 1

Andromache Chalfant / Louisa Thompson / Mimi Lien / Rachel Hauck

July 30, 2020

MAUREEN WEISS We originally came up with a chapter on balance and how we balance our careers and our lives and our schedules, but we came up with this before Covid. Sibyl and I were already having difficulties with how to juggle kids, working at a university, and our freelance careers. And now they're all bunched together. And so, it just feels like I don't even know how to have that conversation right now. It's such a different conversation. How do you find brain space right now, or, just any space. What's helping you?

And then, how do you survive monetarily?

RACHEL HAUCK My total escape is *The Great British Bake Off*. It's so completely about nothing. And those people are always so generous and, when it's really the dark days, we just start another season.

I'm still interested in this thing. It's my medium, theatre. And so, I will never not be interested in it and I find ways to sort of keep myself busy. But it's pretty clear it's going to be a minute.

MIMI LIEN I feel so bifurcated because part of me actually feels really excited by this once-in-a-lifetime—like, no one ever imagined that anything like this could ever happen and that it's blowing everything up. That feels like a real opportunity.

There was this article about what a socially distanced theatre looked like and it mentioned the David Lang piece that took place on Governors Island [NYC] with these musicians all scattered around this mountain. I love that kind of work and maybe this is the moment for that. I feel, actually, very invigorated by that possibility. But at the same time, I'm on this Covid think tank and they're all just trying to figure out what the protocols might be in order for theatre to come back. And because that kind of theatre can't come back, other than fully the way that it was, I really have been feeling more and more strongly that we shouldn't go back to what it was because it was really flawed.

Set Design by Andromache Chalfant, *War Stories*

2. Patterns & Systems

RACHEL HAUCK In a lot of ways.

MIMI LIEN Yeah.

LOUISA THOMPSON So many ways. I guess from a designer standpoint I'm so happy that we can just respond and adapt and that there isn't this warehouse of stuff that people are spending money storing right now.

The other thing that just came to mind as you all were talking was that the thing that has been sustaining me is that one of my colleagues and I started communicating only in images, for two years now. Just via text, we're constantly sending pictures back and forth. I just realized that that actually has been sustaining me; that I'm still thinking of the world as a visual place, a place where there's oddity and beauty and moments to sort of gather.

ANDROMACHE CHALFANT I've found a lot of strength at being very angry with theatre. And angry with the institution. And so my engagement with the theatre, now, this sort of conventional theatre, is political.

I think Mimi said there's something exhilarating about having a real break and real time to kind of renew your process. But I feel active. I feel like action is possible.

I wonder—because Maureen, you asked about making a living.

MAUREEN WEISS Yeah.

ANDROMACHE CHALFANT Can I jump back to that for a second? Because I just wonder—were any of us really able to make a living in the theatre, is the first question. [Laughs] Is it possible?

MAUREEN WEISS Right, and that's a great question because that was sort of the original area we were trying to cover. That's why I teach, right? That's how I sustain being a designer.

RACHEL HAUCK It's all such a massive, massive conversation, right? The financial part. I don't know what to say. You know, until very recently my work, financially, was charity because I spent everything [that] I made to make it. Which is, you know, unsustainable, unreal.

LOUISA THOMPSON I've been wrestling with this question of access on every aspect of theatre. One of the things we're talking about is spaces and a lot of it is, Who's the audience? I do feel that as theatre starts to really come back to life at some point, it's going to have to ask itself as much about its audience as its artists. I don't feel like there's enough discussion right now about who the "they" is. Who buys the ticket, who even finds the poster or the postcard to know about the thing? Who is it serving really?

As I've moved into this world of TYA [Theater for Young Audiences], I get who that audience is because that audience is talked about nonstop. It's a constant conversation about where are they, who are they, how can they be reached?

Set Design by Louisa Thompson, *Washateria*

2. Patterns & Systems

Design by Mimi Lien, *Model Home*

Design by Mimi Lien, *Model Home*

I love that conversation. I personally have been less excited about the adult theatre world conversation.

I realized I'm not honest with these theatres. I am subsidizing their work. I'm not breaking even because, in order to be in ten different places at once, I'm generally paying somebody else to do the work. And the money that they're making—the salaries that these assistants are making—nowhere match what my fees are. And thank god I have a teaching job, but we need that for our rent.

I'm never breaking even, and I actually think it's been a disservice to these institutions to not have some transparency around that. Ultimately that trickles down to all the young people who want to do this work. Because it's false.

I actually go back to the origins of my first shows in New York. And I'm like, Oh, right. I got hired a lot because I had a car and I was schlepping shit for people. And I was paying for the gas. And I never turned in those fucking receipts because I just wanted the work. I wanted to make things, I wanted to collaborate, but it didn't pay for the gas. So that to me is such a messed-up thing and I don't want to be a part of that anymore. I want to make work. I totally echo you, Rachel, and everyone else. It's like I crave the collaborative—let's get together and do something. I feel those conversations are like a life force for me but—

MIMI LIEN It feels unconscionable, too, because of everything that we just said. Because of the economic circumstances, and the climate, and then particularly now, how do you tell someone that this is what they should pursue? It almost feels unconscionable. And yet, I can't imagine doing anything else, you know? I don't know what to tell them—

LOUISA THOMPSON I think in this country, especially, we have some reckoning around the notion of theatre as art versus theatre as a profession. Right? What does it mean to be theatre artists? And I think, to me, that's not just a money conversation. It's also a titling and hierarchical conversation.

And yet, we're all paid differently. We're all treated differently because of how we've been hired or what our titles are and that feels really like—and I guess I'm saying this in the context of talking to students because there is, I think you said this, Andromache, there is a roll up your sleeves-ness when you're training artists.

RACHEL HAUCK You know those moments, right, where they say, Look to your right. Look to your left. Only one of you is going to stay in this field. It was a major class, like four-hundred students. The only way you're going to do this work is if it's so pure in your blood. That— it's that you have to tell these stories because it's too fucking hard. It's too hard to make this life work.

And I think I remember the periods of, oh, twenty-five years old. This first wave of people went and found something reasonable to do, and then again at thirty, and then again at forty. You know, when you sort of watch the ranks thin [out] because it's so hard. I also think it is a fucking surreal experience to suddenly have projects that you are so passionate about become interesting to the commercial world.

Set Design by Maureen Weiss, *A Midsummer Night's Dream*

And then you start to see the other side of this, right? Like this ceiling I couldn't get through—which I wanted to break for the sake of breaking it—of working on Broadway, right? Because everybody around me had been able to get there and I could not get that chance, and then it came. I've been lucky to do three—they're projects that I'm super passionate about. They're all hyperpolitical for various different reasons. And then all of the sudden you're like, Oh, this is commercial theatre. This is different, you get a paycheck every week. I remember calling my agent and being like, They're going to send me this check every week?

And then you start to like having money come in the door. That changes your perspective—it's fucking surreal, having never had it. It's been a fucking surreal year-and-a-half and I feel impossibly lucky that the timing of it happened. Because I wouldn't survive this [pandemic] if it had happened a year-and-a-half ago. I mean, quite literally, I wouldn't have been able to survive it or sustain it.

It's the art. It's the work, right? And then whether or not the culture values it enough to make it sustainable for artists and values the thinking behind it enough to find a way to make that essential.

I think about other topics, like what's really the lifeblood that kept me going? The crazy thing [is] that Sam Pinkleton and I wound up being in charge of the Obies this year, so I had raw, artistic conversations with ten of the most brilliant artists about all of this remarkable work.

I got lucky to consult a little bit on Sundance and be [a] creative advisor. Suddenly in the most urgent moment—let's talk about plays and ideas and philosophies and hear a bunch of brilliant actors read plays and that's sustained me in a deep way.

But the bigger conversation behind all of this is about culture in America. What's valued and what isn't, right? Nobody ever—no matter what—I don't think anybody anywhere, in any country, would be working at the level that this entire panel of people is working at for the money. It's the art. It's the work, right? And then whether or not the culture values it enough to make it sustainable for artists and values the thinking behind it enough to find a way to make that essential. You know what makes it? What's the great Winston Churchill quote about should we close the theatres or not? And he said, Well, if we close the theatres what are we fighting for in the middle of the Second World War?

MAUREEN WEISS **I'm interested in theatre and what theatre can expose.** Tadeusz Kantor wanted to figure out death through theatre. I don't understand why doctors have the key to that. Theatre can look at it, too. I have to keep reminding myself that, right now, what it's missing is audience. And that is this key, central thing. How do we find that audience right now? I don't know. Maybe we just wait. And what we're doing is we're probing through this time?

RACHEL HAUCK I mean, this is the time, right? We have the people—this is a golden, golden, golden time in the theatre, right? The people who are writing and directing right now, these are the greatest thinkers. I don't know what's going to

come out of this. Our job in this time is to survive this time. Are all the writers home writing? I don't think so.

Somebody said this on one of the Sundance calls—it's a very international combination of artists. So, some of them were in the Middle East, which was extraordinary. At six o'clock every night the power went off and the Zoom calls died. I mean, it was unbelievable to be on those calls and one of the guys who was in Lebanon, where also the economy has completely crashed, said this thing. He said, You know, it's like the job of the artist at the end. We are all in the moment, immediately after the car accident. We don't know what's coming. Nobody knows what's going to happen there. That urgency and perspective—and he kept talking about a dance piece that he and his wife were making together. He was the musician, she was the dancer and choreographer, and they kept talking about how they couldn't step towards nostalgia. Anything that became nostalgic in the piece they would destroy. It was fascinating to watch the various ways they did that. Somebody finally said, Why are you so—what is the thing around the nostalgia? And he said, I'm afraid, because I want to be there so badly, that if I go there, I will never be able to come back. I can't. I cannot allow the nostalgia in. Which is misquoting what he said, but the essence of it was the lifeblood of culture and story. Whose stories do you hear? This is the struggle we're in now. We know what it means for people to see themselves on stage, to see their own stories, to tell their own stories. It can't be limited to the people who don't need the money to do that or you're just not going to hear those stories.

I have to stop talking. I'm sorry you guys. I've commandeered this whole conversation!

MAUREEN WEISS That's not the first time in the past week that I've heard a really interesting conversation and comment about nostalgia and the danger of it.

Set Design by Rachel Hauck, What the Constitution Means to Me

BALANCING ACT 2

Collette Pollard / Deb O

June 23, 2020

SIBYL WICKERSHEIMER I think part of our survival is talking to each other.

COLLETTE POLLARD Right. The business end of this industry is significant, and we've all navigated [roadblocks] in different ways.

You know, there are so many ways around everything. In terms of survival, I've always gone around like you talked about, How do I get over the wall? Ladder? Bulldoze through? Or, look around the wall and walk around kind of quietly, and then I'm on the other side. And that's fine. But it feels exhausting because it makes you feel like the crazy person in the room. **Why aren't we just walking around the wall? Why is everyone making this so hard? Tear the wall down. It's actually just a piece of scenery!**

We're service [people] and we're calling it art. I just wonder about that because that's where I get like, Okay, so now we're artists when we're part production manager, or [our] own agent, or website designer. Then we're the maker of the scenery, then we're collaborators, sometimes, and often we are the artistic vision of the whole thing.

At what point do I focus? Energy, balance, health, happiness, and I'm going to challenge the institution on top of it again?

SIBYL WICKERSHEIMER Yeah. Well, right now if anyone's failing it is going to be the institutions. They need to turn it over to the set designers because we actually know how to get shit done. No, I'm not kidding.

COLLETTE POLLARD I know you're not. I relate, I laugh out of relating.

I think about being back in school twenty years ago. There were older voices sending me a message that the only people I knew that were doing this work were men. There was that message and then the world was sending me a message of like, Oh, there's a woman. And so, that person might be able to be a mentor and they weren't really the greatest mentor, so that sent me a message like, Okay, then who's supposed to be figuring this out? Which was me. But I have to say when I had my kid it was mixed because I read this amazing article where it showed a male and female relationship and having children, and it was all about the money the man was making over time.

And the graph was, like, here is the man and it was going up, up, up. And, like, the woman too, seeing this graph made me see it as a reality which was: If you're young, as a woman, and you don't have kids, you kind of have that same

[upward] trajectory. But you never get as much as the man—if you are young and have kids, there's a huge dip. We're constantly messaging and constantly gathering information that's telling us how the world works and then, at a certain point, we either stand up to that and challenge it or we see it for what it is.

The amount [of times] I've come on last minute and fixed a main stage [design] because a male—and this is all factual with no anger towards the male set designer—a male set designer said like, Fuck this. There [are] always two stories, right, there's the designer story and there's the institution story. And they're like, hey, the director last minute would love to work with you on this mess, and you go clean up the mess. And you do this amazing job. And then you get shit on for it in one way or another.

Does that make any sense to anybody? Has anyone experienced that?

DEB O Yeah, I had so many things to say. I feel really bad because I'm not up to speed with all [of] how you're thinking, to be so pushy and to be so in there demanding these things because I'm just doing this thing that I love so much. And so—and I keep on having this conversation with myself—I need to change the vocabulary that's in my head, but how do I make that shift? I almost want you all on a conversation with me weekly.

I was a year behind in rent a couple years ago because I just kept on taking the things that were being offered to me [that] looked interesting. So that model didn't work very well, you know? I wasn't taught. I didn't have parents with big financials teaching me those things; I didn't have that in school, either. I'm really stuck and trying to get myself out of this rut, you know, which I do have people around me going, Oh my god Deb O, your work is so, so amazing and you're so hands-on. You have to ask for more money. A lot of them have been saying we're going to help you because this is ridiculous.

I just did get somebody to look at a contract and they're helping me, and I was like, Oh my god, oh my god, you can do that? Oh this is really scary. You know, so I'm in that position and very jealous of you guys at the moment.

MAUREEN WEISS What I did at a certain point is I realized I wasn't good at creating a career for myself as a professional scenic designer. Do I love it? Do I love doing it? I do, I do. Do I prefer to write grants that will get me paid? I knew I needed to go and become a teacher because that's the only way I was going to survive with this desire to continue to work in theatre.

I wonder if maybe what you're describing is the way that you're trying to figure out your career.

DEB O Oh, I've been trying to figure that out for quite some time. There are many aspects of that that I'm working on and trying to figure out, but I also think that I need to undo some of the systems that I was taught when I was younger—about how girls keep their mouth shut and we just do what we're supposed to do, and we don't ask for things I think it's the unraveling of that and tearing that system down also, you know.

Set Design by Collette Pollard, *The Donkey Show*

Set Design by Deb O, *Uncle Vanya*

Regina García writes to MW & SW in an email

January 1, 2021

[First] is my intro built from some words after 20 years of watching [Narelle Sissons'] work evolve and the bottom is all 1997 which is 25 year old Regina. It's really about me seeing what's possible on stage thinking thank god I'm in school! LOL

How I Learned to Drive, 1997

I've always been a fan of Narelle's work. I had to look back in my journal, because I am obsessed with tables and composition of bodies in space today because of this design and direction.

The characters linger a little bit longer in her spaces. It's almost as if they don't know how to navigate their reality and are stuck in this limbo—or suspended halfway between poetry and a cinder block.

And why is it so hard for them to clock time passing? When you're building transitions around moments of stillness, perhaps time is not as important as the elegance of the space between (and around), how it receives and responds to light, how we as the audience are invited to linger and reflect as well.

The space is feminine, but not overtly political about it; it does not reveal anything about the story but provides a gestural anchor for location ushering us quietly into the

deeper memories of Lil'Bit and her uncle, their fears, their longing for one another. That's how I remember it today!

As I wrote this, as 25-year-old Regina in 1997, perhaps I was also reflecting on the work I had in front of me as a first-year graduate student:

> Perhaps it's my inability to understand three-dimensional space, it's parameters and how to hide and reveal them with paint? Light? How? Why is theatre so intriguing? There's nothing and everything is there. Perhaps—is its ability to transform from one tangible space to another—the fact that this exists—some design work and is draped with feelings and meaning, one idea, one cry!
>
> As a designer I will have to provide a design that allows the play to be much more profound, transcendental? Oy—but it has to be sincere and not superficial. There lies the difference between theatre and an "installation" I guess—I will have to choose which way when I'm feeling more confident, and finally not be afraid of…me? I've always known that I have to learn more and study and figure out what the ideal concept is for the space. But I have to see myself first in that space. Should I? Is my set a self-portrait or a playground?

Set Design by Narelle Sissons, *All the Names*

Set Design by Narelle Sissons, *The Crucible*

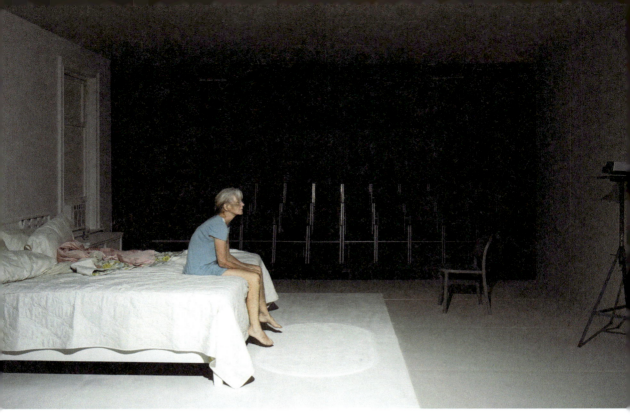

Set Design by Marsha Ginsberg, *Notes on My Mother's Decline*

DEVIL IN THE DETAILS

Marsha Ginsberg / Narelle Sissons / Regina García

July 21, 2020

NARELLE SISSONS Recently, I was working on a production of *Halfway Bitches Go Straight to Heaven* by Stephen Adly Guirgis, and John Ortiz directed it. We were trying to create this kind of world of the halfway house. We realized early on that, even though it's written with so many different locations inside that house, we had to really centralize it and keep much of the storytelling in an all-purpose room. It ended up being like a slice of a building of a halfway house stuck inside the Atlantic Theater. To kind of create this authentic space for, not just the audience to look at, but the actors to live in, I suggested to John Ortiz, Why don't we do an art therapy session with everyone in character? And he's like, Yeah, that would be really great in character. So, I'm playing the character of the art

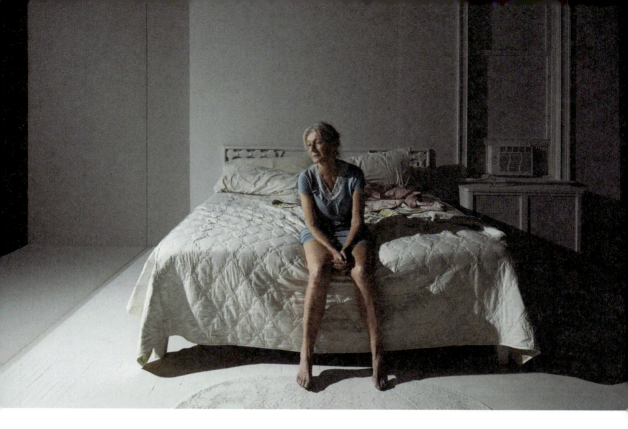

therapist. I did all this research on art therapy because I'm not experienced in this at all. I discovered a lot of the projects, [art] therapy wise, somebody paints a portrait of themselves and one side is what you see, and the other side is what you would like the rest of the world to see. Then you do these two paintings and then you have a conversation about it. The plan was [for the actors] to do all the exercises first and then spend later in the day in character with the woman who sort of runs the projects going through and talking to everybody. Then we made puppets, which were puppets of themselves—who they felt they were. It was really amazing that these actors got so into their character.

Once we had all of this stuff it felt like we needed to incorporate this into the set. All over that set we had these pieces of these puppets and these self-portraits that we did that day, and that became the set dressing for the design. I got rid of everything else—that's all we needed because it was a very honest experience and when the actors walked into that room, it felt really familiar to them because suddenly there was their artwork on the wall. They walked past it. It was completely inclusive—every single piece of artwork that we made that day was on the set somewhere. That was such a wonderful experience. I can say, though, playing the role of that art therapist, with all of those fantastic LAB actors was

Set Design by Narelle Sissons, *Halfway Bitches Go Straight to Heaven*

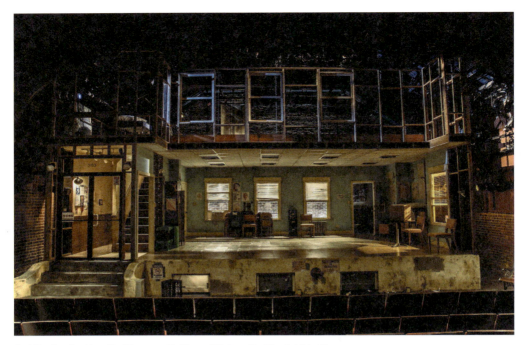

Set Design by Narelle Sissons, *Halfway Bitches Go Straight to Heaven*

just—I'll never forget it. You know, people [who are] really playing the character wholeheartedly.

MARSHA GINSBERG I'm really connected to the people building the set because I don't like when things are built in a "scenographic" way. I'm often using things that are just not typically scenographic. It always requires a really deep collaboration with the person or shop.

And this generally, I would say, is a more common practice when I work in Europe. You either have a situation that the scene shops are directly connected to the houses—so an opera house will have their expansive scene shops. In some circumstances, you can get really, really detailed. When I work in the US I kind of try to, in a small way, replicate that process.

I had done a show this fall [where] half the set was plaster. It was a plaster cast from this apartment of the mother character in the piece. It was a two-person piece that was part memory. And so, it was challenging to set that up.

And we finally found a shop that was really great. I have a friend who does high-level contracting work and he connected me to the woman who does all the plasterwork. She came for a day and worked with the shop to show them how to set it up and stuff like that. I'm often doing things like that.

Of course, these issues depend on proximity. This was a show that the audience was quite close to, but I would say even when I do work in big opera houses, I'm still really a stickler for [an] architectural resolution of things.

NARELLE SISSONS I think it's really complicated here because, on the one hand, you have this piece of paper that becomes the contract, but at the same time quite often—if you get to talking to people there [are] people who have artistic integrity who want to actually get the extra detail into the architecture correct. Whereas as you point out, in Europe it's a bit different. You could just draw a rough window and sketch on a napkin and they'll come to you and say, Oh, do you want it to move? And they'll start to want to know the details and they'll want to bring that to the project.

MAUREEN WEISS Have you had those moments where something that you thought was going to look a certain way and you show up and it does not? And you can't move back?

MARSHA GINSBERG It's a good question. I never let things go that far.

Technically, a shop is supposed to make shop drawings from my drawings. I agree with Narelle that I've had to train assistants to put very, very precise details.

I had this show built that it was shocking how many things they got wrong. When the set loaded in, I was like, Whoa, these are not the proportions that I designed. What happened? I literally had to go and measure everything, and everything was wrong. The set wasn't tall enough, the baseboard was four inches higher—it was so many things.

So, some shops are trying to help you but actually they're not helping you because it'd be better to just be upfront and honest about what can be done and what can't be done, and what kind of sacrifices or changes you need to make rather than cutting corners without discussing it with you and then having this disaster show up.

MAUREEN WEISS Right, if anything is irregular on your drawings—like [when] it's not a traditional build, I find that it is just so difficult to explain. There [are] often times where I will put the asterisk noting, YES this is irregular. This is not normal for a traditional door. It is a half-inch bigger. And the TD will assume they know better. But which battle do you pick at that point, when they've subtracted a half-inch and they don't want to change it?

NARELLE SISSONS **I always approach design from the aspect of architecture. The space is really the container for the production and how is my set, the world that I'm creating, fitting into that container. Does it fit in? Is it floating in that space? Is it part of that space? How does it feel in that space?**

REGINA GARCÍA I think [it] usually happens with perforations or, let's say, with window or door reveals and wall reveals and things like that. Everybody has an opinion on what they need to be in terms of [the] interior-versus-exterior door. If I'm doing an interior or exterior wall—because I'm in Chicago and we do a lot of

realism here—and we get into annoying little backs and forths about the height of a light switch or an outlet. And conversations about what it really needs to be and when it changed—whether it changed in the fifties or sixties. At the end of the day, I've strategically worked around the proportions of those performers in space.

I wonder at times if my male counterparts have to explain it or if they can just make the request and it's done with—something as small as a light switch. But I do have to explain the reasoning behind the choices a lot, I find.

I think the TDs that know me understand—they actually enjoy hearing the story behind it, like all the ones that really care, and they're engaged with the process. They really do want to hear it because they also want to understand your process and understand you for next time. I do appreciate the ones that want to hear it for the right reasons.

I want to say, also, in terms of the container and thinking that I have both Marsha and Narelle in front of me—growing up, design-wise, in New York and observing their work as a young designer. I was most definitely a late bloomer [in] understanding composition and how we start and end a set, what the parameters are for that set, and I get into a lot of discussions. Some of them positive, some negative, about flexibility. What kind of flexibility do you have about how your set ends on stage in the space? That's interesting to me and because that's a lesson that I learned early from looking at Narelle's and Marsha's work. It is something that I am not flexible about, like conversations about masking. Is it okay if we put this piece of masking here? I think our audiences are used to seeing this kind of masking at the end of the set, so they won't have issues with it.

NARELLE SISSONS Yeah, I find that masking is one of those things, isn't it? I think about it at the very end, to be honest, and I tried to live without as much. I mean, if you need it—

REGINA GARCÍA Yes.

NARELLE SISSONS I always think of every single production, whether it's inside a traditional theatre or if it's in a warehouse as a site-specific activity, because everything is really a site. There's a kind of plasticity to everything you know—every space that you go into. And so how you respond to that site is kind of how I approach things.

Someone said this to me years ago when I was a young student, Everybody, every designer has their own preference for how finished they want their work to be, and so some people leave their work a bit more [unfinished] or other people like it to be very polished and very finely finished.

But one of the most important things is to be thinking about the production more in terms of the bigger ideas. If the bigger ideas will need to be covered with molding, then I think it's our responsibility as a sculptor of three-dimensional space to do that well. If you start with this idea that you want to create a set with molding in it, somehow you're missing that step of thinking about the bigger idea

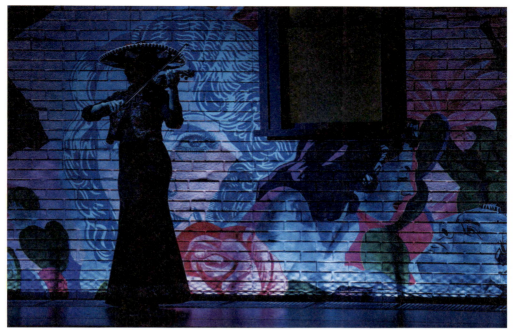

Set and Elevation by Regina García, *American Mariachi*

2. Patterns & Systems

119

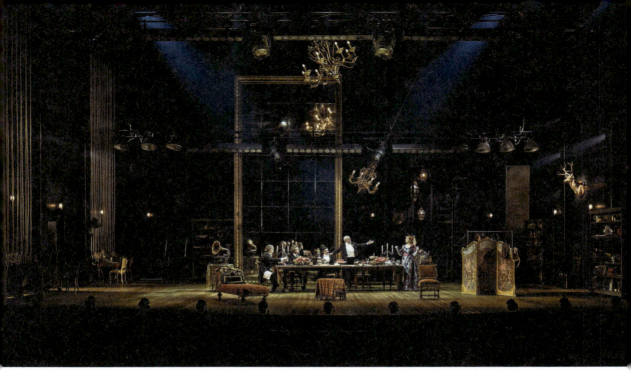

Set Design by Narelle Sissons, *Bernhardt/Hamlet*

of what it is that you're trying to achieve. If molding ends up being part of that conversation, you have to do it precisely and architecturally accurate.

MARSHA GINSBERG I've kind of learned over the years to just be a little bit more aware of the situation and understand what I can get and what I absolutely won't get, and find where there is maneuverable space inside of that. But it's hard when you're working at some place for the first time.

SIBYL WICKERSHEIMER I wonder if there should be a scheduled deadline for the response from shops within our contracts, where the shop is asked to produce construction drawings on a certain date for us to review. After some projects where I haven't worked well with the shop, I end up trying to internalize it. What did I do wrong? I delivered my drawings on time and I was ready for the conversation. But the conversation never happened or became muddled. I want to know how a shop prefers to build a set and to have time to discuss it with them. Because there are many variables. Let's talk about what the materials are and the construction methods. I might need to change details based on how the set is being built because it changes the look or, possibly, it's intended use. I also love exposing construction details, but I need to confirm how it will be constructed. Even if I'm willing to engage in that process there is often not a drawing communicating the shop's intentions or time built in for this conversation or successive adaptation. Does that make sense?

MARSHA GINSBERG Totally, yeah.

NARELLE SISSONS It is a major problem, too, with what I haven't talked about yet, which is the rehearsal process because things are a living, breathing art form. Things are changing. You're in the room in rehearsal and you know the door has to suddenly move or the door has to become smaller. I did a project with Mabou Mines and one of them was *Mabou Mines DollHouse*. I just got cardboard boxes and we made a cardboard dollhouse and we cut it on the breaks between rehearsals. We were cutting new doors and taping doors back in and adding windows and doing all sorts of craziness to this cardboard box set, which was really fluid. And it was fine because I was there, and we can just do it with cardboard. But you know when you're looking at a design that felt right and everybody's excited about it? You go into rehearsal and then you realize, actually, it'd be so much better if such and such happened. You discover there's no space in our system at all for any significant changes. You can change props around and anything that goes on the rehearsal report seems [to be] fair game but there's a restriction in the amount of stuff that is flexible. I find that really difficult because I come from working with the director who, you know—we want to adjust things.

SIBYL WICKERSHEIMER There should be an intermediate date where there can be an adjustment made, but often the set is already being built or has been built. I think if there was the inclusion of a portion of the set that would be mocked up and be in the rehearsal room—just one piece of it.

MARSHA GINSBERG What you have in Germany is you have a *bauprobe*. They basically do a mock-up of the set. But it's done with flats that they have handy; they mock out the dimensions. If you're doing ten-meter-high walls, they might do it with curtains or something like that. It's really immensely helpful because if we're acknowledging that this thing is a spatial entity and that as soon as you're working in scale, your body doesn't have the correct relationship to scale. I'm pretty precise with my proportions and generally pretty accurate, but I've definitely seen things in a *bauprobe* that I have learned from and shifted.

SELFISH SELFLESSNESS

Regina García / Shannon Scrofano

July 28, 2020

MAUREEN WEISS Regina, you mentioned that people ask you to replicate people's designs that are within the group, have they actually said that?

REGINA GARCÍA It hasn't happened in a while. Let's say that it hasn't happened since I left New York. It's been ten years, but while I was in New York that was a request that I received often towards the end of [my] living there. I left New York in 2008. Maybe it was because of the circles that I was working in, but there was a moment where I was asked, Do you know this artist? This is what I really want.

It's like, I have their contact info. Let's get you in contact with them. This is how I would like to contribute to the conversation.

Design by Shannon Scrofano, *Nuestro Lugar*

But there's always that awkward pause—why do you feel that comfortable with me? I guess I should say thank you for feeling comfortable and trusting me with that little nugget of info that you really want to work with somebody else or are looking for something else. But, after that I really had to be just clear with what I was looking for and how I wanted to move the conversation forward.

MAUREEN WEISS Yeah, that's a sneaky way in. You're right that directors often want to throw out all these other images of other people's stuff as you're trying to push yours forward. Yeah, yeah, that's a good response—Here's their contact info.

SHANNON SCROFANO [I] wonder a little bit if it's director training. I mean, I am not in those rooms, but I feel like I've seen an increase for young directors bringing that imagery as some sort of direct line to what they want us to do. I also think the general scarcity mode of operation makes people think they have to pursue an efficiency or, sometimes, authoritarianism to get them where they need to go as opposed to being in a process that might actually uncover a thing that you didn't predict you would uncover.

2. Patterns & Systems

Design by Shannon Scrofano, *Islands of Milwaukee*

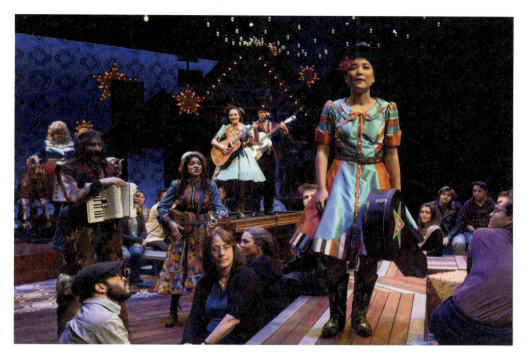

Set and Paint Elevation by Regina García, *The Yeomen of the Guard*

2. Patterns & Systems

Set Design by Sibyl Wickersheimer, *Black Diamond*

2. Patterns & Systems

REGINA GARCÍA You know, you have to dig. I like that word, efficiency.

I try to dig a little bit further in terms of what—when I do get those images, when I do get that request and other ways, because it comes in another way, right? It comes like, Did you see the show or have you seen the work of—? Even though, in this particular example, I was asked to do it in the style of this person, which is really just wrong. But efficiency—when you start digging you discover that there's something about the way that the story sits in the space, that there's a way that it all builds up to a really big eruption of action and conflict and that's what they're looking for is that progression. But they can't articulate that in the moment. So, it's useful to dig a little deeper and ask.

The funkier question is, Okay, give me an example. Or, Let's talk about the scene— what exactly is it that you're looking for? How did you feel after you saw this? It can be a little bit more directed and targeted. I love that word efficiency.

SHANNON SCROFANO That connects to me in a very succinct way, too. How do you give students that center? Who are you in the work? And I think a lot of students that come to theatre design come because a lot is in place already. They're not in the big, open, wide range of being a fine artist in their studio, so they are attracted to the parameters, the other structures that help move the work forward. But you still have to have your own way of moving through. If you don't, it's just not sustainable, no matter how clever you are.

SIBYL WICKERSHEIMER One of my students put me on to this TED Talk last night— Nancy Baker Cahill—and she was talking about the moment, as an artist, when she invited other people into her practice was when she actually discovered she could make much better art. So, going out to find a group to interact with and collaborate with is when that cracked the nut open. And I thought, okay, this is a germ of something I can bring to students and say, This is why we collaborate and this is why it's so important to understand how to figure out what theatre wants to become. That's sort of the key, you know. For me, the part that I hold dear in my practice is reaching out of the collaboration, but then coming back to it and figuring out what material is the story of that process. I love that journey of getting as many materials, and sourcing [them], and then finding that arc to the end product. It's hard to teach that because that's investigation. But that's my selfish little place, you know.

As set designers we often are the source for leading a conversation down a path, or a collaboration down a path, and you have to, at the same time, be selfish in saying that your idea might have merit and let's follow it for a second. But you also have to be selfless in terms of being able to veer another direction or let it disappear in a moment's notice. And, I still find that hard even though I'm still trying to teach myself to deal with it later. Like, just let go in an instant so that I can appear really flexible, because that's really important. And then, later, to process that and go, Okay, well, why am I still trying to hang on to an idea?

MAUREEN WEISS And I am on the other side—I'm not always that flexible. I don't want to be that flexible. And I mean, I've had to learn how to be okay with that

too. So, that's the other designer: Not flexible. There are so many things I will not do. They're not allowed to put couches on my sets. No couch and no purple.

So, [the phrase] "selfish selflessness" came out of us having these discussions. Maybe you also have these things.

REGINA GARCÍA What do we do with the urge to create, to respond to what's happening today and the conversations today that could be fulfilling or satisfying? Because that is where I see the parameters of my practice more clearly. Shannon, you have other practices—you do installation and you also work on landscape, but I was just wondering what the group—how are we looking into crafting, working? I feel like a cobbler and, I just don't know, at times I find I understand what my contributions could be in the conversation within academia right now, but in terms of my creative output it's a little bit more challenging. I cannot do a Zoom play; I am not interested.

SHANNON SCROFANO I think that's true. Last week, my partner was like, What are you going to do if CalArts [California Institute of the Arts] closes? And I was like, I'm going to go get my landscape architecture degree. I feel you right now. Let me just go be with the bees outside.

I actually don't do that much theatre anymore, either. Partly, at some point, there were a lot of things I didn't want to do. I didn't like the story. I didn't like circumstances. I didn't like the people. And I kind of have that buffer of an academic job [that is] allowing me to choose. **I really like working in community-based circumstances where it's not about my authorship—it's about me trying to be in the room to help shepherd a process and connect resources.** A lot of that work is on pause in this particular moment, but that's the work that really grounds me.

I started a class last spring called Healthcare by Design at school and we partner with a local medical institution and we work with their clinicians. They have a very specific problem—it's not just the theatre students, although a lot of the designers take the class, but we've had artists and musicians and dancers and critical studies, creative writers—and we just work on the challenge that the clinicians have put in front of us. We try to bring the full force of our creativity and not assume what they need and help them not assume what they need, and make it a really interesting space. Then we make something for them that's useful to their patients or staff, or whatever else. Circumstances like that really help keep me going.

REGINA GARCÍA I wonder, all these thoughts about theatre and regional, these models, if they connect back, Maureen and Sibyl, to what Marsha was saying about the monolithic American theatre and who fits within that structure and who doesn't, or what kind of work doesn't. This is the time to rethink it. What do you think?

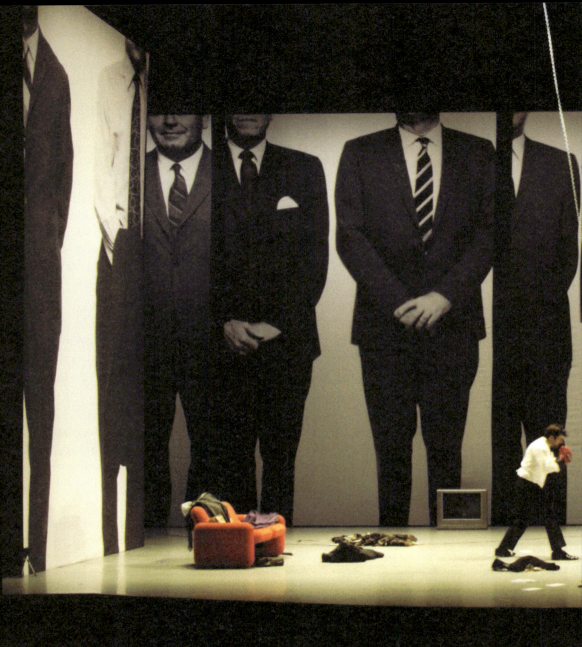

"I think in Off-Broadway theatres in particular, the budgets are actually too big for the size fees and resources of the companies. I think we'd all be better off with smaller budgets, shorter techs and previews, and a more civilized approach to the expectations of staff and

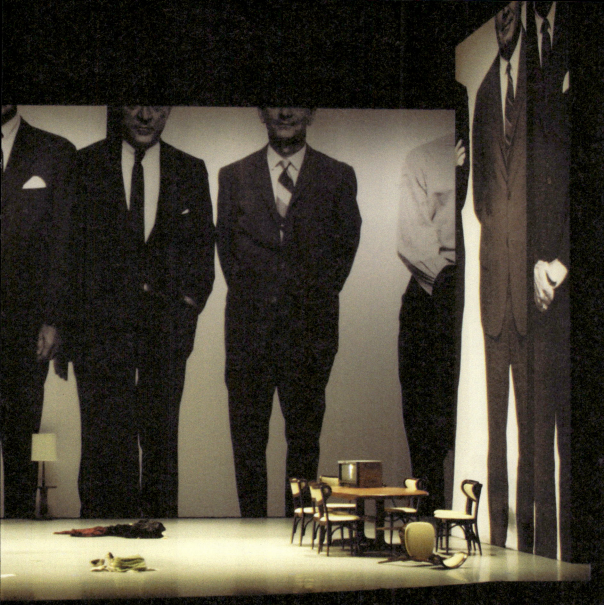

Set Design by Laura Jellinek, *Owen Wingrave*

freelancers. I obviously would enjoy doing a $30 million musical as much as the next person, but I also get plenty of satisfaction out of very low budget shows, so long as there is actual support in terms of staff, etcetera."

—**LAURA JELLINEK**

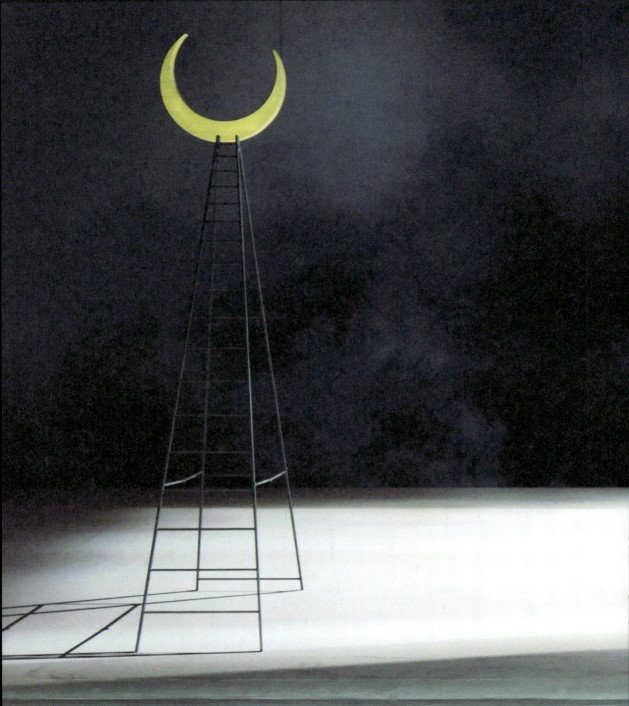

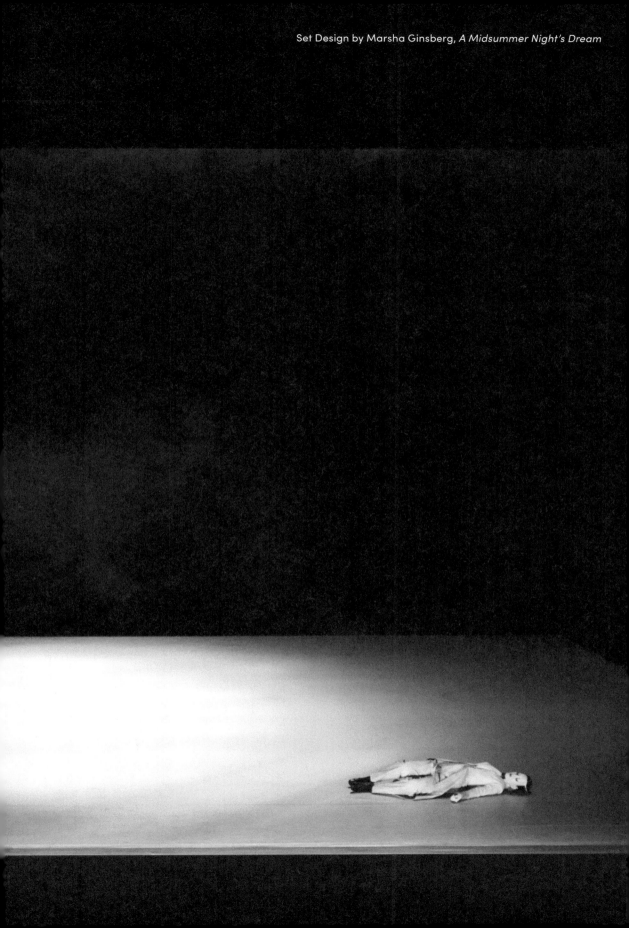

Set Design by Marsha Ginsberg, *A Midsummer Night's Dream*

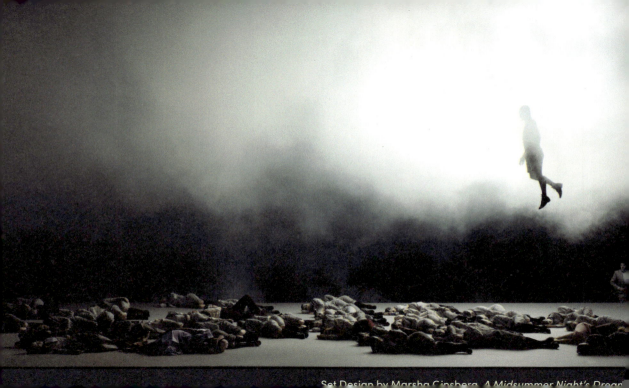

Set Design by Marsha Ginsberg, *A Midsummer Night's Dream*

INTERNATIONAL PERSPECTIVES

Markéta Fantová / Marsha Ginsberg / Narelle Sissons

June 6, 2020

MARKÉTA FANTOVÁ I'm not in the States. I moved to Prague to lead the Prague Quadrennial. I went from working super actively and teaching, to enabling others to design. Part of what we do here in Prague is applying for large European grants and we now are coordinating one and that gets me back into pedagogical work. We have projects all across Europe. That's been really interesting and fulfilling because there are many things that we had been doing with emerging designers from Norway, from [the] UK with V&A [Victoria and Albert Museum] in London, and then in Cyprus. And we found this really wonderful group in Ukraine called IZOLYATSIA with a really, really, moving past. The whole project is about things that happened in history and that were shoved under the carpet by various different countries. It's now becoming very visible because of everything that is happening around us. We discovered so many things in these countries that we're working with, like histories that people simply just really don't want to talk about and don't want to put into history books.

And now it's about vision for the next PQ. That's crazy because we are where we are, and we have to think into 2023. And think [about] what is scenography going to need, what are the scenographers going to talk about in 2023? So, what am I going to give them as a theme to come to Prague? It's a very different way of thinking. It's a lot of writing. So, that's it for now. Nothing as exciting as Abu Dhabi. I'm so curious to hear about that. How that works and how did that happen.

MARSHA GINSBERG I'm so Western-centric in my understanding of space. And I also realized in teaching this Intro to Design course that I'm also Western-centric in terms of the texts I assigned students, that I was having them read Georges Perec. He's talking about the structure of dreaming that expands. You start in your bed and [it] expands, but it's all a Western conception of what it means to be

in your room. And a highlight for me [was] when I was there in Sharjah, which is one of the [United Arab] Emirates. There's this really amazing art foundation there. They had their first architectural biennial and that was huge for me because it was themed around future generations. I went to the four-day opening and all the opening lectures and parties and events, and I met all these people. I also brought my students there. What was great is that now I'm friends with this architect in Bahrain! And we were just texting about these modules, this seating arrangement that they have for men. It's totally opened up my ideas about how I see space. I have students from all over the world, I'm just listening, you know, doing assignments with them and listening to them talk about different spatial configurations and norms in their countries. It's just been really eye-opening.

MARKÉTA FANTOVÁ That sounds really great. I wish I could sort of pick your brain on that not-prioritizing-Western-centric-thinking and just getting into a different area where it really opens up different kinds of perceptions and views, because we're constantly fighting this. The main part of Prague Quadrennial is the exhibitions of countries and regions. But it's been, for many years, it had a Western view. It's been organized by people with the Western aesthetics. Now, since 2003, it's been trying to open up as much as possible to everything else. So, we have over ninety countries participating. We are trying to be as open to their perception as possible. But no matter how hard we try, there are always moments where we're constantly trying to push different countries into different slots that are still coming from our culture. The further we move away from trying to just grasp everything with this type of culture, the worse the feedback from Europe is sometimes. It's really interesting that Europeans don't want to give it up. So, there's that clash between what is traditional and what they, particularly [the] older generation in Europe, is expecting from us and what the young emerging designers want to do from around the world. And the clash is so interesting; interesting discussions come out of it. Sometimes they are pretty sharp, but they're usually sharp after the fact. So, the exhibitions happen, the festival happens, and then the writing afterward is the most critical. During and before it's great, but then [afterwards] all these things start to come out [about] how some of these cultures do end up clashing after the fact. It must be wonderful to be exposed to the young generation and be able to learn from their perceptions, their ideas, their thoughts.

MAUREEN WEISS For you, Markéta or you, Narelle. When you came to the United States how did our notion of space, and how we deal with a theatre space, throw you because we have these traditional notions of what a stage needs to look like. And I'm sure that might have been confusing when you try to adapt to it.

NARELLE SISSONS I trained in London. I went to Central Saint Martins [College of Art] and then the Royal College of Art after that—did literature, then film, actually. The type of data that I grew up on, mid-eighties, was very much about [a] mash-up of political theatre and very physical theatre that was coming from Europe. So, the work of Peter Brook and companies like Complicité. I broke my teeth on that type of thinking of how a story or a text that you're creating lives in a space and the space is a really critical part of the character of the storytelling. That's always stuck with me, you know, even in the work that I do here. A theatre is going to be viewed separately but everything about that space counts.

I've been in the country now for thirty years almost, [I] think it's twenty-nine-and-a-half-years or something like that. I remember some of the first impressions I had when I came to the States was going to see En Garde Arts and that site-specific work that was kind of thrilling and amazing. In the street or in the Meatpacking District or in some of the most extraordinary places. There was a production I saw that they did in a Masonic temple somewhere in Chelsea. The Wooster Group made work in their performing garage but everything—every texture, every sort of object in that space really counts. That's really the background to the work that I've done. And it continues. I have a really hard time designing in a space that I don't know or I haven't visited. I have to go in there to kind of feel it out [and] get a sense of [the] cubic dimensions of that space because, without that knowledge, it's hard to respond to the spaces architecturally as well as respond to the text, which to me all merges together.

I had a Fulbright specialist grant to work in Estonia doing a workshop for two weeks with different schools from around the country. There were five groups. A colleague of mine who is media-savvy from Carnegie Mellon and I put this together and asked for five different spaces to have five different groups make work. It was so interesting how the work responded to their spaces and how different the pieces were just depending on the space. We had two groups that were in a modern TV lab and then we had another two groups that were in warehouses. It was kind of dusty and it felt really, really, creepy in these two warehouse spaces. Their work was in contrast with very slick work that was happening in the TV studios. You know, the particles in the air that were filtering through some of the images and very rough walls and the strange kind of places that people could come from and enter into the space had a really different feel to it. And then the fifth group was actually in a basement space in, I think it must have been a medieval castle. It was in this walled city in Tallinn, where we were. They got to be in the catacombs with the curved ceilings and we were really trapped in the catacombs with them. And it had a very different quality to it. It felt like they were dealing with entrapment and death and deep history. Even though we were using media that still came through.

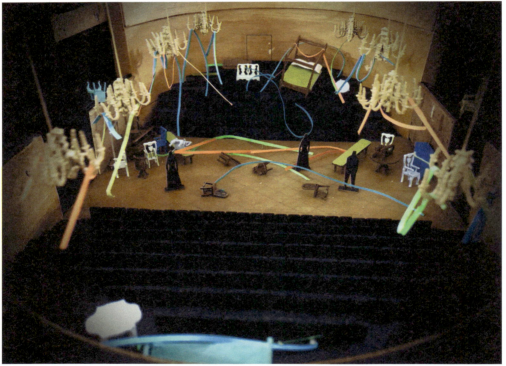

Set Design by Narelle Sissons, *Pride and Prejudice*

MAUREEN WEISS Do you ever wonder, going back to what Marsha was thinking, if our attachment, our Western attachment, to catacombs is death? But in another place, it's life. Will they feel the same in that space?

NARELLE SISSONS We are influenced by our own history. How do you train a bunch of Americans who didn't have that history there in the catacomb? What they might come up with would probably have been quite different content-wise. However, I think that the character [of the space], though, remains the same.
You can play with the character with light, with the text, but there's something about that sort of visceral quality of a space that is really important. Every single site is site-specific.

MAUREEN WEISS Right.

NARELLE SISSONS You're doing a disservice to yourself and to your audience if you ignore the site. Even in a Broadway house, if you look at some of the work that's going on, people understand the relationship the audience has to the space. My friend who designed Harry Potter, Christine [Jones], even changed that space and made it a holistic experience. Honestly, there [are] some sites that are more interesting than others, but they're all site-specific. All sites need to be treated with that respect. My favorite kind of site to be in is one that is a raw space because then I feel like you can do a lot more, you can bring more to it. I find that a space that has the most flexibility and has a rawness to it allows the audience to use their imaginations because you're not being too prescriptive about where you are. And also, the level of disorientation is always fun so that people aren't necessarily fully comfortable when they walk in. They have to participate.

MARSHA GINSBERG The whole environment of working outside the States is different. I think that the United States is really anti-artist and the theatres have become worse and worse about this. It's actually been really invigorating to be working in environments where it's incredibly supportive of artists. **In Germany, they always talk about the creative team as the director and the whole design team. Also, the attitude towards text in Germany is totally different. It's not like this country that—when I was talking about this monolithic theatre—is all about text and it's all about the well-made play, which they call in Germany, "The well-made play" in quotes, and no one wants to do them.** I've done a few new plays with contemporary playwrights in Germany. And they basically just leave—they give it to you.

The attitude towards text is totally, totally different. I did an Elfriede Jelinek piece in New York and on the opening night she wrote us all a letter. And what was so sad is that it was actually her first premiere at a real theatre—other than an educational institution. And she's won the Nobel Prize in Literature and her plays are done all the time in German-speaking Europe. She used the metaphor of a soccer game: I've kicked the ball into the field and you all have played with it. And that was her way of thanking us for playing with her. Right there, it's a fundamental shift in what the relationship of the playwright is to creating an event. I'm very interested in the conceptual foundations of that and going at a text in a more sideways direction, which I can't do so much with new plays in the US.

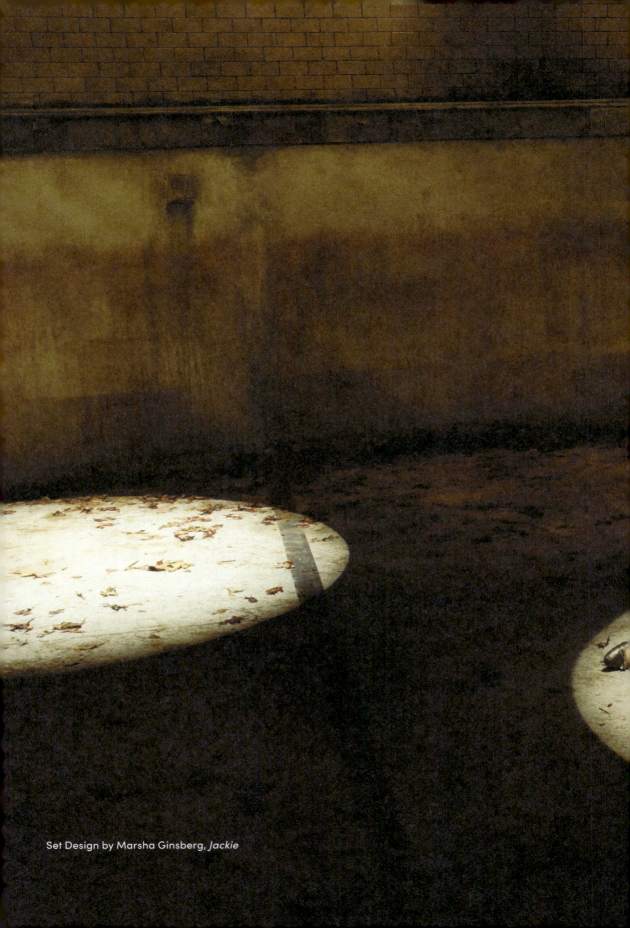
Set Design by Marsha Ginsberg, *Jackie*

MAUREEN WEISS Do you agree, Markéta?

MARKÉTA FANTOVÁ I agree with some of it, but I was lucky in the United States that I always found a way where I met people who were willing to work with metaphors in a very dreamy way. I also worked a lot without a text. So, I might say that I'm not always a text-based scenographer. I work a lot with dance and physical theatre, site-specific work. All these have taken me out of the text-based theatre, but I know exactly what you're talking about.

I came from a training that was architectural as well as scenography that was based on very metaphorical and dramaturgical thinking about space. And when I came to [the] United States, I remember being a little bit in shock with the American audience being so enamored with box sets. I could not understand why anybody in this century, or even the past century, liked box sets. It's not as exciting as [sets] that change, that are dynamic, that you can break in space and do all kinds of interesting things and take it completely as a site-specific world when you walk into the theatre space. So that was something I didn't understand. I was kind of rebelliously fighting against the box sets. Why is there such a need to be realistic?

When I came to [the] United States, I went to Detroit first. That was a big inspiration for me [in] working with space. As somebody who went through training in architecture and thinking about urbanism, Detroit is a space and place where urbanism was in a dire, desperate situation at the time when I was there. It's very interesting to see this decay and [the] destroyed spaces, which are incredibly inspiring and beautiful. [I] also thought about movement of people and presence-versus-non-presence in certain areas of the city, as well as areas where people commercially lived. It was so interesting to come into that environment first in [the] United States and see that as a first thing and be a little bit in shock with something that can be so brutal.

Then I went to Dallas. It was opposite. But I always looked for people who are willing to work, as you said, without being locked into the text. I kept thinking about this. Why are some directors so text-based and sometimes limiting the designers by the text? A bit of it has to do with dramaturgy in general. Dramaturgy in Europe is taken completely differently and works differently than in [the] States. I'm not sure if you have [had a] similar experience. The work of a dramaturge in Europe—whether it's in Germany, or in my country, or Australia, or in Central Europe—is just so much more about rebuilding some bits and some blocks of the play and really taking what the playwright writes, and taking it with the director and the team to a whole different dimension. In Europe, it's understood that the author has written something that is going to change, that is going to be taken away and moved and shifted and it might be chopped into pieces. I agree that there's a big difference. But I also think that there are always creative people who want to work a certain way and they're everywhere. In my

experience, I ran into people who love teamwork and will break all kinds of rules to do what they want to do together.

MARSHA GINSBERG I'm usually hired to do the impossible nonlinear text, like [with] this amazing poet, Ariana Reines. I did her play called *Telephone* with [the] Foundry Theatre. I've done a couple of really, really interesting projects with Foundry that have been site-specific and/or really like a poet writing a text that is one section of it. [It] is totally like stream of consciousness by [a] hysteric. Those are the kinds of projects I tend to do in the US theatre. Maybe we can make a separation between the projects that you do that you're absolutely passionate about artistically, but unfortunately those projects are not things that sustain you financially. When I say monolithic American theatre I think about the jobs that you actually can have to make a sensible thing as a designer, as opposed to the things that are your kind of heart and soul artistically that you do. I sometimes think that there's a track in the US between your early career and then everyone is trying to move into the paying gigs. And I know directors who were doing such brilliant work in this kind of more investigatory way. Yet, they get nervous doing new plays and suddenly they're doing new realistic plays and hired by regional theatres and stuff like that. It's been challenging for them because they're happy to finally be able to work. Their profession could be their life, but they're not doing the kind of work that they would have liked to have continued to do.

Also, just to circle back about this dramaturgy thing. Every theatre in Germany, whenever you work on a project, you have a dramaturge. So there's always a discourse between the director and members of the creative team early on because there are different phases. You have these different points in the process [where] you're really engaging with your creative team and talking about the piece, and the dramaturge is giving input. It really allows the piece to kind of grow. When I design plays in Germany, I'm there for six weeks, I'm in rehearsals. That's also a huge difference. I'm having daily conversations. Everyone goes to the canteen for lunch after rehearsal and hangs out and talks about the play. You're always engaged in conversation about what's happening in rehearsal.

MAUREEN WEISS I was really curious what you said about being called a creative team and, whereas over here it's the production team, how those two words are within opposition. I never thought of it.

NARELLE SISSONS Something that was just said earlier about this kind of reverence for the text—that the writer is at the top of the pinnacle. And a director then feels, especially with a new play, that they need to serve that. I'd love to understand or know why the structure in this country is so much more directed towards the playwright, whereas, as it was being said earlier, in Europe the expectation is that you will look for subtexts. Essentially, you'll create a visual language for that piece and you know it may not always coincide with what the author hopes.

Design by Markéta Fantová, *Letter to the World II*

Costume and Lighting Design by Markéta Fantová, *Limina*

MARKÉTA FANTOVÁ In Europe, you just go so quickly from one country to another, and from one language to another, so that's part of it. I was just thinking about space and, again, going back to urbanism—I was working on a play that was set in Romania and I was trying to figure out why people were so fractured in terms of their beliefs and understanding, and why there were some issues. And I just looked at the map and I realized that there were so many different communities from different parts—there were Hungarians, there were also Romanians, there were also Roma, Germans were coming in at a certain time of history. There are areas where each historical building, essentially, was made in such a way that [it] was a little fortress. So everything was walled off and [there were] the buildings where people lived or where they had the animals. It was all essentially closed off in the evening and you could only get in through a gate in the morning. You realize just looking at the way the historical buildings—and the cities, and the streets, and all these things were built—was all defensive. Then you realize, Oh my god, these places were always at war with each other, always [having] problems. **History is really something that we are always living. No matter what we do, we're just pounded by it. And now we're definitely, definitely having to face it.**

NARELLE SISSONS Let's face it, we are a global village. We're no longer isolated as countries, even though some governments talk about wanting to become isolated again. But we're all part of this bigger planet. Having conversations about social injustice and also about [the] environment is something that affects everybody. So, if the theatre can do its job, it can have those conversations.

MAUREEN WEISS And I wonder if some of that has to do, within the United States, of destabilizing the playwright, you know. We're looking for someone that is telling us what to do all the time. Maybe if we all come together in uncertainty—

MARKÉTA FANTOVÁ Or having a visionary playwright like in my country. It was great—through the change from communism when the Berlin Wall went down—we have Edvard Beneš who went straight from prison into the presidency. Theatres did a lot of work. I mean, it was theatres which went on strike first and it was happening in theatres. But it was also happening in theatres many years before that because of the use of metaphor that was speaking secretly to the audience. Of course, everybody got the metaphor. It was anti-governmental. It was a brilliant way of getting under the skin of the system, which was impressive. Theatre can make change. I think it does have the power.

Set Design by Tanya Orellana, *Point Fuga*

REGIONALISM & MICRO-CLIMATES

Andromache Chalfant / Collette Pollard / Nina Ball / Regina García / Tanya Orellana

June 30, 2020

SIBYL WICKERSHEIMER I recognize that theatre's about to change. There was some concern over [this] book being out of date by the time it comes out. But if we don't capture the moment that we're in, then it won't be captured.

ANDROMACHE CHALFANT Are we following down, potentially, a year or two in this very limited medium, or is it going to take us on a path to reimagine, reinvent theatre? Or is it closer to video design, and video art, and performance art—in that direction? I don't know. I'm so curious what other people are feeling.

TANYA ORELLANA I personally have not been pursuing the video art route partially because there are so many great digital artists that—if you guys are shining right now, I'm totally fine with that. Because I don't want to then do the thing that sometimes people do where they think, if I'm very good at this thing, then I must be good at this [other] thing. I've invested so much into space as something you see in person and in theatrical storytelling. That's generally what I think my personal voice wants. I just heard about a project where they did a theatre show where you put on a headset or headphones and went around to different locations and got a story. I'm very interested in the new medium of theatre—theatre in this world. I do think there's a world where you could set up an outdoor show: shows for one, shows for two, walking shows, where you see one scene and you're socially distanced from the performer. I'm very interested in that development. We are going to have to go through that before everyone [is] sitting in a room together. I think super interesting stuff comes out of that.

REGINA GARCÍA Following a character through the city or following a map to get little interludes from a story—and then you take a break and you get entertained or you eat food. All of that is really interesting. If anything, the Zoom readings and the Zoom work that I've been seeing is satisfying the immediate urge to connect. We were just ripped out of each other's lives so quickly. So many projects were already in the pipeline, so many people were already in rehearsals that it was the easiest step of, Let's remain connected somehow and finish this

Set Design by Maureen Weiss, *Dirt Bird*

baby up in whatever way we can. I've seen all sorts of readings with pictures and renderings and cut-out dolls and funny radio plays and things like that. Of course, also plays from student playwrights where most of the play is happening in the chat—with some characters only existing in the chat responding to the conversation between two others that are real or that actually have a person in the picture. Those things are interesting, but I think that at some point it's going to get old and tiresome, because it's limited like Andromache was saying. But it's satisfying that urge and I welcome it because of that. We are social people—even

the most introverted introvert of us needs that connection and we build on each other's ideas and energies and connection so, for now, I'm game to play. I don't know what's going to happen six months from now.

COLLETTE POLLARD It's this idea of reinventing the wheel and not having to reinvent the wheel. Something else that's been interesting is that you can see everybody is in this mode of trying to reinvent. What's also so interesting about what, Tanya, you were saying is [that] I can't, all of a sudden overnight, become a designer for Zoom when I'm not that. So, we have a lot of great conversations that keep inspiring me about what it means to be theatrical, and that's something. I look at my own work [and it] is around those questions. It keeps us coming back to what really makes theatre outside of being live, which is already taken away. But how can we bring it back? **So now the question is what does it mean to be live? What does it mean to have shared experience? What does it mean to have catharsis, you know? What does it mean to reveal something like you can in the theatre?** I hope it influences content. I think it's going to but, for example, Zoom is a frame just like the theatre [is]. Let's remove it being so different because it might help us get to making something theatrical together. I have no idea if we'll make a hot mess of a thing or something that will create any of the things. It's been really helpful to not force yourself to be filmmakers. What we do is important.

MAUREEN WEISS I've been asking my students, When you see theatre online, what feels live? What feels like it's living and live as opposed to film? They've enjoyed that question. I'm noticing that it's in the handmade props for some reason, right? It's not like it is speaking to that screen behind them that is sort of filmic, but then putting the handmade prop in front of it all of a sudden—I don't know what happens, but there's a moment of like, Oh, this feels live. I don't have answers to it, but the probe is fascinating. And it does bring me back to Gertrude Stein all the time and how she would just embrace this and she would layer in that we're just speaking about time and this is our new layer for time, right?

TANYA ORELLANA That's so interesting about the hand props because I think one of the freedoms in set design is when everyone in the audience knows it's not real. That's the big thing. I can make just the frame of a house and I'm not tied to realism because nobody in that theatre thinks this is a real person's house on stage. But in film, you know, you watch a movie and all the little people in the back are real. Even if I know it's an actor, something about that medium feels like a reality that is timeless and will always exist because you can just watch it over and over. So, that's so interesting knowing that what is handmade in the screen is making people feel [it is live].

ANDROMACHE CHALFANT I had a conversation with a director who said something along the lines of, In performance, the performers urgently need something from the other performer so that there's an engagement across the frames that is felt. I thought that was kind of great.

MAUREEN WEISS How many of you have worked out on the West Coast that aren't originally from the West Coast?

Set Design by Andromache Chalfant, *Henry V*

Set Design by Collette Pollard, *Hannah and the Dread Gazebo*

Set Design by Collette Pollard, *Hannah and the Dread Gazebo*

ANDROMACHE CHALFANT I mean, I worked a couple times with The Old Globe.

MAUREEN WEISS Okay.

COLLETTE POLLARD I'm moving from the West Coast, so I've worked there. But I was born in San Jose when those folks were in their garage making these computers we are on right now and it was a very different place.

TANYA ORELLANA Yeah, San Jose.

COLLETTE POLLARD Yeah.

SIBYL WICKERSHEIMER In San Francisco, I visited a lot in the nineties and early 2000s, and it did feel artistically vibrant. But, I was doing a show in the new Strand Theater in 2015, which is the new smaller space at ACT [American Conservatory Theatre]. In order to get to the theatre, I was stepping over needles and homeless people and shit on the street and it was awful. I was confused by that in contrast to this cute, cool theatre along a great strip of the city and in contrast to the commercialization happening along that whole street. I don't know what's happened now.

NINA BALL Yeah, the commercialization of that growth kicked out a lot of people that used to squat in the Old Strand and some of those buildings. As soon as you fix it up all the people that used it as some sort of shelter are now on the street.

MAUREEN WEISS Yeah.

Set Design by Maureen Weiss, *The Subscription*

SIBYL WICKERSHEIMER So it feels like if you go to the theatre and you're stepping over homeless people, it's almost like you feel guilty going to the theatre. I'd rather just give them my money than buy a ticket. That's going to be a problem, you know, just getting out there and going to see work. Not that we can do that anymore, but in thinking about audiences and how they're going to shift. I am worried.

MAUREEN WEISS Well, my theatre had a whole homeless population outside but they came to all the shows. They were the best audience—the best audience ever— and they consistently helped with all of the activities, were a part of it. This was Santa Monica before Santa Monica got super expensive and they displaced us. The city of Santa Monica felt bad so they offered all this different stuff—but what they offered us instead of our theatre was an office building. And all the homeless population that was living by the beach has just been pushed and pushed.

TANYA ORELLANA I think, in San Francisco, part of what happened is that things have gotten really compartmentalized. It used to be that there were homeless populations in different parts of the city or someone had an apartment and a lot of people were living there. And then, the Strand—what's happening there is that some of the only housing that can't be taken over in San Francisco are the SROs [single room occupancy housing]. And, so now the SROs are becoming much more full than they were before.

Set Design by Sibyl Wickersheimer, *I Carry Your Heart*

Set Design by Tanya Orellana, *Nogales*

3. Perspective

ANDROMACHE CHALFANT The same thing has been going on in New York. I grew up in New York, so we're talking '72 to now. I've seen a lot of versions of it. When I listen to this conversation I wonder, because artists are part of the gentrification of things. There's a long history of artists being willing to live in more challenging areas and see the potential [in] big spaces and all that stuff.

My dad was a sculptor and had a space in SoHo. I went to college in Vermont [and] when we all graduated, the art kids moved into Williamsburg—this is '93 to '94—and it was really desolate. I think there was one local bar and we felt [like] we owned the place which is, of course upon reflection, horrible in many ways. But we were kids and we weren't afraid. We were having fun, we were making art. But that has been to me just so extreme. I don't know if any of you—if you all have been or hang out there. Having lived there so intensely in the nineties, I can't even go back. It's unrecognizable. New streets have been created and new skylines—in a short lifetime.

I'm forty-eight years old and I've watched two major shifts in New York, from the SoHo scene to the Brooklyn scene. I ended up in Red Hook and now I'm in New Jersey. You are always shifting away. We came out of Bennington as art students and there were all these spaces on Ludlow street.

REGINA GARCÍA Listen, I'm smiling. I had no idea you went to Bennington, but it makes so much sense to me.

ANDROMACHE CHALFANT I'm full East Coast. And our Sarah Lawrence/Bennington ties, too.

REGINA GARCÍA That's exactly what I'm saying!

ANDROMACHE CHALFANT On Ludlow street there was the bar, Max Fish, which was with a [performance space] called Todo Con Nada. There was a [theatre] place called House of Candles. They were these little divey storefronts and we would just take them over—and our friend Marc Spitz was a rock and roll playwright. And I could build, and I could paint, and we would put on these shows. It was a scene. Eventually one of the actors opened up a club called the Slipper Room— that whole block, it all blew up, the Lower East Side. It's a mix of things in a way. We're part of the scene, we're making the scene and then it becomes popular. But it's all, for me, tied up with performance and theatre.

COLLETTE POLLARD **It's just access, right. Which is such a huge, important word for all communities and we're not practicing enough of it. But the arts become access.** So then, someone goes because someone said to go, or it feels accessible, or it's cheap, or it's free, or it's my friend's party up in the loft in Wicker Park—which was a total dive and now it's one of the most expensive areas in Chicago. It's access.

I'm excited to hear you talk about it because it makes me frame it in that way, which is good for me to think about to stay on the positive side of this whole thing. We give access to people to see things now. Whether or not they get taken away

and gentrified—that's a whole other Zoom call. The fact that everybody wants to be somewhere healthy, ultimately. That's inspiring to me to hear you talk about it because it did give access. Gentrification is a different conversation where there is negativity in the opportunity, in terms of pushing people out and not being responsible for taking care of one another. I'm fascinated that artists feel accessible.

SIBYL WICKERSHEIMER Well, the access to space is really interesting, right? These past years we're all talking about—the spaces that used to exist that we could take over. And now think that we can't be in a space together.

MAUREEN WEISS The interesting thing is that we're looking for homes for people, too. The homeless population is so high, it does feel like, How dare we take any space? We don't have homes for people. I wonder how this is going to affect how arts move forward. I'm not sure.

REGINA GARCÍA I think there's going to be an interest in these spaces as they exist right now. There's potential for really interesting projects—speaking one to the other. I'm excited that some of these studios and warehouse spaces already exist. We just have to engage with them in a different way.

TANYA ORELLANA I've also been thinking [of] what's happening with Covid in relationship to what's happening with more of a public conversation around the injustices of white supremacy as it pertains to the entire structure of the world. The silver lining is the amazing opportunity to say [that] we were all having to be innovative because of Covid and now, as we're restructuring, we can figure out how the system can incorporate new ideas. And, yeah, if we're all having to experiment, maybe that also means experimenting with cultural expressions—whether that's aesthetics, or a type of theatre, or even what they think is theatrical within their culture. It's fascinating.

MAUREEN WEISS I really love that you said this restructuring that we have to keep speaking about. There [are] a lot of people that are thinking it's just going to go back to a structure of comfort and what I enjoy about these discussions is it's all about restructuring.

REGINA GARCÍA There was a particular type of work that was being amplified which was very, yes, I'm going to say it, male. I think [Northwestern University] has the same issue—very male. And let's just say this: there wasn't an invitation for the students to trust their voice, to trust their work and their individual—the uniqueness of their potential practice. What was going to become their practice, ultimately, because when you're in school you're training, you're figuring stuff out, it's messy. I think it brought up all sorts of questions that I had for my alma mater about amplifying voices. Why the formula? Why one way of doing things is the proper way—why isn't it an invitation instead? It's not only access. Yes, you brought these people into the program. But where's an invitation to continue the work and the rigor, an invitation to find your own voice, an invitation to be innovative and unique within the form? And how that, for some of us, has come so much later. As we've gotten older, as we've found our tribes—and I mean that

Set Design by Nina Ball, *Blasted*

wholeheartedly, my community, the people that love me warts and all—and how that also has an impact, perhaps. Now most of us that are professors—how we're trying to shift that and we're getting a little pushback from our institutions.

SIBYL WICKERSHEIMER It's really difficult as faculty, and I recognize this. Not that I'm making excuses for the male faculty that I had when I was entering into set design, but to challenge your students and not impose your own work ethic and process on them is very difficult. You have to teach them to listen to their own voice. But we've been listening to male voices our whole [lives] and so I didn't realize that I was supposed to listen to my own voice as a designer, and yet I instinctually did anyway. The most important thing to get from a book like this is that you see a collective of interesting people and work, and they're each following their own voice in order to make what they make. And we all happen to be in the same field. There's something to that. It's hard to teach young people that they have to be listening to themselves and yet, they [also] have to learn about everything else out there. It's like a double standard, right?

TANYA ORELLANA Everything you're saying I agree with. A lot of times the theatre design education does not talk to set designers, or any of the designers, to think like an artist with a capital A. So much of our work, especially in the United States, is based on how popular you are and how many people want to work with you.

I do like the idea [that] we're chameleons. I really feel it's important to be part of the group and not just impose a singular aesthetic every time at the table. At the same time, it's a big task to teach a young person how to both collaborate, but then to have a personal process and individuality so that you don't end up looking like everyone else.

Unless you're in a company like the company I'm part of, Campo Santo. I still meet with the directors and have strong conversations. If they have a strong idea, we go with it. Because I've been with the company for twelve years at this point, there's a lot of trust [that] this is what I want to do, and they're like, That's a great idea, let's figure it out. Or the process with the writer is [that] the writer will read us three pages of a script and then I'll have an idea. A lot of the work we do with Richard Montoya—he'll respond to what people responded to when he was writing it. It's not an afterthought to include the designers in the writing process. It's been really interesting to have this small company that could only do it because it was small, because ticket sales don't have to be as big. I mean, it's important to us, but we don't make decisions based on [money].

SIBYL WICKERSHEIMER Are others of you in a company setting like that?

NINA BALL I'm a part of a company called Shotgun Players. I've been there almost my whole professional career, which has been the place that really let me be seen and play. There is something amazing about a company of artists where you get to work with the same people over and over. And it's not exclusively those people, but that trust that's built, the shorthand that's built—and really getting to experiment in a way that you wouldn't get to with many other companies has been huge for me. Also, I have been coming from a visual arts background where you are the person who leads the art. We all love, like you said, Tanya, the collaboration, but the "text is king" thing is hard sometimes for me. I agree with it, of course, but I would love to see a different type of theatre created where the— and I've done it at a few workshops and it's been super exciting—where the design leads the story and you create something and then a group of artists come in and create a narrative around that. I would love to experiment more with something that just gave me a sense that I'm not always in response to something else.

SIBYL WICKERSHEIMER In a national model like that, the state or the country might give spaces and monies to theatres. But then there [are] only a few who are invited in.

NINA BALL You know, maybe, I'm not sure what that problem is. Yeah.

REGINA GARCÍA I've been involved in a couple of projects that had long incubation periods because of a Mellon [Foundation] grant. As you were saying, Nina, that our muscles are not used to respond to that amount of time. What I discovered was that, without specific prompts or guidelines from the director, we still end up doing a mad dash [in] the last three months of the project. I was lucky. It brought me into the rehearsal room and into tech in a different way. And I really appreciated having that experience, but I haven't had it in a long time.

Set Design by Sibyl Wickersheimer, *Elliot, A Soldier's Fugue*

NINA BALL Yeah, you bring up a good point about being in a rehearsal room. How many of you actually get into the rehearsal room with any regularity?

SIBYL WICKERSHEIMER I used to in my experience in LA working with [The] Actors' Gang or other companies that were smaller companies. I worked with them for ten years and not as resident designer, but I was there all the time helping to build the sets, leading teams, and it was amazing. It was that relationship that I had wanted with several directors working there.

ANDROMACHE CHALFANT It's different using different models and different structures, sometimes to your own ends. I don't know how you all feel, but I feel the regional theatre is generally well-supported shop-wise. It does give you this opportunity to deal with your craft on a more detailed level. It's like a bigger—it's something else. Then there's the version of more experimental, devised work. At least, that's how I separate it.

SIBYL WICKERSHEIMER There's a lot of resistance to building a physical structure to use in rehearsal, even at the places that could do it so easily. And so, in the smaller spaces where you would be building the set and rehearsing on it, they have the benefit of that. I've tried almost every show because my sets tend to be physical. Let's just build a mock-up of a portion of it, just so they can feel what that slope is, or what that step is, or whatever. Just a tiny section of it. There's so much resistance to it. In places where they aren't so heavily structured with the shop on the staff it's actually easier to get that to happen. When we're talking about structural change of theatres, I think this is a huge one I'd like to see. It will only happen if a designer gets to be at the top of the structure, so that you have to listen to that person.

ANDROMACHE CHALFANT It's gotten so corporate, in a way. I'm just less optimistic that those kinds of changes will happen, but it's certainly worth looking at. Everyone's put in their little compartment, you know, to some extent. So, yeah.

SIBYL WICKERSHEIMER Maybe, in terms of moving back into theatre spaces, we will have to remain local and travel won't be as easy because the funds won't be there.

REGINA GARCÍA The Alley [Theatre] already announced that they were going to hire local for the first year and a half.

SIBYL WICKERSHEIMER I'm guessing that that will be a thing. So, hopefully regionalism will have a day again and we'll be able to be in rehearsals again.

"Where do you step outside of the boundaries of theatre? How did you know how to do this?

Literal answer: When Covid hit and theatres shut down, it was a risk for me to apply for unemployment because I am on a visa, and furthermore, I need credits to apply for my next visa. I knew that I could not wait for theatre to come back or I will die with it. It wasn't a matter of how I knew but I was forced to. Nonliteral answer: The theatre space is such a surreal space on its own, even when it is empty and with that comes many possibilities. I love that one can jump up on a table and say they are now on a balcony, pour sand out of their shoes and say we are in a desert. There are no boundaries because the imagination is infinite."

—KIMIE NISHIKAWA

Set Design by Kimie Nishikawa, *Indecent*

Sibyl Wickersheimer, *Big Hau*

CHAPTER 4

Space

CREATING THE SPACE TO WORK

Collette Pollard / Marsha Ginsberg / Mimi Lien

July 7, 2020

SIBYL WICKERSHEIMER We are interested in your thoughts around space and if you have space to create what you want to create. There [are] sort of three different facets of space: Space that you make within your practice and within your life to create work, then space within theatres which is often programmed for us, and then the space that we can take and program in the way that we want to program it. I don't know where to start. What is, what are the projects that you most enjoy that are outside of set design, Collette?

COLLETTE POLLARD Design-related outside of set design? I have a tiny little company. And it's only three ladies including myself, and we take on unusual work. Some of it you could consider commercial, for sure. But it's so funny because it's Girl Scouts, the Obama Foundation, and then a private party. They're these little gem projects that fuel the theatre side in new ways because you're like, Oh, right, why don't we just put people in the bathtub writing letters on typewriters and handing them to people at a party? That fuels the questions [of] what is our experience, what is story? It's all the same stuff in a different kind of— not form, but a different audience experience. How they interact with it. So that's the stuff that I enjoy doing and always find it really rewarding, but I've never gotten into the big commercial projects.

MAUREEN WEISS Maybe we just start with how you find space for your work to just actually do it. I'm relieved that I don't have to come up with too many ideas for shows right now because I'm not sure where I would find that place, but I'd love to hear if you have been able to carve out spaces in time for that sort of thought right now?

MARSHA GINSBERG I'm always working. I'm always thinking and reading and looking. It manifests itself in a specific design—I have, like, one hundred little side projects and stuff. Even when I'm teaching, I'm learning things because I'm reading stuff that I might not have read before. It's all kind of feeding [me]. That would be my general answer, but now it's a little bit trickier. What do you actually need to work? It varies, depending. I basically need a printer and two large tables, a big monitor, and I already had my computer. I'm setting up a workspace here. That's what I really need—and tools and stuff like that.

Round Table 5

Create the space in order to create work (architectural space and artist space)

• Marsha Ginsberg • Mimi Lien • Collette Pollard •

Questions to think on:

- How much does the actual theatre space decide your design?
- Are you interested in finding the idea before entering the space or vice versa?
- What happens when you enter any space? What do you pay attention to?
- Are you finding yourself missing space right now- interiors especially?
- How do you actually work? Do you have a studio? If you have kids, how are you able to carve out time?
- Do you have favorite theatres to work in? What makes them interesting to you?
- How much time do you spend trying to storyboard and place actors in specific places on your set? Do you enjoy helping a director see the possibilities of your set? Are there difficult moments in this process?
- When is a space designed, and when is it just space?
- How do you use space to impact culture?
- How can theatrical space be used to reclaim an audience today?

From the survey:

"i think it's imperative to be a collaborator when designing for theater, but i also enjoy leading the design concept thinking process. what i do know is that i am not an artist whose forte is working solo. i like to always have collaborators, and design is inherently responding to a prompt or set of given circumstances." -Mimi Lien

"theatre / dance / some architecture / people think of me as a designer who deals with architecture, so i've been able to create some works that are outside of typical theatrical avenues… like installations and parks." -Mimi Lien

"If there is any kind of guiding force behind my design work it is that I am interested in the audience's experience from the time they enter the front doors of the theatre, to the box office, their experience prior to the show, their entrance to the theatre and their relationship to the space and how they see and hear the performance and finding the "truth" in the story being told. I have always been interested in storytelling and influencing the audiences experience and expectations of the story by keeping their attention and focus on each moment. If the story isn't told with love, magic, the intention to unearth a "truth" and the audience isn't engaged, then the work we have done isn't working." -Collette Pollard

Draft Agenda for Round Table 5

Set Design by Mimi Lien, *Superterranean*

MAUREEN WEISS The objects are interesting, of what you actually do need around you to begin the work, because I'm usually at a loss. I'm grabbing for things—between kids, toys.

MIMI LIEN Yeah, until you sent the agenda today I was like, Oh, wow, does that mean physical space or emotional space? But I guess you kind of mean both.

SIBYL WICKERSHEIMER Yeah, there [are] many different ways of looking at that.

MIMI LIEN Mm-hmm.

COLLETTE POLLARD So, who works from home and who has space outside of their home?

MIMI LIEN I work from home. It's funny, for a short while I had a studio outside of my house. I thought that that's what I had always wanted. When I had the opportunity I was, like, I finally have arrived. I had it for four months. It may have been circumstantial, but I realized during that time that I'm just the kind of person who, like Marsha was saying, I kind of want to be working all the time and I want to be able to do that. I thought that it would be a good idea to separate the two, that I would be more efficient. Like, I would go and I would work and then I would leave and I would have home life. And then it totally didn't work.

4. Space 173

For me it's always been late at night—like the quiet time when you don't feel like you have to respond to emails or when you can just not feel like there's anything that you have to do. That's when I'm able to do the conceiving and creating. Now it's still the same with kids, basically after their bedtime is when I'm actually doing work. And then during the day if I have a few hours here and there, I'm basically responding to emails.

SIBYL WICKERSHEIMER Yeah, that's how I figured out how to do it too. I have a space that is at my home but [it] is closed off from my home. For me, the space to work is just having several hours together. I don't feel like you can do it in a few minutes. You might be able to respond to an email or something, but even to get into an idea or phase of the project you're in, you need more than a few minutes; you need several hours. I think that's where the late at night comes in for me. I can spend as long as I want because there's no cutoff, you know, except for being tired the next day.

COLLETTE POLLARD It really changed for me when I had my son because he was up so early that the late hours were just so unhealthy for me. And frankly, I spent three years sick in tech because we would get home, ten out of twelve [days], by midnight. Get in the car, get home, and then my son would be up at six. I am a night person, but I just really trained myself to be a day person because I have a finite amount of time. In some ways, I'm way more efficient with my time, but it's not my time, it's time that I have to make the work happen. I really enjoy the quiet time in the morning. It's amazing. Our community really is a ten a.m. community. So, those early morning hours [were] when I would do a lot of the planning type of thinking. You have to carve it out, like you said. I have a studio that's separate of my home. It's about a ten-minute walk, though, so those challenges aren't as challenging in terms of logistics of getting something, and I'm always happy to host a meeting if someone's willing to come to me. You can cut up stuff right here and do whatever we want to do. Home has always been a place of rest and revitalizing. So, having [my office] in my home made me crazy personally. If it was out on my dining room table it was really hard for me because I cannot let it go. I cannot. I would become fixated on solving something.

MAUREEN WEISS Are you using that now? That outside space?

COLLETTE POLLARD Yeah, I am. There [are] three of us here. It's a mess right now, my remote teaching corner. I tried this product, [it] is a magnetic paint product. It actually works. So, I painted this whole wall the magnet wall for research and things. All my stuff is out of the corner right now, but it looks so much bigger than it is. Four of us in here is very—it would be very tiny for five of us in here. I have a modeling station, then I have under this is a laser cutter and one of those huge cabinets, and I have a computer station over here. I can really have three assistants; I rarely do, I usually have two. Right now, I was thinking of going down to one and just making it more viable for that individual. But all that's changed, obviously, right now.

SIBYL WICKERSHEIMER Well, it's interesting because what we're talking about today, in terms of space, you're setting up for your space to work as a teacher more than a designer in a way, right? And you'll still be able to function as a designer within it.

COLLETTE POLLARD I think it was Marsha [who] said it—you're learning all the time and so teaching is such an interesting pair for those who enjoy it. Because if you're learning all the time and then you're teaching it, you're relearning it or you're learning how to share it. So, it feels very fluid. I'm going into this mode of being uncomfortable learning all the new things because if I'm lucky enough to work somewhere outside of Chicago, it's going to benefit every online meeting I've had with any director ever. This camera on a screen has been on my to do list for two years, because I was finding it so challenging to only meet with a director, like right here. [BUT] it's hard because some of the technology is so convincing. So, should I be spending all my time on this new 3-D technology so then I can make the curtain move beautifully in the 3-D or should I be spending my time moving that curtain in person, by hand? It seems like the technologies are erasing the model making but the models—I find them very valuable. They're very tactile for people, especially directors. I often send them my model if I can't be there in the same state because they're the most spatially tangible over the flat pictures that move and show space.

MAUREEN WEISS I've always thought that directors believe them more than they believe the 3-D virtual world. When you hand them a model, they believe it more [and] they're less likely to change it. I sometimes go back and forth, seeing which one a director will deal with better. When I hand over a real model they seem to be like, Oh, yes, this is it. And if I hand over the 3-D, they're like, Well, could you move that thing? And I can in a second.

MARSHA GINSBERG It really comes down to, ultimately, your own personal philosophy of scenic design. I'm very connected with architecture. For me, it's very much a three-dimensional space. The model is a sketch for me. It's how I work. I'm just exploring ideas three-dimensionally in model form. Anything that's two-dimensional flattens out space. You don't see the depth of the space.

I don't do that first. I first do a lot of dramaturgy work. That's the first work that I do. And a lot of discussions with the director. One director I work with—we go to a lot of museums and galleries together for each project. We're kind of building up a visual vocabulary of things were mutually interested in.

MIMI LIEN I'm fully a three-dimensional person and I can't do anything without building a model, a physical model. Part of the reason that I don't use 3-D models is that I hate sitting in front of the computer. Why would I want to sit in front of the computer and build a 3-D model if I can build it out of cardboard and glue? There are definitely times when that needs to be done. If I do need to do some kind of previsualization, I have other people do that when it's necessary. But in general, I'm pretty lo-fi and maybe that's one of the reasons why I do theatre instead of architecture. My background is architecture, but I think there's something that

Set Design by Marsha Ginsberg, *L'Orfeo*

drew me to the theatre because it has remained kind of low-tech. I have a thing about using very anachronistic aesthetics on a digital platform.

SIBYL WICKERSHEIMER Have you ever worked as an architect in an architectural firm?

MIMI LIEN Not really. When I first moved to New York, I had decided that I was going to pursue set design, but didn't know anything about theatre. There was a temp agency specifically for architects, and so I did that. I [was] sent around to a couple [of] different firms, and I did actually have a job for two or three months. Just a few months while I was trying to get an internship on a film. I had a job for two months, and then I got an unpaid internship on a low budget film and I quit that job.

SIBYL WICKERSHEIMER I found that architecture state of mind can be very rigid—and to come from a world of theatre where every moment you're changing things and you're communicating through those changes.

MIMI LIEN I was working with a choreographer who runs a school called Ballet Tech. It's a foundation so they have a building and a lobby, and I was working with them and we were getting along great. They were redesigning and renovating their lobby and [the choreographer] was really frustrated with his architect and he's like, I just want you to design it. So I said, Sure, great, because

despite [my] leaving the field of architecture, I'd say the majority of my inspiration is not from the theatre world [but] is from the architecture and visual art world. I like to stay in dialogue with architects. It was my first love. In theory, if I could just have stayed in architecture school for the rest of my life, I think I would have been happy. Maybe being a set designer is the next best thing to being a student of architecture.

MARSHA GINSBERG I really admire that architects are involved in the social practice of space. I try to do projects where I can explore that more and/or I turn projects into that. I don't have conversations with American designers about what space means—representational issues about space or where the kind of representational implications of the decisions that we're making as designers [lie]. Those are discussions I have with my friends in the art world and my friends in the architecture world. That's always kind of an interesting question for me.

SIBYL WICKERSHEIMER In theatre school, I hadn't ever heard the word "program." What's the program supposed to be for this building? But it's what they speak about in architecture all the time. What is intended for the social use of the building? It's critical for what the design of building wants to become.

COLLETTE POLLARD Right.

MIMI LIEN It's rare. There are a couple of directors who I work with who I do have that conversation with, and I'm grateful. Sarah Benson at Soho Rep. is one of

them. I just remember my first time working with her. The first thing we talked about was what is the nature of this event, which basically is what is the program? And that's why I gravitate towards designs where I get to decide how the audience is experiencing the piece. Since that time, I tend to ask that question almost always first. **What is the nature of the event that we're making? Is the audience participating, are they not participating? If so, how are they participating or why not?** Why aren't they participating? All of that needs to be a decision and not just taken for granted.

COLLETTE POLLARD I completely agree that the relationship of the audience to the space sets up the whole experience of the night. If you've ever experienced getting a ticket to your own show and going to it as an audience member versus getting to your seat through the back door—those are two very different experiences. Sometimes my mind is blown how disconnected the experience is from getting the ticket to going [as a designer] and experiencing the production. Some of it is logistical, and some of it's because the bandwidth, or some of it's the artistic leadership. But it's really surprising. Sometimes the experience starts from entering [the space] because you have had a hand in that. And that's exciting. That's the most exciting work I've gotten to be a part of. But sometimes it's just a very separated experience in terms of what it means to enter the theatre. It's very rare to have a curtain down, in my work. But when it's used with intent the reveal of something is important, sitting in a space without the sense of being able to dwell on this space is important. **Often, it's really important to pick up a space and look at it and have your own ideas about it, and then we can shift the expectations of what the audience thought it could do.** That idea, of expectations, I'm really interested in. And to connect it back to the bigger social question about space beyond space. There's one group here in Chicago, they started very small and they've been around for quite some time. It's called Timeline Theatre [Company]. All this dramaturgy goes into making these productions. We wanted to make a little museum for the audience experience before they came into the space. They've continued that tradition on their own. They always have a space dedicated—they call it the museum but it's so tiny. It's just the front area outside of the theatre that is redesigned every time. Something I really appreciate about them is that they commit to rearrange their audience to experience [the] story. There's the sense of the "yes, and" in terms of the value and importance in hearing the story in this that it's presented, and I just find that work so incredibly rewarding.

SIBYL WICKERSHEIMER Cultivating that audience engagement is, I think, one of the reasons that I got into theatre. I think it's the main reason. Mimi, I thought I'd ask about what led you to get a space and what your programming interests are.

MIMI LIEN Well, I can't take too much credit for it. It [JACK Performance Space] really is the brainchild of my husband, Alec Duffy. But the idea came about while we were both at this TCG [Theatre Communications Group] conference in 2008. All of the conversations there tend to be about how do we develop a younger audience, and how do we do this, and how do we change, how do we improve the

Set Design by Collette Pollard, *HIR*

Set Design by Maureen Weiss, *Home Seige Home*

current state of the theatre in terms of audience and community. When you think of community theatre, it is not radical work. I think the space started to ask this impossible question of whether you could have a place that was both connected to the community and doing really adventurous work. That was the catalyst, and at the time there was the stock market crash. It was 2008 and we [were] actually looking in Philadelphia because we did not think that we'd be able to afford a space in New York. I'd worked in Philly a lot and I know a lot of people there, and it's a lot cheaper. We looked at a bunch of spaces there and then didn't end up finding anything great. And then we eventually felt [that] staying in New York is the right thing and found this space that was not cheap, but was rentable. So that's basically how it started.

MAUREEN WEISS How are you monetizing that space? I think that we all have this idea of what Collette was speaking about with the theatre company she works with. And in the United States, it is hard for us to push forward with some of these theatre models that I'm more interested in designing for. I'm hoping it's part of the changing of whatever this system has been, but how do you see a way that these companies can function?

MIMI LIEN It's a great question because it's only really this year [that] it shifted slightly to become more sustainable. Alec basically worked for free—he didn't

draw a salary for the first number of years. We were basically living off of what I was making. It literally was hand to mouth. It's not a sustainable model.

MAUREEN WEISS Yeah I did that for several years also with our theatre company and we didn't pay artists. There was no money to pay artists. I wasn't paid and it was youth [involvement] that was able to sustain that a little bit.

MIMI LIEN Right.

COLLETTE POLLARD There's something that I recognize in different institutions or groups, where the values dictate the outcome. There [are] artists out there that would rather have a budget and make something with the budget and not get paid. There are some artists out there that would be like, Please pay me, and it will be scrappy. We probably all have something that feeds us and the fact that we can feed ourselves lets us do the thing that can't, but it feeds us in a different way. There's my hopeful side talking, right? There's got to be a way to do both.

MAUREEN WEISS **The theatre that I'm interested in has always been on the periphery.** And therefore, my students who don't get out to the peripheries can't see this theatre, right? And this theatre is existing in a different hierarchy altogether.

4. Space

181

I wanted to end with asking if you have any favorite theatres or spaces that you've designed in?

MIMI LIEN Stage Two at Bard I designed this production of *Judgment Day*. It wasn't in the big opera house [Sosnoff Theater] but was in their other space [LUMA Theater in the Fisher Center at Bard]. And what was great about it was that it was actually able to be truly flexible. We've all worked in so many spaces that purport to be very flexible and then [they] just eat up your entire budget or it takes too much time to move all the seating. [In] that space, the seats just push back like bleachers. And it worked. I was able to make this kind of alley seating that was eighty feet long and have this gantry crane that was able to move over the audience. It was not a huge budget, it was a SummerScape theatre show. So, it was not like the opera budget. And I guess I don't know if that is truly a great space, but I had a great time working [there]. And this main idea of—spaces are always meant to be flexible and then they're not. And that one was.

MARSHA GINSBERG I've done three shows in that space and I definitely sign up for the same reaction to that space. **It's really architecture [that] makes something a great space, but also the people that are behind it and their attitude about how to use the space.**

SIBYL WICKERSHEIMER I've really enjoyed the Lookingglass [Theatre Company] space in the Waterworks building. I've done three shows there. It's a black box and it's an amazing space because there's also a lot of height. The Theatre for a New Audience space in Brooklyn—while I love that space and I thought would be a bigger version of the Lookingglass space because it's got so many options—it's really difficult. It's exciting, but it's so tricky.

MARSHA GINSBERG The space that Mimi and I both love [Fisher Center], I know the origins of that space because JoAnne [Akalaitis] was at Bard at that time and so she was very involved in that space. And I think John Conklin might have—I don't know the extent of it, but it was definitely a space that had been created with the people who use the space.

We could probably have a very long conversation about the architecture of spaces. I've been on one committee with theatre consultants designing a really horrible theatre and not being very interested to hear from someone who uses a theatre. It is interesting that the spaces that we're all admiring are the spaces that the artists have actually been involved in [designing].

COLLETTE POLLARD The black box. That's it. I mean, just black box spaces are ultimately a theme in the spaces I enjoy working in where you have control of the audience. I haven't worked in the space that you two [Mimi and Marsha] both mentioned but Timeline Theatre is in a church, in this tiny little hole, but you can rearrange that space in any way you want. Some of the spaces I love are flexible and [I agree with] this idea about support and how we make that [flexibility] work. The Owen Goodman Theatre is a flexible space and not a ton of your budget goes to arranging it. It's been a really rewarding space to design in, in terms of the bigger institutions here. Sibyl, did you talk about Lookingglass' black box?

Set Design by Marsha Ginsberg, *Kafeneion*

I got to design the craziest thing. It was *The Donkey Show*, which had been previously designed but the designer was moving on to other projects and we got to design it at the [Adrienne] Arsht Center for the Performing Arts—the huge theatre there, on the stage and close the huge red curtain and make it a total experience. The thing that was so amazing about that is it's a black box with an entire fly-rail. It was dreamy for me; a total new model for a new space. It was just incredible to bring things down into the audience and change their sense of space because they had to respond to something interrupting it and it made for the best kind of dance party. We can do anything in that space, which made it very communal.

MIMI LIEN I just wanted to voice something—is there anything else you are interested in bringing out, because it's so rare to be in a group of just set designers. I'm curious, going back to this question of values and where the money goes. I've been involved in a lot of conversations about how to remake theatre. I'm on the board of SoHo Rep., and we were having this conversation about this dream of paying the artists for a season where there's no stuff and all of the budget that goes to the set and the costume would go to artists instead. Climate-wise—rather than buy ten different options of props from Amazon Prime and just [using] one of them, or none of them—to basically value paying the people. I'm 100 percent on board with that, but at the same time, the stuff is what I work

Set Design by Collette Pollard, *A Streetcar Named Desire*

with—the stuff is my tools. I get very excited about designing the paths that people take and how to divide up an existing space, but there's probably a limit, there's a million things you could do. But I have found that I'm a person who has expensive ideas. It's just a conversation that's come up recently for me that I feel conflicted about.

COLLETTE POLLARD I just don't know why in the world we can't take a percentage of something and put it in one place and another percentage and put it in another place—and the value is in the percentages. If there's more of the money going to the artists and that value is higher, then it clearly values the artists. It doesn't mean that there should be nothing to make with, I don't think, unless you approach it [with] using stuff from your home, using what you have. I was constantly like, Why is my $500 fee staying the same and my budgets are getting bigger and bigger and bigger? And I didn't feel valued in that. I felt a little mortified when the budgets get bigger—there's maybe more you feel like you can accomplish, but really, the problems get bigger, the workload gets heavier. It's not always the case that a bigger budget just means that then you can do your idea. It's so out of balance with what someone is paid and what they're asked to work with.

I've talked myself out of so many set design jobs—this is something about space, too. I actually don't go into a space first, I doodle, the most terrible little doodles. I always show them to my students [and] they feel so much better about themselves.

It's the ugliest little thing. And by the end of it, it looks exactly like the set. Often, I have these little doodles that are the idea and—this doesn't need a set, this needs the black curtains and the reveal on the cyc [cyclorama]. It's still set design and it's still scenic materials. It does render a different relationship than maybe some teams have been comfortable with. I'm constantly collaborating [about] what idea tells the story the best in this moment and if it's not scenery, let's not spend it on scenery. I've been criticized for that like, This design looks like the theatre was empty. Yeah, because we decided to put all our money into the people that were tapping for two hours and what was under their feet was actually really important, and I'm okay with you not seeing that because I know we did the right thing. And the story was amazing.

MIMI LIEN So maybe if you take the entire budget—instead of the production manager deciding that there's $30,000 for the set and $15,000 for the costumes—if you handed over the budget to the creative team.

MARSHA GINSBERG I was going to circle back. I think that the problem right now in American theatre is that it's really ceased being about artists. It is a really important question in terms of how can we bring that back. And it's really interesting that, in this discussion, most of us have worked in both big spaces and small spaces, and all the spaces we are saying that we liked are the small spaces. So, the small spaces [are] where you have experimental work, you have work by emerging artists. You also have work by people of color. It's really the site where I would say the most interesting work is happening. This idea that we should be paid less makes no sense, because the work we do is not any less. It really comes down to asking the theatres to shift—just because the main stage takes in more money doesn't mean that artists who work in this other venue should get less money. **Stop making the second space seem like it's a bad space. It actually can be the fucking best space, you know?**

COLLETTE POLLARD Why not put the main stage show in the small space and let the youth show not be on top of the set of another show—which sends a message in terms of its value. Design it in a huge space that supports it and makes the next generation feel as amazing as possible, right? Why aren't we doing that? It sends a really clear message of what we value.

Shing Yin Khor, *The Last Apothecary*

Shing Yin Khor, *The Last Apothecary*

FINDING NEW SPACES

Deb O / Louisa Thompson / Shannon Scrofano / Shing Yin Khor

July 9, 2020

MAUREEN WEISS You do so much, Shing, and you've really carved such an interesting career. I'm always proud to share you with my students, which I do all the time. I show your tool drawings and I put them in the shop. My TDs are always so thankful for them.

SHING YIN KHOR That's hilarious. I should finish more of those. I think that's why I largely quit theatre. I still do it, but now it's more installation first and theatre when it comes up. It's just the fact that I felt like I was doing a lot of work and I wanted a lot more control and I wouldn't get that control unless I was running my own production crew and leading my own projects. I'm older now, but when I was younger I definitely had that chip on my shoulder where I'm doing the work, I'm building all this shit. Why am I listening to an old man tell me what to do? I had a

Design by Shannon Scrofano, *House Music*

good, long string of all elderly male directors that I was working for, and I was like, I'll just do my thing, I want to lead this project. So, as it turned out, you can just do that!

MAUREEN WEISS Yeah, I love that you just did that because it did open up a really good path for me to show my students.

SHING YIN KHOR It was surprising. I was not expecting it. I'm actually scaling down again, mostly because taking an entire year to build one large-scale installation is a long time. I was already scaling down before the pandemic and now I feel like I'm doubling down on that a little more.

SIBYL WICKERSHEIMER Can you talk about how your set design education and background influences you in the installation work, and how it was a natural lead, if it was?

SHING YIN KHOR Absolutely. I mean, I'm essentially still building sets. All my installations just have solid set design principles behind them. The only thing I've removed is the actors. The thing that changed completely or let me see that this is a possibility—this is absolutely typical—but it was going to watch *Sleep No More*. I didn't follow any actors. I spent the entire time just wandering around the different floors. Specifically, I walked into the candy shop and there was an audience member there that stepped behind the counter and he was handing out candy and inhabiting this self-made role as the candy shop owner. So, we stood there and we ate candy with this other audience member. Since then, I've been fascinated with creating spaces that implicitly invite that kind of engagement. **How do you walk into a space and immediately start interacting with it? What are things that call you to it?**

I've been doing more urban exploration, so abandoned spaces really play into that. I've been exploring counters specifically. I put a counter in one of my installations, just to see if people would automatically play—and they did. People would walk in and they would step behind the counter and they would be like, Alright, I now own the space. How do you invite audience members to play? Everyone understands when you step behind a counter you automatically fall into the role, right? Whatever that role happens to be. Some people became herbalists some people became apothecaries, some people became just really standard pharmacist-type people.

SHANNON SCROFANO I have always been someone who wanted to look at the norms of practice and the norms of survival, and then the standards of how you enter and then maintain your position in the field. I've not wanted to be ignorant of those things. But I've never been that interested in them. My career has had these invitations to do something a little bit differently in this mainstream center [and] then just being so disappointed or bored or frustrated with the amount of work it takes to work differently within systems, particularly regional theatre systems. I went through a period where I was trying to work within all these different regional theatres to do more proper process-based work, and it sounds kind of naive. It seemed like there was interest from those institutions to try more

ensemble-based making practices or more devising-based making practices. Over the years, I've stopped trying, to a degree. I've developed a pretty satisfying set of collaborators and invitations and practices to be able to keep making work with my training and with my commitment to what set design might be. Systems that don't want to have anything to do with anything that isn't exactly what they already know—and maybe that will change. Maybe the fault lines are cracking open enough that there will be some other possibilities.

I really can see that at the edges, things are destabilizing right now. But I don't know how these big places do it. I was talking to a friend the other day who was a football player in his younger days, and we're having this conversation about football owners and the complaints about how much football players are paid by ownership. But there's no football without players, and there could be football without the owners. I feel that way.

I don't do well in super mainstream situations because this is my face. I don't have a poker face. I really feel pretty strongly about these failures of our institutions that are so generously giving us the invitation to come and design this thing for $3,000 for six months of our life and everything else.

MAUREEN WEISS Did anybody read the article by David Zwirner in The New York Times about art right now? He ends it with—most of his artists, you know, most well-known artists right now are holed up making work. Like, that's what they're doing in this moment. But for me, I'm like, it's not how I make work, right? I don't isolate and create something.

LOUISA THOMPSON There are two conversations in this, layered up. One is the pre-Covid institutional realities and, two—I'm thinking about the hired gun gig economy that we're automatically assumed to be a part of even though it's not a means of living. Many of us are teaching and doing other things to support our incomes and therefore actually are under two institutional bureaucratic systems simultaneously. The academic structure feeds the theatrical bureaucracy [and] how that privilege creates access and creates a scheduled pipeline of how people are going to work, and when they're going to work. And the fact that those two kinds of bodies don't actually interact is becoming more and more clear to me. I know personally, as a designer [who has] been teaching for eighteen years I've been smashed between those two calendars. Just because the gig economy won't be flexible around the academic calendar [and] the academic calendar won't be flexible the other way, so it [has] limited projects. I've literally had conversations like, You already have tenure, you don't need to do more than a show a year. Completely disregarding any notion of what the relationships are or why certain opportunities are actually beneficial to the university and how they could be even more beneficial.

I know I'm saying a mouthful, but I'm looking to let it all sort of fall apart right now. When it comes back, I actually feel this need to respect a space that's opening and not rush in and fill it. I just personally feel like this may not actually be my space to fill right now. I don't know whose space it is to fill. I've spent the last five

Set Design by Louisa Thompson, *Blasted*

years shifting my work into the world of theatre for young audiences (TYA). I just prefer the conversation and the art, frankly, both internationally and selectively here in this country. I'm drawn to the fact that TYA, consistently, is interfacing with education. It's consistently interfacing with the notion of who the audience is and who has access. It can't not think about that in a way that I think major theatre institutions in this country take for granted, and therefore take a certain form for granted. I'm really looking at those two [models]. I want to see how those [academic and institutional entities] start to speak to each other in a clearer and better way, because too many people are leaning on those [academic] jobs to survive in the theatre economy. The way that students get mish-mashed and false promises through that, I think it's a sham. Not the space of training and creativity and sharing knowledge, all of that I believe deeply in. I just don't know what systems we're all trying to say are so successful that you should spend thousands of dollars to do it. And, because of doing this TYA work lately, I find it's fascinating that I can't imagine an MFA program in this country assigning a play for young audiences to its grad students.

DEB O When I first thought about teaching, I thought that I don't want to teach. Like, how many of them really can truly go out there and do set design? There [are] not enough places. I hate to—they're wasting their money. You know what

4. Space 191

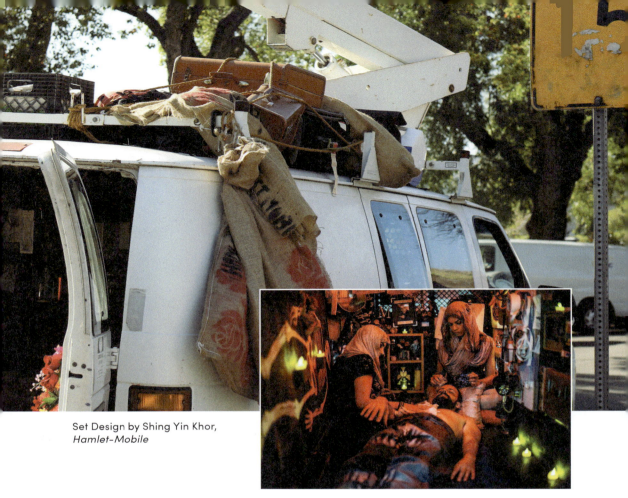

Set Design by Shing Yin Khor, *Hamlet-Mobile*

I mean? I'm sure that somebody will do it, but I don't know who and so I got all upset about that. But then afterwards I thought, Oh my god, NO! I am going to be teaching them critical thinking skills which will be used everywhere. They don't have to do it in that line, that field. Because when I was teaching, most of the students that were coming in had no critical thinking skills and [having] to develop those was going to help them in life always.

SHANNON SCROFANO And critical seeing, too.

DEB O That goes in with it. Seeing is part of thinking.

SHANNON SCROFANO We honestly have rebuilt undergrad programming around exactly this. We have really shifted to say, We believe in this training. This is why we believe in this training and this is where you can point it. We have a partnership with a company that makes spontaneous place structures. It's a nonprofit, and we are doing collaborations with them where undergrad students are looking at what they're learning about, you know—time-based experiences and stories, dramaturgy, gathering folks—and how to put [those] into different

kinds of contexts that are not just the context[s] that start with a dramatic text. It's pretty exciting. It's still anarchic and the paths aren't clear, and the demand—the sources of demand for those skills aren't always obvious. But we make progress. Some of my students make more than I do fairly quickly out in Los Angeles, admittedly. If they don't go into theatre.

LOUISA THOMPSON A couple conversations I've been in recently have gotten me thinking a lot about these ideas of how we speak to students about self-generated work, new forms, and what is creative producing, right? How producing is sort of a design problem. And all of that is amazing, but what I then find is that there's this cliff moment where you go, Okay, I can see what I want or what I'm going to make. Then there's a, Oh, I guess I'm in this sea of other projects seeking the same resources or spaces or whatever, and I don't know quite where I fit in. Right? **I've been thinking a lot about partnerships lately and about this funny binary of, are you an individual artist or collaborative artist?**

But I'm also really interested in—Deb, you've had this experience way more than I have of being a collaborative or individual artist who then partners with another pre-existing organization that has other resources, skills, knowledge, that benefit the work and is thinking almost spatially. I'm thinking about social justice organizations, I'm thinking about educational organizations—that they occupy other types of performative spaces serving other audiences. How do we teach our students to see themselves as travelers?

MAUREEN WEISS Right. Well, Shing Yin, you left grad school and you entered Burning Man. So, do you want to speak about that space and making work in that realm?

SHING YIN KHOR All these questions are also questions that the more indie, immersive art, and theatre communities [have] been dealing with for some years now because we've been losing our spaces. It became extremely acute after the Oakland Ghost Ship fire, so now working in warehouse spaces and working in spaces not meant for theatre has gotten more and more difficult. I think a lot of the shape of Los Angeles immersive theatre has been shaped around that in the past couple years, you know. People are sort of throwing guerrilla shows at bars. Things like, Well, what do we have in Los Angeles? We have cars. What if we did theatre in our cars? And I think, Maureen, you did one almost twenty years ago where you [drove] through LA in a car. And that basic structure has been replicated so many times. There's so much immersive theatre happening in small spaces that are just carved out of nowhere.

I found my way into installation design largely because I wanted to get my hands dirty building again. I was already going to Burning Man, and I applied for a grant and they gave me lots of money to build a large structure in the middle of nowhere. Then I got a taste for it, so I built more. But clawing out these spaces, like Burning Man, is not a place that most people want to work in. Having to build your own scene shop out in the desert out of a box truck in hundred-degree heat—it's not fun. As I'm getting older, it is also not something that I want to do for

the foreseeable future. It's something that the immersive community has been processing a lot in the past years, even before the pandemic.

I think we're all thinking towards things like how do you create theatre in the home? The Geffen [Playhouse] did that magic show recently where they mailed the audience a box. I didn't watch the show, it sold out really quickly, but that concept is really fascinating to me. It's already something that lots of people are processing and thinking about. What fascinates me most about that is how do we bring an extremely high level of production design to it when people are in their own homes? How do we bring what we do when you can't just build a set in someone's home, but maybe you just kind of can?

I've only been able to identify fairly recently how much the lack of liminal and transitional spaces has affected my work. And it's because I went on a one-hour drive yesterday and had an idea— something which hasn't happened in four months. I've had no ideas in four months. And yesterday I had to go pick something up and it took an hour of LA traffic and I was like, Oh my god, I have an idea for a thing. We are switching between our personal and professional lives with no transitional period whatsoever and the loss of that space is what has affected me more than anything else. There's no time that doesn't matter anymore. Like, all time matters. The point I'm getting to, I think, is we've been trying to figure out what theatre means when you don't have space. We didn't have physical space for a while now.

MAUREEN WEISS And what about money?

SHING YIN KHOR And money. This is forcing our hand. I think that theatre has not really grappled with the lack of money and, especially, how to do high-quality productions with very little money. I think part of what small-scale theatre means is how to create those high production values at large scale. Or, in a sort of mass-produced scale.

MAUREEN WEISS When I'm teaching my students, I feel bad because I'm not teaching them for now, I'm just teaching them for the future. And my hope is that we unsettle enough that they will be geared for this unsettled place. I'm hoping— and this generation that we're teaching right now, they were educated poorly until they got to us. They were educated to think that if they studied the test and they studied the rules they were going to do okay. Then we get them and we're saying that's not the case. I have to teach against that a little bit. I noticed from my own kids' generation—they are actually being taught more about this unsettling. I think that by the time that we watch this movement happen we're going to see a better space. I don't know if that's true, but that's sort of what I think when I'm teaching.

SHING YIN KHOR That makes me incredibly hopeful. Every time I meet kids—like, I taught summer camp a couple years ago and they were brilliant, you know. Yeah, just that they're evolving and catching on to ideas about social justice and sexuality and feminism at a pace that I did not experience in school. And the summer camp I taught at—it was a summer camp that builds things. They gather

a hundred kids together and they build a piece of art. And they were able to synthesize a lot of the information that was coming in and to continue exploring it outwards. I still follow some of these kids on Instagram and they're not just going to protests—they're running their own zine collectives, they're starting their own community gardens, they're doing theatre. Like, they're just making their own stuff at sixteen and seventeen and it's amazing. I love it.

MAUREEN WEISS I mean, it was almost four years ago, but when Trump was elected and I walked into my classroom, they were not fazed. And they didn't vote. The students I have now—they are fazed. I'm really hoping that part of this is about the students that were not paying attention.

DEB O It was an assignment in my class that they had to vote. We had to talk about where they went, what it all felt like, what all happened and who was running. All that stuff. We had a big conversation.

SHANNON SCROFANO We did a design challenge. They reinvented voting in an hour and in pairs—it was right before the election, and it was pretty radical. It was cool.

MAUREEN WEISS But then what happened, what were their ideas?

SHANNON SCROFANO Honestly some of their ideas, I was like, Who do I mail this in to? Because, goodness, we really need to. I mean, the nice thing is [that] you witness that activation sustain in different ways over some time. I also just wanted to say, Shing, when you were making a list—you're saying they're there, they're doing theatre, they are planting community gardens, they're making zines—I actually saw that as a colon after "they're doing theatre."

SHING YIN KHOR Yeah.

SHANNON SCROFANO And that made me feel good. I really think those things are our theatre. Not trying to own everything, just trying to figure out what's in the soil.

We need to be more like a good wine cellar. Like, some wines are best two years out and some wines need to be sitting there.

LOUISA THOMPSON It's making a lot of people anxious, but I think it goes along with [letting] people come in and do something in a space that's sitting empty. Why does somebody hold the keys?

SHANNON SCROFANO I just want to say because you asked us that question, how can we use space to speak to the moment that we're currently experiencing? And I have been thinking about it. I am really a believer in we produce space, space produces us. It's very dynamic. It's very fluid. And I'm just really interested in what that means to us right now. What spaces we do have? I also just stopped working and building at some point because I couldn't handle this little box. [gestures to the screen] The box doesn't have the accident in it in the same way. It doesn't have all of that ambiguity that I really get excited about.

4. Space

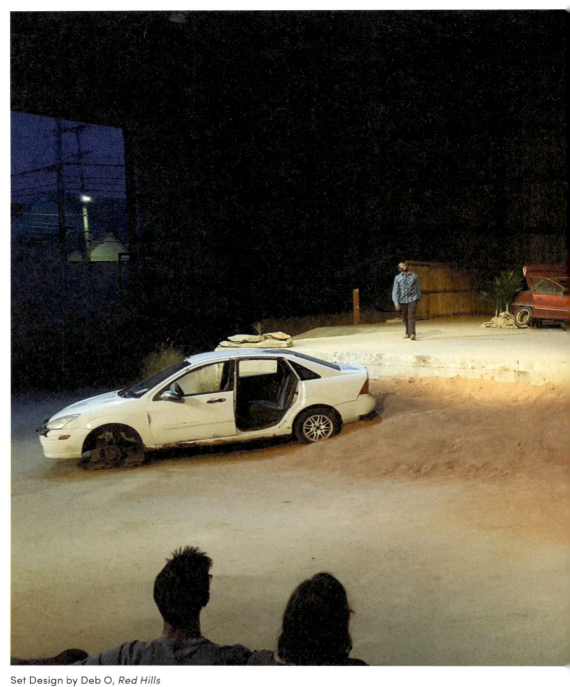

Set Design by Deb O, *Red Hills*

4. Space

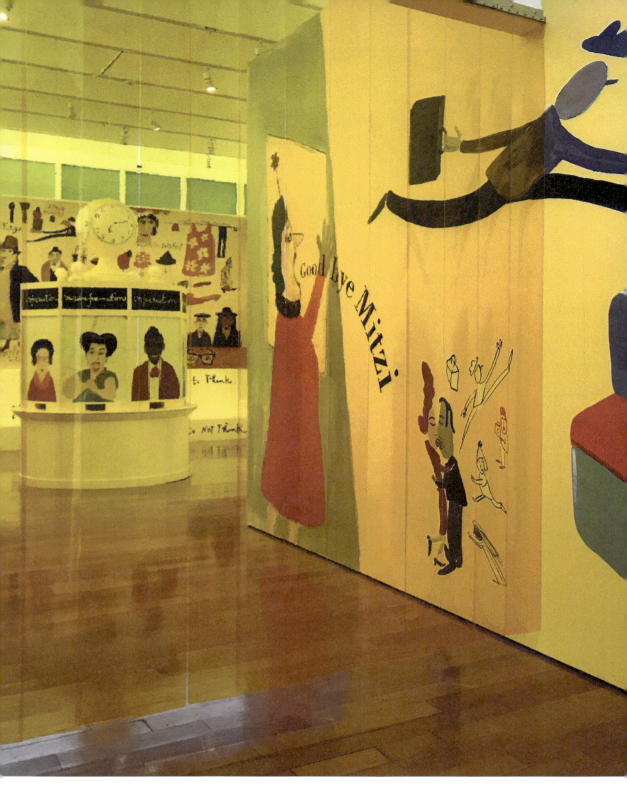

Exhibit Design by Louisa Thompson, *The Pursuit of Everything*

SHING YIN KHOR There's this whole generation of people that have been designing for digital mediums for a good, long while. I've been watching all these miscellaneous TikToks. These are all largely teenagers and the sets that they are creating to do these, like, thirty-second performances happen to be getting progressively more complex. And same with game streamers—they're creating these environments to perform in. If anything, we could learn a lot from that. It's something that still feels a little bit foreign to me and I feel like I'm generally more plugged into that space than a lot of people.

LOUISA THOMPSON When I was in graduate school in the Ming Cho Lee Land, this notion of—we come to the theatre and see how the pure, clean, simple kind of set became so that the play can sort of happen in it. That sort of teaching, that's an approach. And then I'm looking at all of you in these little Zoom windows and there's so much detail, right? There are little pieces of paper and light and it's really busy, but also sort of satisfying. This realness. And I just have to share with you that I had this one moment, probably ten years ago, where a prominent male set designer came through the theatre—somebody told me this secondhand—but he came through while one of my shows was sitting in the theatre and said to somebody, Only a woman could do this. Because it was full of shit, it was just full of details and crap. I'm just thinking about all this in terms of the spaces. It takes a lot of energy and time and multitasking to pull together a lot of disparate little pieces and parts. It takes a different sense of how you interact with space. I'm just so curious, after being in our homes, are we going to go back to some sense of get rid of it all, is it too much? Is it a reflection of this overused and poorly maintained stuff? Just so much stuff. But, I also love stuff. I feel like it's what I can get my hands on and make claim to, have a relationship with. I'm thinking not just about space, but the stuff that makes up spaces.

MAUREEN WEISS I love how you spoke about the male designer walking through saying, Of course a woman designed this.

LOUISA THOMPSON It sounds so binary and dumb—and why do we have to be having that conversation? It's patronizing. I feel gross bringing it into a sexed-out moment but at the same time it's stuck with me for a really long time. What does that mean? I am sort of paying attention now in terms of who is willing to expose themselves in the midst of their life—details and who has a backdrop, or who has a curated—

SHANNON SCROFANO Yeah. What a privilege of having no interruption.

LOUISA THOMPSON Interruption is a great word. I love that word, right, because my stuff interrupts me all the time and I have to have constant conversations with my stuff like, Out of my way. So yeah, I love that. I'm not saying anything other than it's just making me think about what will we feel about stuff, coming through this? Like, who knows?

SIBYL WICKERSHEIMER I imagined Ming Cho Lee's classes to be that he just takes the model and rotates it: Oh, no, this is more interesting because now we've disrupted it. But that isn't enough anymore. That's not enough disruption.

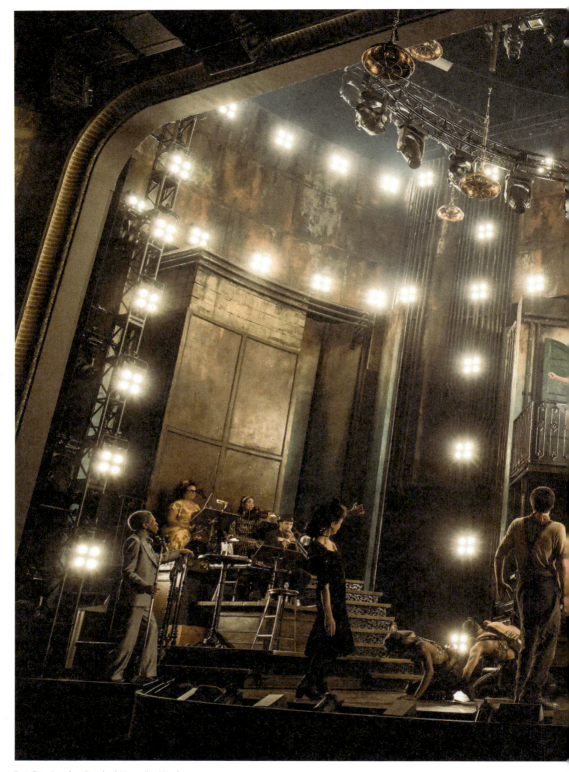

Set Design by Rachel Hauck, *Hadestown*

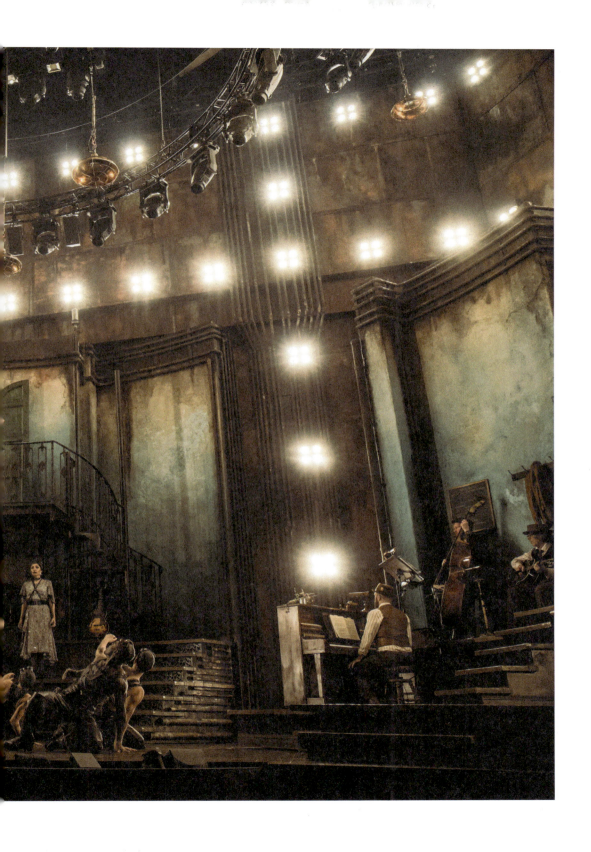

4. Space

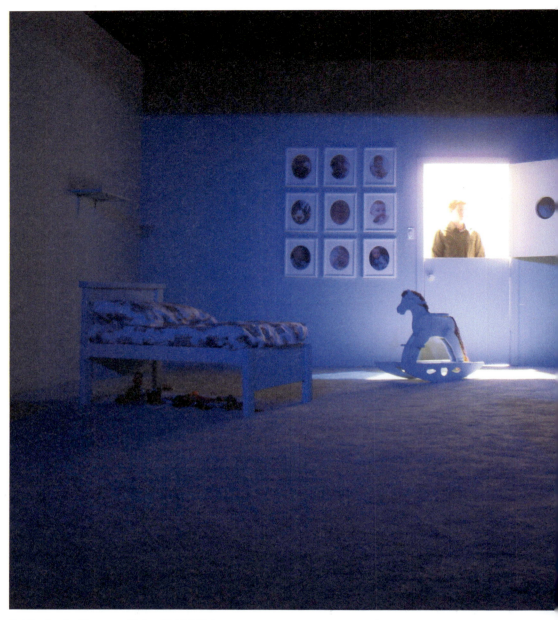

Set Design by Maureen Weiss, *Rabbit Hole*

Disruption, to me, is telling the audience, You're not going to experience this as you thought you were going to experience it. And, whether it's outside or not—but in a space where the audience has to kind of let go. They're really expecting a set on stage, whether it's messy or clean. That's what they're expecting. I don't know that we need to give that to them.

DEB O I haven't been doing shows in theatres, and so is that my disruption? **I hate fucking black velour legs and all that shit.** If I do have to be in the theatre I, like, rip everything out. It just pisses me off those stupid little flats and all that. I can't do that shit. And that's why I think a lot of my jobs are not normal, they're not hiring me for normal theatre either.

SIBYL WICKERSHEIMER That's why I'm glad to have this moment with the students where they can't be in a theatre. Because, actually, it's problematic. They're being asked to create what you hate, right?

LOUISA THOMPSON I know, it's sort of interesting, right? Like, is this a moment where all of us as designers should be going in and cleaning the floors of stages the way that you would wash the stones of an altar or something? Well, on one hand we're talking about rejecting all these spaces. On the other hand, there's something about sacred spaces that have this potential.

MAUREEN WEISS I don't miss the traditional parts of it. I miss the congregating.

SHANNON SCROFANO But it begs the question—what are invitations going to look like? They're going to have to start to change what they look like.

LEADING THE STORYTELLING

Andromache Chalfant / Rachel Hauck / Tanya Orellana

July 14, 2020

MAUREEN WEISS Does the center have to be the playwright?

TANYA ORELLANA I think it can shift. Saying anything is a singular way is a little difficult for me because every collaboration feels so unique and feels like such a new partnership every time. I've certainly been in situations where it's director-led or designer-led.

ANDROMACHE CHALFANT A play is on the page, it's not a complete thing. You can read it as literature, for sure, but it's meant to be performed. It's meant to be a collaboration of multiple parts for it to actually be. It's only one part. Being a self-generative artist is a different act, or a different process. When I'm engaged with the text, to me, it's this exciting map to pull from and respond to and react to. There is some subversion going on even with the director, where there's enough respect and understanding and belief in the voice of the playwright, but there is also a way that we have to understand that we can maybe express something non-literally. It might be challenging for a living playwright to grapple with. A lot of times the director plays the role of blending those voices together and creating a safe enough space for that kind of exploration, back and forth, and synergy and synthesis to happen.

RACHEL HAUCK Yeah. This is one of those topics that you can spin sideways so, please spin me back. I think what Tanya said is 100 percent right—it's like, there's no one way. There's no single path. It's a breathing art form. And it's genuinely collaborative. I always look to the playwright first in the same way that when I get lost in the middle of something I always go back to the text. It all has to be born of that. There [are] so many different ways that can look and still honor that text and that's the art of what we do. That's a huge part of the conversation. I could design the same play for five different directors and it's going to look five different ways.

I don't think that I am ever leading the room. Do you know what I mean? But what we do as visual artists is a huge part of that room. Watching an actor in a rehearsal room, which is often the purest performance—that last run-through before we get our hands in there, you know. That, in the same way that watching an actor change the day they get their show shoes, is amazing. Watching the character appear. It also is true that when they walk on the set—**the second an actor walks on that stage—you can see it in their body. I always feel whether or not I got it right, whether or not we've put them in the most powerful spot in the room.**

It's fascinating to me how much within producorial teams we are both respected and dismissed. I always find that fascinating. I did a show recently where we couldn't have been more praised during the process. Then, in this teeny, tiny theatre, we arrived on opening night, we were seated in the balcony to make space for the fancy audience members. I just remember being shocked how much that dismissed the contribution of the designers, having just received so much praise from those same people and how much they recognized—because the designs were not shy—how much they recognized the designs shaped the story and then didn't, you know. It's very complicated. When I speak to audience members it's always interesting to talk about how, when an audience comes in and sees the design. The design feels like a given. Nobody knows how to talk about what directors do, nobody knows how to talk about what designers do, it's complicated and it's interwoven—it's deeply interwoven.

MAUREEN WEISS I want to say, Rachel, my daughter got to see *Hadestown* and, you know, what stood out to her was your set.

RACHEL HAUCK Oh, that's amazing.

MAUREEN WEISS And she could speak so clearly about what your set did, and didn't know why she was affected, but [she] could see it was because your set transformed. I was surprised at how clearly she could speak to what you're set did. Of course, she was raised by a set designer.

I guess my thing is—it's rarely noticed that it is the visual that takes you there, right? It's very noticeable when the music takes you there. It's very noticeable when the actor takes you there. I personally am so thrilled when it's really noticeable that it's the visual and you see a transformation in a time that's different than everyday time.

RACHEL HAUCK It's true. It's also trusting that the visual world can tell a story in a particular way and have a particular effect.

ANDROMACHE CHALFANT How does the model fit in to this conversation, like, if you have a director who's engaged with your model? What you're saying about the playwright, I think, also stands for designers in the sense that we're not creating a closed system. You know, it's got to remain open so that—what is a finished model, really?

4. Space

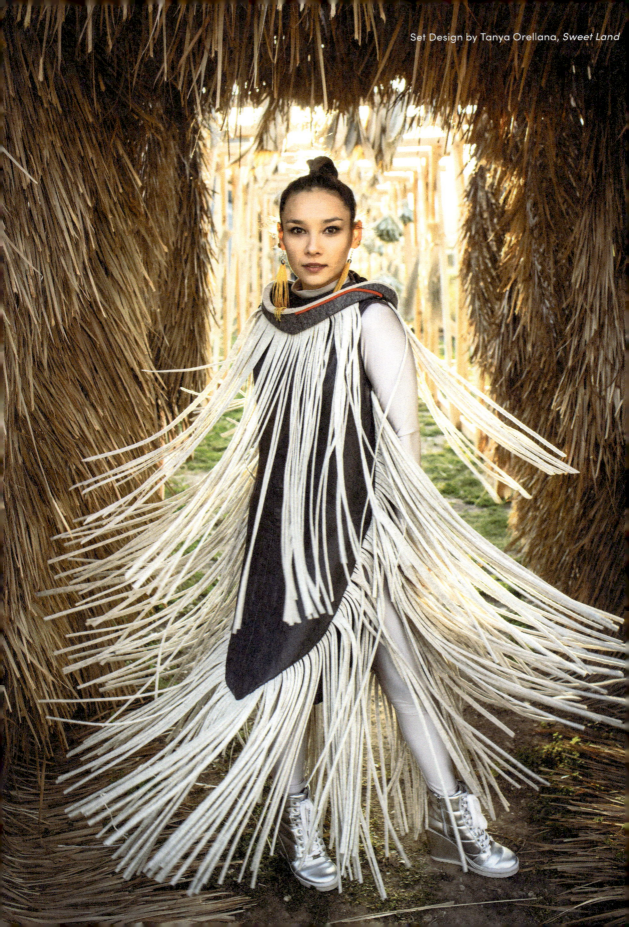

Set Design by Tanya Orellana, *Sweet Land*

SIBYL WICKERSHEIMER I never say that anything's finished. I've taken the word "final" out. I don't want to move past the model question, which I think is very important because it's the thing that is touchable. For directors you can say, Break it, it's fine. Because often you'll get, Oh shit, I broke that! It's like, No, just break it. We can remake it. The need to visualize the set transitions—I find it very intense. And sometimes I feel that responsibility as a weight and sometimes I feel that responsibility as empowering.

MAUREEN WEISS And also, the directors—when they get the model—they love it because they have full control and it's their little dollhouse. And sometimes I'm very aware with my directors who's going to just love that so much that, when they get the big thing, they're going to be let down. [Rachel laughs] And so, [with] some of those types of directors—I can't give it to them because it's just never going to be that cute little thing that they're really enjoying having control over. It's going to fall apart in different ways. When it's bigger, the glue won't pull it together.

RACHEL HAUCK Right, right. I find the model invaluable, [and] as Andromache knows, I am obsessed. That's the way I create it. That's the way I work—I have to get my hands in it. I couldn't have chosen a more labor-intensive way to design. I find that the sculpture of that space and sculpting that space through the model is useful. I have done an awful lot of stuff that's very, very minimal. Of course, everything is dependent on the lighting designer. I know that I am handing the lighting designer a canvas of some sort. I need them to be interested in what the "thing" is in the set. Knowing who the lighting designer is affects the design of the set for me.

You get into tech and the lighting designer shows you what you made, which has happened a few times like, Oh, you've taught me why I made that choice. Which is a stunning experience. It works. It works!

SIBYL WICKERSHEIMER I really think the lighting designer has a huge part in whether it works and—

RACHEL HAUCK —when it's not working. Completely. When you get something you're like, Oh, I can see why that doesn't work. But I can't be like, If you just did *this*. I don't have that skill.

If they [the lighting designers] are not responding in a pure way to the text [then] that's a different conversation, you know? Or if their vision is different, or they see a different thing than I saw, or the director sees a third thing, or—

MAUREEN WEISS —they want to add a lot of gobos.

RACHEL HAUCK Well, gobos are evil. If there's too many gobos, you're fired. I mean, that's—

MAUREEN WEISS I put it at the bottom of every design contract, No gobos, please.

TANYA ORELLANA This goes back to the question of the playwright. It's not so much obsession with what the playwright has written as much as it gives a subject for

Set Design by Nina Ball, *A Midsummer Night's Dream*

the conversation to center around. If some people in the group have done the work and know a lot about that subject, it's a much better conversation. If everyone is making the same point over and over again, it's a boring conversation. Every designer—bringing their perspective into it. I agree, I've had the similar relationship with lighting designers where—my wanting to ask questions is not appreciated. I don't understand why. I think it's the pressure of the quickness of tech where we've been spending months discussing—

It's important to say [that] it's okay for us to have conflicting conversations during tech. Yes. In a positive way. There's a way to do it without judgment and there's a way to do it to engage the person to keep pushing the conversation. The same way [that] if I disagreed with someone on the point—hopefully, if they disagreed with me we would just keep talking. With Campo Santo, my relationship with that lighting designer is amazing. We've known each other for so long. We're just kind of blunt people in process with one another. The work we do together is amazing because he'll just say, This thing here is not working, Tanya. I feel [I can do] the same about his work, but that trust has taken ten years to build.

ANDROMACHE CHALFANT I actually think there is a storytelling aspect to the relationship between set designer and lighting designer. I'm mostly in the collaboration closest with the lighting designer. What the lighting designer adds to the story of the set is temporal, it's movement in time. Otherwise, the set is just still. In a way, you are telling a story together that moves in time.

RACHEL HAUCK Completely. Yeah.

SIBYL WICKERSHEIMER I never know I'm on to something until I move the light around in the model box.

MAUREEN WEISS Me too. Maybe that beholden-ness is awkward in the relationship. If it doesn't get there, then I can't do anything to change this shape right now.

ANDROMACHE CHALFANT Right. When I have aligned with the lighting designer in a set idea the temptation is there to really collaborate on the set as a light piece. If I've not been successful in that, in fact, it's been pretty disastrous.

Set Design by Nina Ball, *Who's Afraid of Virginia Woolf?*

4. Space

MAUREEN WEISS There is an economics with tech that started to happen. I do find that it's not flexible enough for me to get where I want to get with a lot of plays. It's that there needs to be all these answers in those weeks that don't allow for mistakes.

RACHEL HAUCK One of the things that's so exciting about these conversations that we did for years at the [Eugene] O'Neill [Theater Center/National Playwrights Conference]—which is about sitting down directly with a playwright in the very early stages of their play and helping them to picture for themselves the world in which their play takes place, as opposed to writing it into a void. The point was never to catch somebody in a thing that didn't add up from A to B, but rather to help them as their play was evolving and help them see what the world was, What's exciting to you? When I'm teaching, I'm often talking about how a text is a mystery, and you are discovering from characters whose room it is and how it feels.

MAUREEN WEISS There's just something about me that's interested in not having a hierarchy to it at all. When we put preferential treatment on actual language and the playwright, or the play, what we are beholden to is written language. If we were to change that up, how could it change theatre?

Set Design by Regina García, *El Paso Blue*

SHIFTING THE NARRATIVE

Nina Ball / Regina García

July 16, 2020

NINA BALL Some of my favorite collaborations—it wasn't even just me and the director, it was me and the director and the other designers just what if-ing and playing around.

I really do try to be very, very open, very malleable throughout the process.

I don't know if you feel the same. Sometimes those first ideas are really the right ones. You hit something and you're like, I feel that. I love that part of it. I love that feeling that you're understanding this world and digging into who these people are and what their spaces are. My favorite part, really, are those first "aha" moments.

MAUREEN WEISS It's a lot of psychology in those first months—

SIBYL WICKERSHEIMER Yeah. After working with the director [for] the first time I always want another opportunity right away. I feel like, Okay, now I think I understand the way you're speaking—your language—and I can have a better conversation with you now that I know you. But you don't always get another chance.

NINA BALL Totally. Oh my god, I've had some experiences where at the beginning I just thought we are not hitting it off, this director and I do not see—I don't know what they want. Everything I showed them is never right. You're just so frustrated. Yeah, but by the end it's, When can we work together again? It takes some time, these relationships that you have to build. I've been lucky that I've worked with a lot of the same directors. That trust and shorthand really makes all the difference.

MAUREEN WEISS It's usually on the second show that you're able to get to that level.

REGINA GARCÍA My initial conversation with the director is then one where I propose several scenarios and I prepare each one as a package. Do you find that they're more resistant to the analog idea, always? The low-tech bit? Maybe this is something that I changed once I went through the model at OSF [Oregon Shakespeare Festival] for the first time. I really dig their request for a concept statement at the top of the process, even before preliminaries. I really

Set Design by Sibyl Wickersheimer, *The Unfortunates*

appreciated that. I've incorporated it into my conversation with all TDs—Here's my big three bullet point thoughts about this project, what I think we are trying to accomplish. It gives the TD a heads-up about the big conversations. If it's not one of those three big bullet points, I'm a little bit more flexible with it but it's also a way for me to give them a heads-up that these are not flexible.

SIBYL WICKERSHEIMER In terms of leading the storytelling—I'm way more flexible with the director than I am with the shop.

NINA BALL I mean, yes and no, right? It's always a give and take within the shop, especially if we're talking about the budget. The "how" it's going to be built. I like being flexible, but I also like them knowing that I know what the hell I'm talking about, you know, that they know that I thought this out.

It's a FINE LINE when you have to turn on the bitch, you know, and you hope you don't have to, but sometimes it comes out. I have to check myself on that if we do want a true collaboration. **How do I make sure that I'm not protective, that I'm not letting my ego get the best of me so that I'm not listening to all the ideas and all the possibilities?** It's hard sometimes. I can definitely feel myself just cringing in meetings.

4. Space

Collage by Christine Jones, *Spring Awakening*

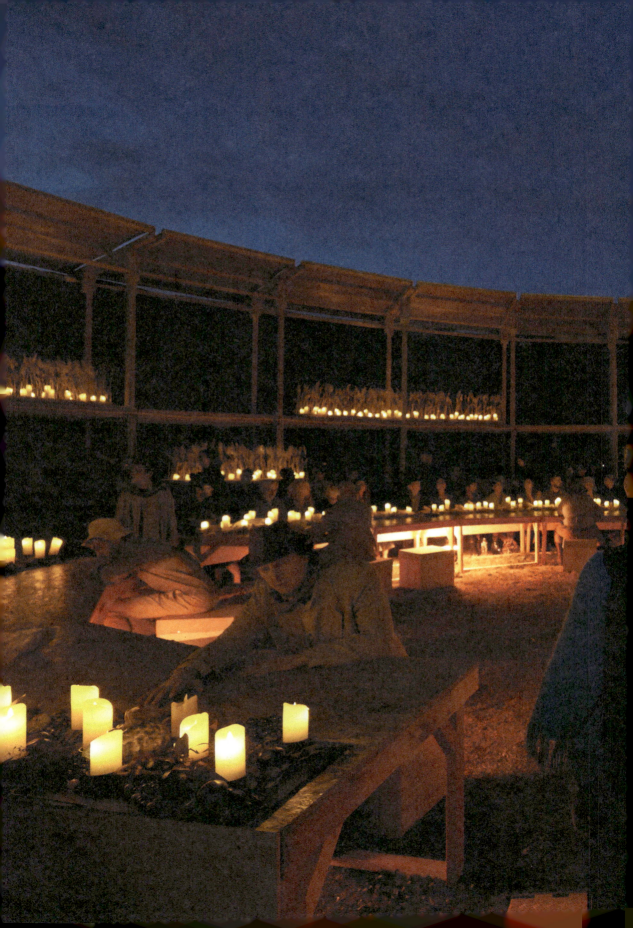

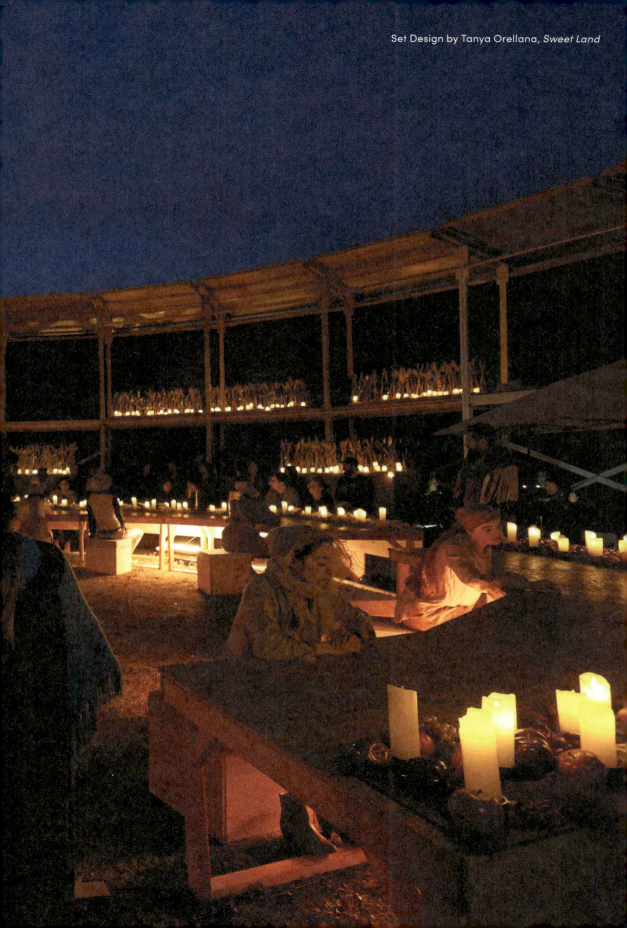

Set Design by Tanya Orellana, *Sweet Land*

Set Design by Mimi Lien, *Natasha, Pierre & the Great Comet of 1812*

REGINA GARCÍA Interestingly enough, I don't know if it's a generational thing or maybe it's an OSF thing or who they hire, but the young women TDs are so much more interested in why I'm making choices. In case they cannot deliver, they at least know what I'm going after and they can propose new solutions if the other one is too expensive. I have noticed that in the last five years there's a little shift with the questions that I'm getting from the TDs and they, right now, they all happen to be women.

SIBYL WICKERSHEIMER Yeah. It's awesome. Is that a training thing? Do you think that they're being trained to do that or—that's an interesting question about the nature versus nurture.

REGINA GARCÍA I do know that there are more women in school right now for technical direction or scenic technology and they're very much interested in rigging and automation and all that. I know the numbers are up.

SIBYL WICKERSHEIMER Seventy-five percent of our TDs at USC [University of Southern California]—we have a BFA in Technical Direction—are women. It's awesome. They're pretty amazing. And smart, you know, it's not just about the fabrication. They're thinkers.

REGINA GARCÍA I'm bumping into a situation with the directors. After you've done the first show or maybe it's somebody, an actor-turned-director that knows your work really well, and they hire you to design—that they are not forthcoming with

information or they're too busy. But you still have to make the process work not only for you and the shops that will receive your drawings, but also for the rest of the team that's waiting for info.

When I was younger, I appreciated the space to create and then propose to the team.

Now as I'm older, I just don't. I find it harder. Harder to guide, harder to move the process forward without that exchange. But those directors are out there. I was just wondering if anybody had a strategy?

SIBYL WICKERSHEIMER To get to a strong vision for the show?

REGINA GARCÍA Yeah.

SIBYL WICKERSHEIMER **I'm constantly craving the trust to run with it,** but also needing a more stylistic approach. I'll share my super embarrassing sketches that are the basic, you know, doodles. Yeah. And you know, I just stopped caring whether or not they were embarrassing. I just throw them out there!

NINA BALL I love those embarrassing little sketches, like, we're embarrassed by them. But I find those little thumbnail sketches early on, where it's all over the place and you're grasping at thoughts, just sometimes the best ones. The rendering doesn't capture, sometimes, what that little thumbnail can.

SIBYL WICKERSHEIMER Have you ever seen Frank Gehry's sketches? They're crazy. They are just a mass of lines and there is a nugget there. You can see the shape that the building takes—

DESIGNERS ON DESIGN

Mimi Lien / Tanya Orellana

July 23, 2020

TANYA ORELLANA I'm just hypothesizing here, but there's something about theatre that, because it doesn't get a lot of government funding, it's just not a very democratic art form. The sort of taste of people who watch theatre tends to lean towards a certain direction, whereas in film there seems to be more opportunity for people that have what would be considered a pop aesthetic or something that's a little like, Oh, we understand this aesthetic from a certain world. I don't have the right words for it, but there's more room for that in a more democratic art form—we want everyone to watch this. And now we're going to allow for unique voices because they can reach markets. I don't know, everything is so money driven.

SIBYL WICKERSHEIMER Have you had strong mentors, the two of you?

MIMI LIEN Yeah, in terms of specifically female set designer mentors, I've been really fortunate. Christine [Jones]—she's just always been sort of a beacon and fairy godmother. I assisted her for one summer when I was in grad school. We had a meeting of souls. She recommended me for my first job out of grad school. That was the thing that then led to the other thing and to the other thing and was the catalyst for everything. My first-year teacher at NYU was Adrianne Lobel, and Anna Louizos was also around. **I felt like I was seeing a lot of female set designers working out there which, now looking at statistics, it's lucky that all of these people were in my orbit.**

TANYA ORELLANA I did not have that experience although that sounds amazing. The female mentors I had in my life as a young artist were not set designers. I definitely had strong artistic women in my life, but my main mentors have been

Shop visit with Jerry Vogt, You-Shin Chen, and Mimi Lien, *Moby-Dick*

my school mentors, John Wilson at San Francisco State [University], and then Chris Barreca at CalArts. I've been part of a company for twelve years now. Sean San José is a mentor of mine, the artistic director of Campo Santo in San Jose.

I was working at a place called Intersection for the Arts in San Francisco for five years and Deborah Cullinan, who is now the executive director of the Yerba Buena Center for the Arts, she was really a woman in my life that was always looking at my work and talking to me about it. One of the reasons I went to CalArts [was] because I was sort of searching for the right grad school and Deborah pointed me in that direction. But, yeah, I didn't have a female set designer. I met some great people, like Shannon Scrofano. She's the teacher in the undergraduate program, so it wasn't really as much of a mentor relationship.

MAUREEN WEISS It's always curious how you come to have an aesthetic. What is it? How do you protect it? Do you need to protect it? It's not an easy question.

TANYA ORELLANA I mean, Chris Barreca at CalArts has an amazing gift of seeing people's aesthetics and not crushing them. He could see when I was veering off course and when I was self-conscious.

The culture of the program is very into German male set designers. This is all work that I like, but a lot of the culture at the school made me feel like my aesthetic was too artsy and craftsy for them. I would sort of veer off course and think, Oh, this is what I'm supposed to be, because that student is getting more attention for steel structures. He would be able to see it and give really good feedback on it. I'm actually a big fan of how Chris teaches. I think the way that he

Set Design by Sibyl Wickersheimer, *Indecent*

Set Design by Sibyl Wickersheimer, *Indecent*

interacts with the world is the part that was harder for me. His advice for how I needed to carry myself in situations—I don't think that a tiny Latin woman can operate the same way a cis[gender] white man can.

I never felt like I had someone to show me. Well, I mean, Diane Rodriguez, who passed away recently. When I was an associate on a show she directed, she was great to watch. I remember thinking like, Oh, this is how you can be both confident and have demands for how you're treated and still be not seen as negative [or] like the other negative words that are used for confident women. I do remember saying, Chris, this is why your advice is not working. You don't know how I operate in the world.

MIMI LIEN I was just saying to someone yesterday that my third-year teacher was Eduardo Sicangco. His aesthetic could not be more opposite to what my inclinations were, but we got along great. And I feel like I learned so much from him.

I often get the question of what do you think is your style? And I don't think I have a particular visual aesthetic. Maybe I could. I could say that there's a particular approach, or a kind of goal of having something that feels like it's slightly destabilizing to the general thrust of the narrative—so, dramaturgical, it sort of pushes against things. That might be something that I tend to do. I'm pretty varied in terms of the aesthetics.

MAUREEN WEISS Have you noticed that you have a label that has been given to your work? That people assume what your design will be? This conversation idea evolved because we'd heard other people describe our work and we didn't agree with it.

MIMI LIEN There's maybe a kind of cleanliness or restraint—it's not my natural inclination to be super messy. If, sometimes, I feel like that's what the design requires it's not my natural forte and I have to summon something in myself to make it that way because I know that's what it needs to be. There's another thing that I strive for, which is essentialism. My design is good when it's really stripped down to its barest essentials, even if that means that it's a giant pile of garbage on stage. But that's still stripped down to the only thing that it needs to be. Maybe that's why people sometimes go to the word "minimalist," because sometimes that's what it ends up looking like.

SIBYL WICKERSHEIMER They're very different words, essentialist and minimalist, right? But they could easily be misused in categorizing a designer. We had a survey question, Do you feel like sometimes you're making too bold of a choice for the production? And Christine [Jones] said, Actually, I often feel like I'm not being bold enough. I love that and it says a lot about her.

TANYA ORELLANA Yeah, I love that quote from Christine Jones also. It's more about your point of view, it's not about superimposing a visual aesthetic that we've decided is our tagline.

Set Design by Mimi Lien, *Lost in the Meadow*

SIBYL WICKERSHEIMER What I like is actually the thing you can't see. I like to make some cracks and look through things. I find it more interesting to put the audience in a place where they have to look and move and try to see around things—to see through to what I'm keeping secret or what we're keeping secret as a production. Because it's active, because they have to try to find it.

TANYA ORELLANA I tend not to want to say, This type of thing is female and this type of thing is male. But at the same time, there are some markers [for which] those things are associated. I use a lot of textures in my work. I remember one time I was with another designer and we passed this house that looked like hippies had taken over it since the seventies. It was all these colors and it was not beautiful. But it had a lot of textures. And he was like, This reminds me of your work. What? What I do is a sophisticated use of texture and ideas, but this mishmash of textures has a certain thing that's been given a value and so somehow having to say, like, that's related and not related. Why wouldn't it be okay to say, I see a very feminine eye to this amazing work. But it's partially because that word has not been used positively.

MIMI LIEN Do you find it different working with female versus male directors?

MAUREEN WEISS Yes, but I find it different because I do think that with a lot of male directors, I think they'll okay a lot of my choices based on a niceness, like, I have to be really kind of sweet about it. It's a less direct relationship for me. But with women, it's very direct for me. Like, I like this thing. Do you like it?

MIMI LIEN I feel funny saying it, but it's almost the opposite for me. I don't know. Everything I'm going to say is going to feel like a generalization or something that feels wrong. I don't think I've ever really said these things aloud, at least with the male directors that I work with. I really like haggling—I really like a good, tough discussion about dramaturgy, the aesthetics. And I feel like I have those more somehow satisfactorily with the directors who I've worked with who are male. It might just be personality, it just might be that particular male director.

It could just be a personality thing, but I know that there's a couple of female directors that I work with who don't quite say what they want, but I get the feeling that they already know what they want. And it doesn't feel like it has, in those particular instances, as much [of] a rigorous, satisfying argument. It just feels a little bit, I don't know, mushier, which sounds terrible to say. And there are certainly female directors who I've worked with who are not like that, and the other way around. But I would say, if I had to characterize the men I've worked with and women I've worked with, I feel I prefer working with the men that I've worked with, director-wise.

TANYA ORELLANA What you're saying is super interesting. When that question was in the survey, I put my relationship with female directors. I prefer it because I feel trusted and they just trust me that I do what I say I do, while I feel like I have to convince the male directors. But from what I'm hearing, I have experienced that same thing of sometimes—women don't feel empowered to just say what they want and be direct. I've definitely gone through that process with female directors of, I wish you had just told me in the beginning that you hate this color or, You're not telling me what you want. I have to be like, It's okay, you can tell me you hate this. We can throw this out

the window. And men are taught to just say, I like it. I don't like it. Show me what you have. So, it's a sort of consequence of our position in society a lot.

SIBYL WICKERSHEIMER I'm often labeled as the argumentative one but I see it less as argumentative, and more [that] I'm just blunt. And really honest. And I also, like you Mimi, really love to dig into things. I'm always the one who will say something in tech like, You know, I'm really wondering about this choice. Can we talk about it? I love to talk about what we've made together, especially when we're just assembling our pieces together after planning for so long. Sometimes our planning has fallen short and we should discuss that because that's the time to do it.

MIMI LIEN I almost exclusively hire female assistants, and I'm asking myself, why is that? There's a reason—I feel like it's the flip side of the same way I gravitate towards male directors. I really rely on my assistants a lot for a back-and-forth feedback, and I want to have it be a very open conversation, and I welcome their thoughts and input. I have one male assistant who's a friend of mine who I've worked with for ten years. So, it's certainly not a blanket statement. I sort of want to keep [it] fairly hierarchy free. I'm constantly, like, I don't know. Like when they're asking me what should I do next and what should this be? What color should this be? What finish should this be? I'm super indecisive and it takes me a while to figure things out. It's easier to have this breaking down of hierarchy to be, I don't know, what do you think?

MAUREEN WEISS Yeah, I love my assistants. They're also all women and I love those moments with them. I have had male assistants also where it's very direct. *Yes. Paint it brown.*

MIMI LIEN Yeah. Tell me what to do.

MAUREEN WEISS Yes. They get it done really quickly. But I really value my female assistants where I'm just like, *I don't know, Naomi. I don't know, what should we do?* And Naomi will look at me and say, *I know what you would do, you know what you would do. And [then] do it.* I love that moment and I feel like she's paying attention to me and she's not paying attention to the wood and how we need to cut it. I may be generalizing, but I really hear that.

SIBYL WICKERSHEIMER Part of bringing in assistants is that we're bringing them into our homes often. I work with the assistant based on if I feel natural with them or not as much as playing to their skills, which helps me to do my work. I love having an assistant who's willing to participate in conversations, but I can't force that. I love to honor the fact that I'm a female set designer and that that impacts my work at some level, but I don't need to name it. Rather, to understand why it makes me design a certain way. **I'm interested in how you need to let instinct take over.** Obviously, your instincts change over time, but you gain confidence about those instincts and they sort of shape you.

MIMI LIEN Yeah, that's the thing that you rely on, right? I feel like that particularly as set designers for the theatre. I feel like that's the whole game, to sniff out whatever it is and the piece that catalyzes some instinct within you.

Set Design by Rachel Hauck, *The House of Bernarda Alba*

"It's complicated, right, because it feels like there's a whole category of people who just got through the door. And there are so many people who need to come through the door with us. Yes, but it doesn't mean that we've been heard for a long period of time. It means they should be right here with us. It's a lot, and of course the conversation is good and loud here and powerful and complicated emotionally.

I'm not sure we'll go back to where we were. But, you know, you can't keep creative people down."
—Rachel Hauck

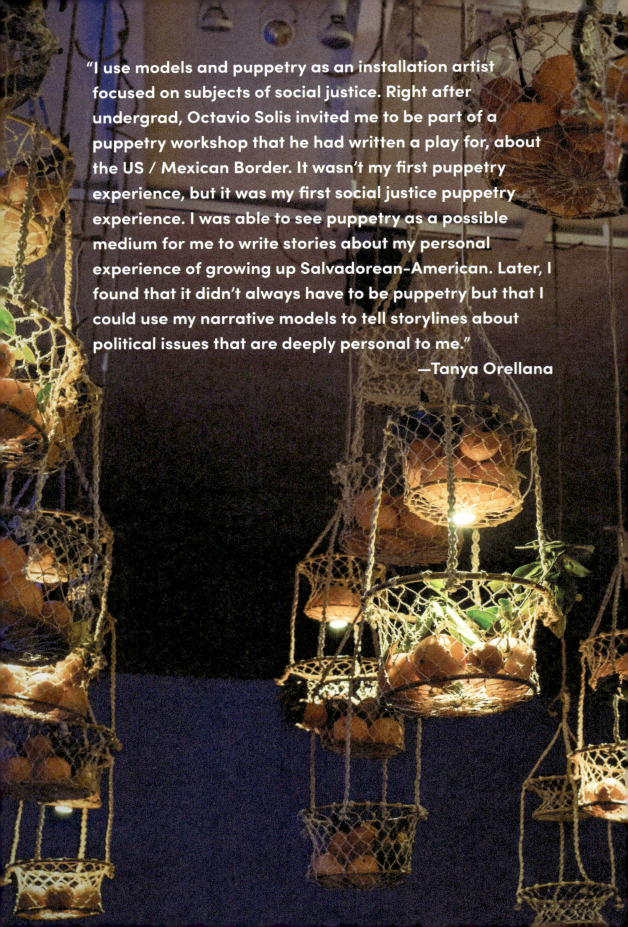

"I use models and puppetry as an installation artist focused on subjects of social justice. Right after undergrad, Octavio Solis invited me to be part of a puppetry workshop that he had written a play for, about the US / Mexican Border. It wasn't my first puppetry experience, but it was my first social justice puppetry experience. I was able to see puppetry as a possible medium for me to write stories about my personal experience of growing up Salvadorean-American. Later, I found that it didn't always have to be puppetry but that I could use my narrative models to tell storylines about political issues that are deeply personal to me."

—Tanya Orellana

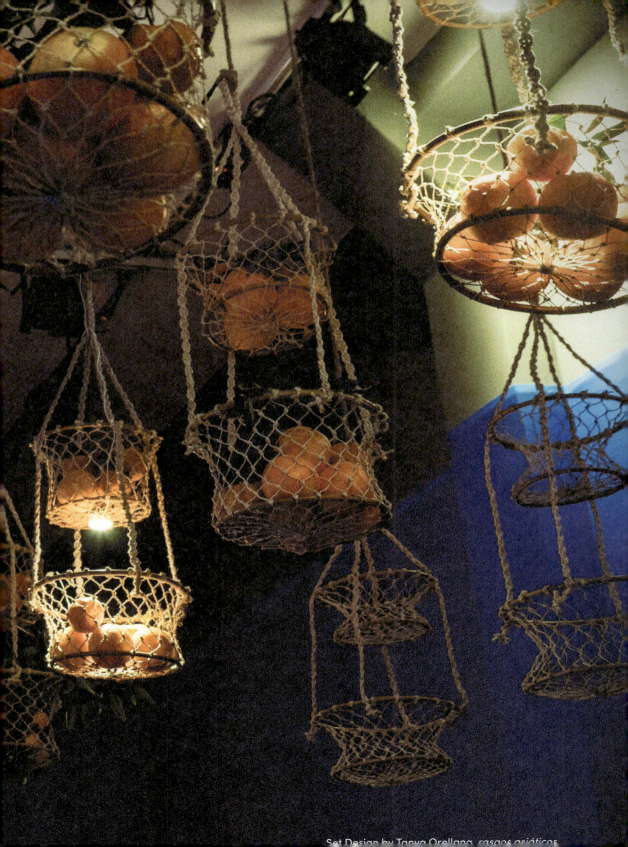

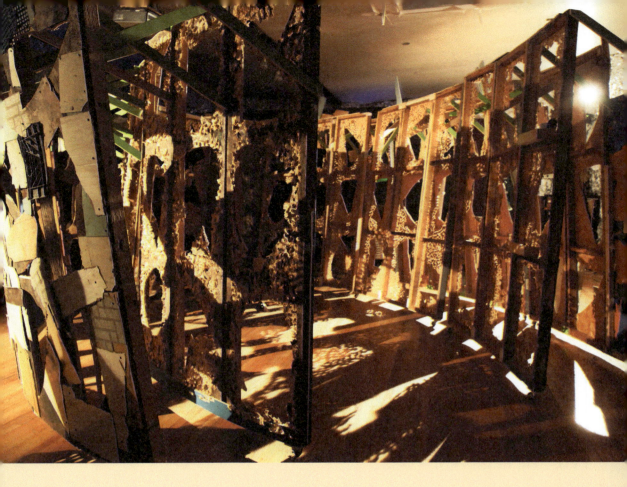

CHAPTER 5

Navigating Boundaries

Set Design by Abigail DeVille, *She Talks to Beethoven*

INTERSECTION OF AN ARTS PRACTICE

Abigail DeVille / Marsha Ginsberg / Shannon Scrofano / Yvonne Miranda

October 8, 2020

MAUREEN WEISS I'm Maureen Weiss [and] I'm here in Alfred, New York.

I am mostly a set designer, but [also] the head of performance design here, and we've been working, for a year, on this book about design and, especially, women in design.

Shannon?

SHANNON SCROFANO I'm Shannon Scrofano. I'm in Los Angeles. I'm a scenic designer and do some other types of things, especially community-based art practices, participatory design, cultural development. So, my practice is a little bit all over the place, but definitely fed by theatre training and design training. I have a general interest in sites of impact outside of theatre space. And I teach at CalArts.

MAUREEN WEISS Marsha?

MARSHA GINSBERG Um, let's see. Well, I don't even know what I would call myself. I guess I call myself a performance designer. I have a visual arts background, but my practice is primarily now creating spaces and environment and clothes for live performance. And it ranges from, you know, gallery-type work to theatre, tending towards non-narrative texts and opera. And—I teach at NYU Abu Dhabi. I'm currently in the middle of this project that's happening in Berlin in the middle of November that I may not get to, that I'm making a video for now.

I'm still making a set, but I'm making a video that's going to be, like, the whole piece. It's a new kind of opera. It's a longer story to get into. But you know it was me wanting to be a devisor. It's with other collaborators—a composer and a playwright, a director, and we kind of based [it] on an idea I've been exploring. We've been working on it also with a vocal ensemble in Stuttgart, so it's just been this kind of long development and it's going to continue. But yeah, it's going to premiere in iteration in Berlin and part of it is a walk through the woods and then this performance in this kiosk. And, so now in the woods there's going to be this video projected. That is what I'm making now.

ABIGAIL DEVILLE Hey. I'm primarily a visual artist. I do mostly site-specific installations based on our site's history and then I scavenge the local area for materials and build on site. And I also collaborate a lot with, primarily, a director named Charlotte Brathwaite. [She and] I have done lots of projects together, but that varies in terms of set and costume design. And we also made a film together a couple [of] years ago.

SIBYL WICKERSHEIMER Abigail and Marsha, I think the two of you started from fine art and moved into set design. So I'm really curious to hear about your process and where that takes our conversation.

ABIGAIL DEVILLE In 2014 Charlotte Brathwaite and I started working, we had tried to work together on our thesis project in grad school [a few years earlier] and the school refused to give us any money towards supporting a collaborative effort between us. They wouldn't even give us one hundred dollars. It was pathetic. So, we tried to collaborate once in 2011. I wasn't that happy about the results, but it is what it is. And then, fast forward to 2014, we did the thing that ended up being the Art21 video at JACK [performance space in Brooklyn, NY]— which is the Adrienne Kennedy piece, *She Talks to Beethoven*. But what surprised me the most was the kind of collaboration and the blurring of roles that happens behind the scenes. And when people just—anyone just takes up something and everyone is working together [on] this concentrated effort to see that this vision is coming to fruition. Which is so radically different from the fine art realms, or the way that sculptures, or visual artworks, or whatever, are produced for public consumption. There was something that was really nourishing about that whole process and it was constantly exhilarating, you know, from being in a more solitary practice in the studio or presenting something in a museum or gallery context. And then, still with

a shoestring or no budget, making magic happen somehow. And I feel like that really happened.

When we did the piece that La MaMa [Experimental Theater] called *Prophetika: an Oratorio* in 2015 and that we had five-hundred bucks for the costumes and set. Like, What do you want to do with this? So people ended up wearing clothes out of my closet for costumes and stuff. It was so janky, but then somehow at the end of that there was an Obie Award! So, I was like, Why is this? Is this real, is this possible? I thought that was the best kind of embrace.

I guess that there are spaces for radicality within theatre-making or conversation-making, right? Because it's more about responding to the moment that you're in in an immediate way that feels, sometimes, even though it's time-based, it feels more embracing than a conversation you can have in visual arts contexts.

SIBYL WICKERSHEIMER Do you find the monetary support similar, in the art world or the theatre world?

ABIGAIL DEVILLE No. Not at all. And I guess that depends. I guess there [are] different levels for everything in terms of where or what you're doing within a visual art context or if you're doing theatre. So, I remember an example—I was an artist in residence at the Studio Museum in Harlem in 2014 and, at the same time, Charlotte was the Assistant Director for Peter Sellers for *A Midsummer Night's Dream* at the Stratford Ontario Shakespeare Festival. I'm sure I was dead broke and at the Studio Museum you get a fellowship, I think it was $20,000 over the course of maybe ten months or something and they provide you a studio and stuff like that. I remember living in Stratford for a month at a house, you know, hanging out with Peter Sellers every day, letting me make whatever the heck I wanted. I sourced the materials from some local junkyards and a Masonic temple basement. It was straight-up junk. He let me put this into the set and I got paid for that. And when I went home and had to make art for a gallery exhibition at the Studio Museum right after that, I mean, as soon as I came back to New York I immediately had to start installing this show. And then dealing with—I know this is rampant in every industry—but there was just this moment where I dealt with a collector at the opening coming on to me in a gross way and his wife was five feet away. And I'm just like, Oh god. It was starting to turn me off to the fine art arena in general. I was just away in a cute little town for a month, you know, hanging out with people having awesome conversations, making art. And I come back and then there's this gross direct way that you have to interact with money that constantly is devaluing you, or trying to keep you hemmed in this particular place, depending on what your gender or whatever physical form you're representing. And it just felt really gross.

MAUREEN WEISS I guess, because you're in a collaboration within a theatre it doesn't feel like it's yours as much. I don't have to feel like it's totally me and I'm not selling myself on every job—*everybody* is selling themselves for not enough.

MARSHA GINSBERG I feel an enormous pressure as the creator of the environment that this whole event is inside of. I definitely feel responsible for the success of the

Design by Shannon Scrofano, *Nuestro Lugar*

event, like, that my work has to be really amazing. And that by my work being amazing, then it will really help the show be more amazing. And then, if the set or the environment is bad, then everything inside is going to be fighting against it. So, even though you are working collaboratively, the notion of ownership is there but different, because we're making something ephemeral, we're not making an object that is sell-able. But there's still an enormous pressure. I just feel like every show I do, somehow my entire career rides on it, you know. So, it's just nonstop stress.

SIBYL WICKERSHEIMER Is there a similarity between the process of collaboration that set designers and fine artists have, with their team and with the site or event space? Because we do so much of, like, vetting our design with the director and what is that process like in comparison?

ABIGAIL DEVILLE That has been challenging, yeah, in set design. Working in fine arts, I mean, the rules and regulations in terms of fire codes or something—stuff like that doesn't really exist so much. So initially, there's a lot of butting up against just how things are usually done and then trying to find where you can get people to kind of bend and give you some more leeway or trust, depending upon the

organization. But yeah, there was something that I was doing at Harlem Stage or something and they threw out a part of the materials. They were like, This is just trash. You can't use this. They were steps—old, reclaimed wooden stairwells from old buildings, torn out of old homes in Baltimore or something. They were like, Get this crap out of here, you can't have this here. So, we had to rebuild steps from scratch. And I wasn't really feeling that. I've had the benefit of working with Charlotte over and over again. We developed this collaboration and relationship of trust and she knows something's going to happen. She doesn't know what's going to happen but she knows that something's going to happen. So, she's not bothering me too much. Whereas when I've worked with other people, it's been a very different experience.

SHANNON SCROFANO What you're talking about really resonates with me in terms of materials. It's amazing how far we've come in some ways in the theatre, in terms of adjusting to different types of performance and different approaches to design, but there's still this sort of script of faking things that's built into the shop mentality and fabrication. I had a project where I had a jar of dirt from a very

special location. No, it wasn't the urinal on the walls in a museum, it hadn't been placed in that way. **But, the fact is, it's dirt. You can't fake that dirt.**

There is such integrity in materials, especially if that material has had a life, or touched the place, or had certain set of hands on it. In most theatrical contexts that's still a pretty alien thing. It is not even being precious about it. Integrity, for me, is the word and I mean I'd rather spend my whole budget retrofitting that set of steps that you were talking about rather than faking it again. There's something fundamental in that inability to recognize our potential relation to materials. I don't do Broadway, so I'm not trying to make something for the audience person who is four balconies up. Someone might actually pick it [the jar of dirt] up. I might get the chance to tell the story of why it matters that it's a rock and it feels this way. I'm just being random right now but I think about it a lot, the intimacy we have had to go to [to create digital performances] in Covid, maybe it will start to land our relationship to objects and materiality.

MARSHA GINSBERG I'm very committed to real materials as well. And, it is a really interesting problem with theatres because I do sometimes work in LORT theatres, and I've been lectured to by male technical directors telling me that I don't understand stagecraft because I'm insisting on, like, a real door. The "gatekeepers" that are usually in production or technical director positions are always the ones calling out what is allowed and what's not allowed. I find that I have to play by their rules, do all of this kind of pre-planning and submit my drawings and my models. But I also really like to leave 20 percent that I can have my hand in and really be on-site and respond to what I'm seeing. That's a really big difference between theatre practitioners and people with [a] visual arts background because if you have a studio practice, you're more used to working with things rather than this kind of straight line where you come up with an idea in the studio and it all just gets sent off to the shop with minimal interfacing. So I think that question of process is really interesting and quite different.

SHANNON SCROFANO Yeah, and to make that room for that 20 percent—I mean, I have kind of walked away from working in regional theatre entirely. I'd say that I have walked away because making that 20 percent wiggle room—budgetary, or in terms of expectations, or in terms of presenting what it is and what might change and giving yourself a chance to work sculpturally a little bit is so hard. I spent half my energy trying to make that space that I thought would really help this show be the best possible version, but it's too hard. The model is a beautiful, extraordinary thing but it could never be everything. And there was always more discovery that I could make once I could have my hands on things or find the thing that I didn't intend to find that [could] be able to wander a little bit in the design. I always show my students that interview with [Robert] Rauschenberg, [John] Cage, and [Merce] Cunningham where they're talking about Rauschenberg. He ran around in the back streets of Paris or Berlin and gathered stuff that day to just throw it up on stage and, sometimes, it was sublime.

SIBYL WICKERSHEIMER Has anyone found that from a gallery or museum space that there is less concern about audience and performers using the set pieces than

in theatre? There's two kinds of museum or gallery spaces: one that encourages you to interact and then one where you're not supposed to touch, that you don't engage with it. And yet in the theatre we're doing both. We're looking at it from afar, as an audience. And we're engaging with it with the performer.

SHANNON SCROFANO I think you're right on. I always feel like I'm the nerd who's like, *Is there going to be egress*? I actually bring more nerdiness or I'm looking at it as if it might burst into flames.

ABIGAIL DEVILLE It depends on the institution because, a lot of the time, in visual museum space they don't even know what to do with performance in general, so I don't know if they're checking. They have these designated black boxes where performances are happening, and we're out where the art or the expensive things are. I have done a performance in a museum and I brought in thirteen crazy-looking sculptures and people were forced to interact with them. There were actors pulling and pushing sculptures around the room, everything was on wheels and, at one point, people are getting pinned up against the wall and sculptures would be coming at them. But that was just luck of the draw that no curators were working there at that moment. I don't think that would ever happen again. But I don't think they're checking too closely as to what's actually going on within a performance in a museum space.

SIBYL WICKERSHEIMER How much check-in do you have when you install in a gallery space prior to getting there?

ABIGAIL DEVILLE That was tough. I mean, we talked a lot. There were lots of planning meetings. But then when it actually came down to it, we had a one-day load in, one-day setup and then two-day performances. And then, maybe this installation of an additional day and then striking everything. So, it was very, you know, quick.

SIBYL WICKERSHEIMER Can you discuss how your art practice and your theatre practice benefit each other?

MARSHA GINSBERG I came from the art world and I guess I don't feel like I ever technically left the art world, but I'm more ensconced in this career as a maker of performances and stuff. So, for me, photographically and spatially I don't really make a difference between it. I think my stage sets are part of my art practice even though I'm working collaboratively and there is personal investigatory work that I'm doing. I'm always shooting photographs and I have an archive that I often draw on. My experience of finding spaces, in the world and in my photographs, it just is a real back and forth. Instead of creating this division, I think one way I really made peace with it is to just say it's all the same. The problem, I would say, about that is that we exist in a world that wants to put [up] divisions. Probably all of us here have pretty fluid practices and so it's really the institutional surround that creates more of a naming of what that practice is, but it's not how I really personally feel as a practitioner.

SHANNON SCROFANO I want to jump in, maybe even from a different angle. I don't know that I have an art practice, particularly. I feel like I have a design practice

Set Design by Abigail DeVille, *A Midsummer Night's Dream*

and a lot of my work that goes outside of theatre is about a particular way that I'm able to navigate design challenges that, I think, takes influence from many different types of creative practices. Some of which are quite expressive and some of which are more like solution-finding oriented. There's a way that I approach designing and thinking about environments and conditions and all that ends up being useful and fulfilling.

ABIGAIL DEVILLE Yeah, I would agree with you both. Maybe the initial impetus of where a work is being birthed from is different when you're doing something else, but it's kind of the same if the work is being birthed through a story or through a kind of material. Whether like a history as material—then it has roots, and it's growing there, and then it sprouts from there. But then it's just communicating differently spatially for different audiences. I feel like I was given a gift coming into set design in the way that I did because I don't think that you get to consider space in a particular way in the parameters of white wall gallery spaces or whatever systems they have set up for understanding a work "in the round." Then thinking about it, you know, the possibilities of the potential that exists in being able to engage in a bodily way with a viewer or theatregoer, and how the story then unravels through the materials and the situation that you're setting up. I think it's very similar, but I don't know. Maybe the takeaways are potentially different in terms of the experience.

SIBYL WICKERSHEIMER Yeah, it's so amazing to hear you all aligned in a way. I think we feel the boundaries are being enforced upon us rather than coming from within our practices, is what I'm hearing.

MAUREEN WEISS And I'm wondering if some of it comes from students having to choose a degree—

SIBYL WICKERSHEIMER We are constantly asked what we do.

SHANNON SCROFANO What do you want to make is a question I'm way more interested in. So I try to encourage them to think that way. I don't remember what the statistic is exactly, but like 85 percent of jobs in 2030—we can't even name them. We don't even know what they are. In a university system, the rigidity of the name of the thing and the promise that's a job which is connected to many forces—capitalism being one. It's confusing and limiting, and certainly doesn't make the most interesting creative or best critical thinking ability. To look at things and make your own judgments and move forward. And to know what you don't know—I think that we are the most useful kind of humans.

MAUREEN WEISS I love that question. What do you want to make?

MARSHA GINSBERG It's a great approach.

SIBYL WICKERSHEIMER How has what you make now had to change? I'm asking myself what I can make as an activist, rather than as a theatre maker and I'm finding people to help explore a topic that needs design support, outside of theatre. My students just did a project with Sabra Williams of Creative Acts, who works with formerly incarcerated people to support them and support the ideas around voting and voter suppression. And now students and I are working with Sierra Smith, a friend who is executive director of Open Paths Counseling Center. Because she's a close friend of mine I asked her, What [kinds of programs] can we use design to support at your clinic? I'm excited that I was able to just reach out to a couple people who I know to ask, What do you need design for? Instead of trying to look to theatre models right now.

[Yvonne Miranda enters the conversation—she has come from a costume fitting]

MAUREEN WEISS We have been talking a lot about the different areas of design and how they overlap with fine arts. And I'm not sure what your degree is in but, you know, whether a fine arts degree does one thing, or if it's all the same.

YVONNE MIRANDA Yeah, I have an MFA. And then I have a BFA in fashion design.

MAUREEN WEISS Is it nice to be working?

YVONNE MIRANDA It is, but then it's like you jump back into it and you forget, Oh, this is why I hate this sometimes. I love it. I love the creation of the idea, the research and coming up with the ideas in the end. But the middle is basically just managing that and making sure it comes out looking like it's supposed to.

SIBYL WICKERSHEIMER There is a lot of that, isn't there?

Costume Design by Yvonne Miranda, *Big Tex*

YVONNE MIRANDA Yeah, a lot of logistical things.

MAUREEN WEISS And if the show is currently being written—I'm curious how you come up with the designs.

YVONNE MIRANDA Aah—that's the fun part. We're building a plane as we're flying it. I'm co-producing with a student who was my assistant as well. So, we're co-producing and she didn't want to actually do it at first because she was like, I'm a white woman. She's like, This is the problem, you know, now with Black projects of not giving space to Black artists behind the scenes, so then they came and got me. But I encouraged her at the same time to [do it]. They're like, I don't feel like white people should have permission to step aside for that because I have to learn Shakespeare, I have to do Chekhov. So, you need to do your research because you might be the most equipped person on hand to tell this story as well. I did Anne Frank. I'm not Jewish, I had to go and do research. I think this is something to have on your resume—Regina Taylor is, you know, a renowned playwright, director, actress. And so, **you need to show that you have a range of work and that you're not scared to go tackle something that's not exactly in your comfort zone. A lot of people [are] just very scared about being uncomfortable.** And I'm like, You need to have discussions about it and just learn

248 Scene Shift

Costume Design by Yvonne Miranda, *Big Tex*

and educate yourself. So, it's been great working with her, not as an assistant, but on this because it's just crazy the fast-paced—

MAUREEN WEISS How did she receive that?

YVONNE MIRANDA She was like, I'll co-produce. She just wanted to be the assistant. And I was like, No, I think you're missing out. You should be the co-designer as well. And then I stated that and she was like, Okay.

MAUREEN WEISS Something that we've spoken about for the past few months, the economic sustainability of the career of a scene designer, can it be something that actually sustains us monetarily? Is it a job? Because I'm a professor and I am not a full-time set designer.

ABIGAIL DEVILLE That feels like a more broad question in terms of the arts in general, right? I always had an interest in doing set design, but going to school for that specifically would have never dawned on me. I just fell into fine art almost accidentally. I initially started out in undergrad as an illustrator, because that's what I knew. I didn't know anything outside of that and then, thank god, loans were rejected. And I never finished that. So, I was at school for three years and I went back and I was like, What's fine art? I'll do that. Then I fell in love with making—making things or making sculpture.

I think it's a career. I'm not sure, though, I don't know. Art or making things is an all-consuming force that ends up being your life's work and somehow you squeak out money here and there. But thinking about it is like a long journey that's purposeful and meaningful, and not necessarily that you will be living in a big house on top of the hill kind of thing. But, you know, maybe at the end of it that you made enough things that spoke to enough people that spoke to enough moments in time.

The idea to be making something right now that could be talking about the present moment is then making work or notes for the future, right? When people go back, like people at the beginning of the pandemic going back and looking to see what were people making and talking about one hundred years ago during the last earth-shattering pandemic, and it seems like not that much, right? People didn't really talk about it. Let's ride over that speed bump and go straight to the roaring twenties, you know. It's interesting to think about. Especially at this moment where so much is changing, even if it's cyclical and the United States likes to repeat its whole thing with pretending that things are moving forward and then taking 5,000 steps backwards. But because of the momentum that's happened in the summer with the murder of George Floyd, that was the first time that all fifty states participated in protesting—especially for racial violence. There's a real reckoning and a real questioning. There's also all this rhetoric nonsense with the Democratic Party talking about the soul of America. When did America ever have a soul that wasn't centered on money or capitalism and exploitative labor practices? So I think if you can move in the time that you're here on this planet in a way that brings light or life or information or a meaningful kind of communication with other human beings around you, then what more could

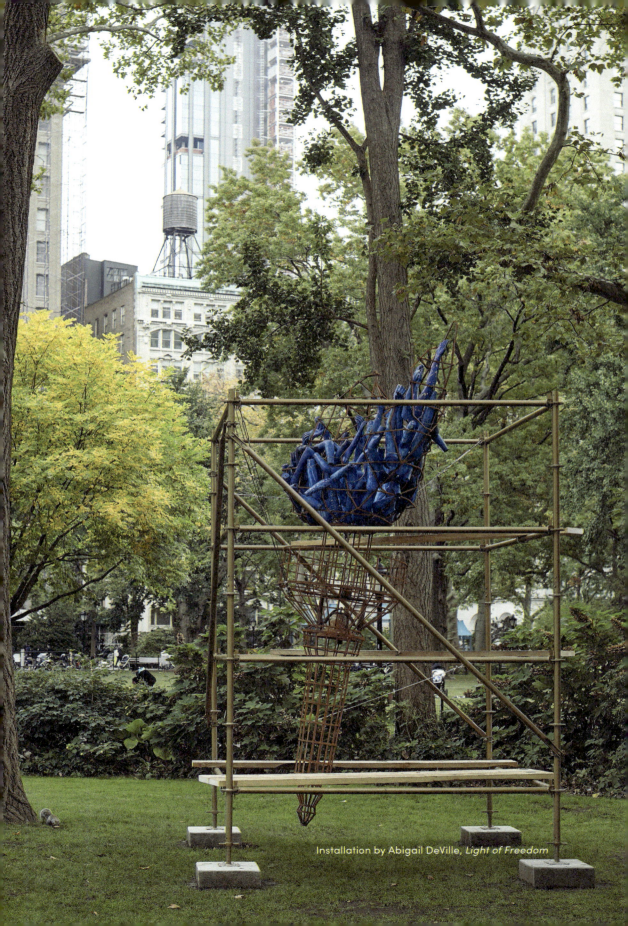

Installation by Abigail DeVille, *Light of Freedom*

you ask for? And I don't know if set design is the thing, whether being an artist is the thing or, Sibyl, what you're talking about finding ways to broaden your practice during this time of the curtain being down kind of thing. We're creative beings and we're moving and working in different ways. So can our creativity answer the call to a problem in front of us make space for somebody else's voice?

I'm always going back and thinking about James Baldwin's "[The] Creative Process" essay and the last line of that essay where he talks about that *"the war of an artist with his society is a lover's war, and he does, at his best, what lovers do, which is to reveal the beloved to himself and, with that revelation, to make freedom real."*

Until then, thinking about if we're in a pursuit of a kind of truth-telling, or mirroring, of society to itself, or creatively thinking about new ways we can frame old tired conversations and meaningful ways where we can talk to each other.

Then, I mean, that's a life's work. That's a real trajectory and it doesn't matter if it has the label of a set designer or a visual artist or a costume designer or whatever, you know. I think if it's meaningful and has the potential to ripple—

MARSHA GINSBERG I like to believe that there's some mission about what you're doing, both for yourself in terms of your own self-expression, but also as a person that is interfacing with the culture that you live in.

ABIGAIL DEVILLE I just wanted to jump back on the question about being a woman in your artistic practice because I just think that's a problem for all of us across the board. I remember, in 2005, I went to an artist's lecture with Faith Ringgold and I'll never forget what she said. She said, You know, I thought the problem of my life was going to be the fact that I was Black, but actually it was that I was a woman. And that's why she became a feminist. I hadn't thought about it in that way or the double dose of being Black and a woman and all of these contexts. Not that it's a double erasure or something. **But it's a challenge—being in these spaces and then being excluded in very particular ways—that you have to continually fight to make space for yourself, and for your peers, and the people behind you.**

Zoom Conference, *Transitions Conversation*

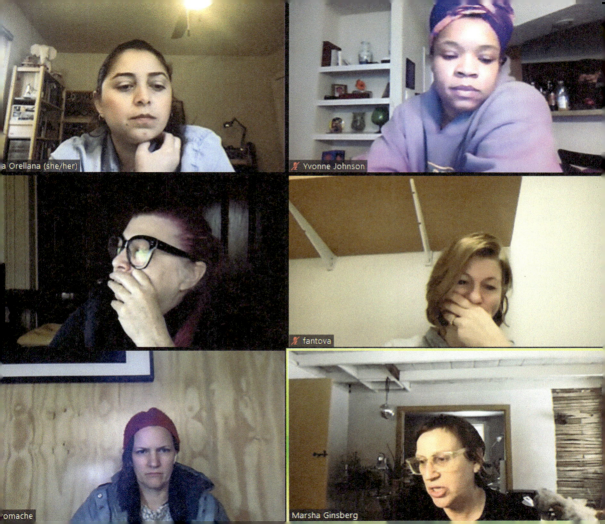

Abigail DeVille — New York, NY
Abigail creates site-specific, immersive installations that are designed to bring attention to history and culture through material objects, such as with the sculpture she built on the site of a former African American burial ground in Harlem.

Afsoon Pajoufar — New York, NY
Afsoon is a stage and environment designer for play, opera, and live performance. Her artistic practice often is focused on the intersection of space and new technologies, including XR and live video.

Andromache Chalfant — Brooklyn, NY
Andromache is a set designer for theatre and opera.

Chen-Wei Liao — New York, NY
Chen-Wei is a scenic designer for theatre, film, and exhibitions in both Taiwan and the United States. She is interested in neuroscience, psychology, and behavioral studies.

Christine Jones — New York, NY
Christine is a multiple Tony Award-winning scenographer, as well as a creator, curator, and educator who works in public art, fashion, and music. She is the founder and artistic director of the critically acclaimed Theatre for One.

Collette Pollard — Chicago, IL
Collette is an associate professor of scenic design at the University of Illinois at Chicago, an Associate Artist at Timeline Theatre Company, and serves on the Michael Merritt Awards Committee.

Deb O — Brooklyn, NY
Deb's extensive scenography training and range of experiences— as well as her background in folk art, dance, gymnastics, clowning, puppetry, found object art, sculpture, and mask making—have lent themselves to innovative approaches to the creation of unique theatrical events.

Ed Haynes — Los Angeles, CA
Ed's work includes academic, regional, Off-Broadway, and international theatrical designs, as well as theatre consulting, network television design, experiential marketing design, trade show design, and boutique retail design.

Hana Kim — Los Angeles, CA
Hana is an immersive environment and media designer whose experiences span film, live performances, and public art.

Kimie Nishikawa — New York, NY
Along with Andrew Moerdyk and Santiago Orjuela-Laverde, Kimie is a co-founders of dots, a design collective based in NYC specializing in designing environments for narratives, performances, and experiences.

Laura Jellinek — Brooklyn, NY
Laura is the recipient of a Tony nomination, a Drama Desk nomination, and an Obie award for her design for Daniel Fish's revival of Oklahoma! on Broadway and at St. Ann's Warehouse.

Linda Buchanan — Chicago, IL
Linda was Associate Dean and Head of Scene Design for many years at The Theatre School at DePaul University. She has designed scenery and environments for regional and international theatre, opera, and special events.

Louisa Thompson — New York, NY
Louisa is a designer, a creator of theatrical work for young audiences, and a professor at Hunter College. She has won an Obie and a Lucille Lortell award.

Markéta Fantová — Prague, Czech Republic
Markéta is a scenic, lighting, and costume designer for theatre, dance, and performance art. She is also the artistic director of the Prague Quadrennial of Performance Design and Space.

Marsha Ginsberg — New York, NY
Marsha is a visual artist and designer for live performance events and creates scenery and costumes for opera, theatre, and performance art in Europe and the US.

Maureen Weiss — Alfred, NY
Maureen is a performance designer and an associate professor at Alfred University. She also curates a mobile theatre truck, The PopWagon.

Mimi Lien — Brooklyn, NY
Arriving at set design from a background in architecture, Mimi's work often focuses on the interaction between audience/environment and object/performer.

Naomi Kasahara — Los Angeles, CA
Naomi is a freelance set designer, prop master, painter, and carpenter in the Los Angeles area.

Narelle Sissons — Connecticut/NYC
Narelle is an award-winning scenic designer originally from the UK. She spent many years teaching Scenography at Carnegie Mellon University School of Drama before returning to her freelance work. In addition to theatre design, her own art practice includes painting and drawing, as well as working with women refugees and young artists.

Nina Ball — San Francisco, CA
Nina is an award-winning scenic designer and company member at both Shotgun Players and TheatreFirst. She teaches performance design at UC Berkeley and is the incoming set design professor at Stanford University.

Rachel Hauck — New York, NY
Rachel is a theatre set designer who is primarily focused on new plays and musicals. She is also an educator and an activist.

Regina García — Chicago, IL
Regina is a Puerto Rican scenic designer and an organizing member of La Gente: The Latinx Theatre Design Network. She teaches at the Theatre School, DePaul University.

Sara Outing — Philadelphia, PA
Sara is a scenic designer, prop fabricator, puppeteer, and illustrator.

Shannon Scrofano — Los Angeles, CA
Shannon collaborates with communities, organizations, and other artists to explore location-based design processes, practices, and conditions. She is the associate director of design at CalArts.

Shing Yin Khor — Los Angeles, CA
Shing Yin Khor is a Malaysian-American immersive installation artist and experience designer working with themes of ritual, tradition, and migration.

Sibyl Wickersheimer — Los Angeles, CA
Sibyl designs inside and outside of theatre spaces. Her interests span from immersive installations and museum exhibitions to design for mental health care. Sibyl teaches set design as associate professor at the USC School of Dramatic Arts.

Tanya Orellana — San Francisco, CA
Tanya designs performance spaces for theatre, opera, and immersive experiences. She is a core member of Campo Santo where she participates in their new work process, conceptualizing and designing sets alongside the writing process.

You-Shin Chen — New York, NY
You-Shin is always curious about human behaviors within a given space. She thinks about how both tangible and intangible elements shape a space, and how those elements have an effect on the human psyche.

Yuri Okahana — Los Angeles, CA
Yuri is an experimental scenographer and is currently a scenic design faculty member at Westmont College.

Yvonne Miranda — Chicago, IL
A United States Marine Corps war veteran, Yvonne traded in her combat boots for a career in costume, fashion, and scenic design where she gets to live out her passions as a visual storyteller.

Coda

IMAGE INDEX

Abigail DeVille

A Midsummer Night's Dream
PAGE 246
PLAYWRIGHT William Shakespeare
VENUE Stratford Festival of Canada
YEAR 2014
DIRECTOR Peter Sellers
LIGHTING DESIGNER James F. Ingalls
COSTUME DESIGNER Gabriel Berry
SOUND DESIGNER Tareke Ortiz
PHOTOGRAPHER Abigail DeVille

Light of Freedom
PAGE 251
YEAR 2020
MATERIALS Welded steel, cabling, rusted metal bell, mannequin arms, metal scaffolding, wood
DIMENSIONS 156 x 96 x 96 inches approximately
COMMISSIONED BY Madison Square Park Conservancy, New York
PHOTOGRAPHER Andy Romer Photography

She Talks to Beethoven
PAGES 238, 239
PLAYWRIGHT Adrienne Kennedy
VENUE JACK Brooklyn, NY
YEAR 2014
DIRECTOR Charlotte Brathwaite
LIGHTING DESIGNER Yi Zhao
COSTUME DESIGNER Dede M. Ayite
PROJECTION DESIGNER Hannah Wasileski
COMPOSER/SOUND DESIGNER Guillermo E. Brown
DRAMATURG Kate Attwell
PHOTOGRAPHER Hao Bai

The New Migration
PAGE 14
Still image taken from video of Procession on September 6, 2014
LOCATION Harlem, NY
VIDEOGRAPHER Think Out Loud Productions

Afsoon Pajoufar

Lathe of Heaven
PAGE 80
NOVEL BY Ursula K. Le Guin
ADAPTATION Natsu Onoda Power
VENUE Booth Theatre
YEAR 2019
DIRECTOR Sara Katzoff
LIGHTING DESIGNER Mathew Rogers
COSTUME DESIGNER Chloe Moore
PROJECTION DESIGNERS Afsoon Pajoufar, Stephanie Elrod
SOUND DESIGNER Ryan Blaney
PHOTOGRAPHER Afsoon Pajoufar

The Silence
PAGE 73, front cover
INSPIRATION Ingmar Bergman and Andrei Tarkovsky films *The Silence* and *Sacrifice*
ADAPTATION Jay Scheib
VENUE MIT Theater Arts Building, W97
YEAR 2019
DIRECTOR Jay Scheib
LIGHTING DESIGNER Kevin Fulton
COSTUME DESIGNER Shanise DeSilva
PROJECTION DESIGNER Joshua Higgason
SOUND DESIGNER Christian Frederickson
CAMERA Paulina M. Jurzec
PHOTOGRAPHER Jay Scheib

Andromache Chalfant

Henry V
PAGES 69, 152
PLAYWRIGHT William Shakespeare
VENUE Two River Theater
YEAR 2012
DIRECTOR Michael Sexton
LIGHTING DESIGNER Allen Hahn
COSTUME DESIGNER Tilly Grimes
SOUND DESIGNER Brandon Wolcott
FIGHT DIRECTOR Thomas Schall
PHOTOGRAPHERS T. Charles Erickson, Andromache Chalfant

Il Combattimento di Tancredi e Clorinda / I Have No Stories to Tell You
PAGE 56
COMPOSER Claudio Monteverdi/Lembit Beecher
LIBRETTIST Hannah Moscovitch
VENUE Gotham Chamber Opera at The Metropolitan Museum of Art
YEAR 2014
CONDUCTOR Neal Goren
DIRECTOR Robin Guarino
LIGHTING DESIGNER Jane Cox
COSTUME DESIGNER Gabriel Berry
CHOREOGRAPHER Bradon McDonald
SCENIC DESIGN ASSISTANT Rebecca Lord-Surratt
PHOTOGRAPHER Andromache Chalfant

Reverberation
PAGE 27
PLAYWRIGHT Matthew Lopez
VENUE Hartford Stage
YEAR 2015
DIRECTOR Maxwell Williams
LIGHTING DESIGNER Matthew Richards
COSTUME DESIGNER Linda Cho
ORIGINAL MUSIC AND SOUND DESIGNER Tei Blow
FIGHT DIRECTOR J. Allen Suddeth
SCENIC DESIGN ASSISTANT Rebecca Lord-Surratt
PHOTOGRAPHER T. Charles Erickson

The Last Days of Judas Iscariot
PAGE 52
PLAYWRIGHT Stephen Adly Guirgis
COMPANY LAByrinth Theater Company
YEAR 2004
DIRECTOR Philip Seymour Hoffman
LIGHTING DESIGNER Japhy Weideman
COSTUME DESIGNER Mimi O'Donnell
SOUND DESIGNER Darron West
PHOTOGRAPHER Andromache Chalfant

War Stories
PAGE 89
COMPOSER Lembit Beecher
LIBRETTIST Hannah Moscovitch
VENUE Opera Philadelphia at Philadelphia Museum of Art
YEAR 2017
CONDUCTOR Gary Thor Wedow
DIRECTOR Robin Guarino
LIGHTING DESIGNER Mary Eleanor Stebbins
COSTUME DESIGNER Kaye Voyce
SOUND DESIGNER Daniel Perelstein
SCENIC DESIGN ASSISTANT Rebecca Lord-Surratt
PHOTOGRAPHER Andromache Chalfant

Chen-Wei Liao

Mr. Marmalade
PAGE 70
PLAYWRIGHT Noah Haidle
VENUE Rauh Theatre, Carnegie Mellon University
YEAR 2016
DIRECTOR Terrence I. Mosley
LIGHTING DESIGNER Alex Gibson
COSTUME DESIGNER Kristen Clark
PROJECTION DESIGNER Sylvie Sherman
SOUND DESIGNER Anthony Stultz
PHOTOGRAPHER Louis Stein

Christine Jones

American Idiot
PAGE 10
Conceptual collage
BOOK BY Billie Joe Armstrong, Michael Mayer
VENUE Berkeley Rep and the St. James Theatre, NYC
YEAR 2010
DIRECTOR Michael Mayer
LIGHTING DESIGNER Kevin Adams
COSTUME DESIGNER Andrea Lauer
PROJECTION DESIGNER Darrel Maloney
SOUND DESIGNER Brian Ronan
CHOREOGRAPHER Steven Hoggett

Spring Awakening
PAGE 218
Conceptual collage
BOOK BY Duncan Sheik, Steven Sater
VENUE Atlantic Theatre and the Eugene O'Neill, NYC
YEAR 2006
DIRECTOR Michael Mayer
LIGHTING DESIGNER Kevin Adams
COSTUME DESIGNER Susan Hilferty
SOUND DESIGNER Brian Ronan
CHOREOGRAPHER Bill T. Jones

Collette Pollard

A Streetcar Named Desire
PAGE 184
PLAYWRIGHT Tennessee Williams
VENUE Writers' Theatre
YEAR 2010
DIRECTOR David Cromer
LIGHTING DESIGNER Heather Gilbert
COSTUME DESIGNER Janice Pytel
SOUND DESIGNER Josh Schmidt
PHOTOGRAPHER Michael Brosilow

Hannah and the Dread Gazebo
PAGES 154, 156
PLAYWRIGHT Jiehae Park
VENUE Thomas Theatre at the Oregon Shakespeare Festival
YEAR 2017
DIRECTOR Chay Yew
LIGHTING DESIGNER David Weiner
COSTUME DESIGNER Sara Ryung Clement
SOUND DESIGNER/ORIGINAL MUSIC Obadiah Eaves
PHOTOGRAPHER Collette Pollard

HIR
PAGE 179
PLAYWRIGHT Taylor Mac
VENUE Steppenwolf Theatre
YEAR 2017
DIRECTOR Hallie Gordon
LIGHTING DESIGNER Ann G. Wrightson
COSTUME DESIGNER Jenny Mannis
SOUND DESIGNER AND COMPOSER Richard Woodbury
PHOTOGRAPHER Collette Pollard

Hunter and the Bear
PAGE 86
COMPANY Pigpen Theatre Co.
VENUE Writers Theatre, Glencoe, IL
YEAR 2016
DIRECTOR Stuart Carden and Pigpen Theatre Co.
COSTUME AND PUPPET DESIGNER Lydia Fine
LIGHTING DESIGNER Bart Cortright
SOUND DESIGNER Mikhail Fiksel
PHOTOGRAPHER Collette Pollard

The Donkey Show
PAGES 104
CREATED BY Diane Paulus, Randy Weiner
VENUE Adrienne Arsht Center for the Performing Arts
YEAR 2012
DIRECTOR Allegra Libonati
LIGHTING DESIGNERS Al Crawford, Zakaria M. Al-Alami
COSTUME DESIGNER David Woolard
CHOREOGRAPHER Rosie Herrera
AERIAL CHOREOGRAPHER Janos Novak
DJ Rudi Goblen
PHOTOGRAPHER Justin Namon

Deb O

I Am A Seagull
PAGE 12
Hybrid narrative documentary film
YEAR 2018
PRODUCERS Anton's Week, Melissa Kievman, Wendy vanden Heuvel, Julie Buck
DIRECTOR Brian Mertes
ASSOCIATE DIRECTOR Alex Harvey
DIRECTOR OF PHOTOGRAPHY Miklos Buk
PRODUCTION DESIGNER Deb O
ART DIRECTORS Emily Gabler, David Meyer
LIGHTING DESIGNERS Dan Scully, Barbara Samuels
COSTUME DESIGNER Olivera Gajic
SOUND DESIGNERS Broken Chord Collective, Dan Kluger, Brandon Wolcott
PUPPET DESIGNER Julian Crouch
CHOREOGRAPHER Jesse J. Perez
SPECIAL EFFECTS Carlo Vogel
STORY PRODUCER Stephanie Fleischmann
PHOTOGRAPHER Farrol Mertes

Red Hills
PAGE 196
PLAYWRIGHT Sean Christopher Lewis
VENUE Quantum Theatre, En Garde Arts
YEAR 2017
DIRECTOR Katie Pearl
LIGHTING DESIGNER C. Todd Brown
COSTUME DESIGNER Deb O
PROJECTION DESIGNER Joe Seaman
SOUND DESIGNER Steve Shapiro

Selkie
PAGE 38
PLAYWRIGHT Sarah Shaefer
VENUE Z Space
YEAR 2016
DIRECTOR Daniel Talbott
LIGHTING DESIGNER Kia Rogers
COSTUME DESIGNER Tristan Raines
SOUND DESIGNER Jake Rodriguez
FIGHT CHOREOGRAPHER Unkle Dave's Fight House

Uncle Vanya
PAGE 106
PLAYWRIGHT Anton Chekhov
VENUE Chekhov Project at Lake Lucille
YEAR 2007
DIRECTOR Brian Mertes
ENVIRONMENT DESIGNER Deb O
LIGHTING DESIGNER Dan Scully
COSTUME DESIGNER Olivera Gajic
SOUND DESIGNERS Broken Chord Collective
CHOREOGRAPHER Jesse J. Perez
PHOTOGRAPHER Farrol Mertes

Ed Haynes

2020 Golden Globes Awards After Party for Netflix
PAGE 47
COMPANY Best Events Los Angeles for Netflix
YEAR 2020
PRODUCER Jeffrey Best
PHOTOGRAPHER Melissa Kobe

Radio Golf
PAGE 43
PLAYWRIGHT August Wilson
VENUE Two River Theatre Co.
YEAR 2020
DIRECTOR Brandon J. Dirden
LIGHTING DESIGNER Driscoll Otto
COSTUME DESIGNER Karen Perry
SOUND DESIGNER Kay Richardson
HAIR & WIG DESIGNER Erin Hicks

Coda

Hana Kim

Sweet Land
PAGE 36
COMPOSERS Raven Chacon, Du Yun
LIBRETTISTS Aja Couchois Duncan, Douglas Kearney
VENUE The Industry/Los Angeles State Historic Park (site)
YEAR 2020
DIRECTOR Cannupa Hanska Luger and Yuval Sharon
LIGHTING DESIGNER Jeanette Oi-Suk Yew
COSTUME DESIGNERS Cannupa Hanska Luger, E.B. Brooks
SCENIC DESIGNERS Tanya Orellana, Carlo Maghirang
PROJECTION DESIGNER Hana Kim
SOUND DESIGNER Jody Elff
PHOTOGRAPHER Neil Matsumoto

Kimie Nishikawa

Ain't No Mo'
PAGE 85
PLAYWRIGHT Jordan E. Cooper
VENUE The Public Theater, LuEsther Hall
YEAR 2019
DIRECTOR Stevie Walker-Webb
LIGHTING DESIGNER Adam Honoré
COSTUME DESIGNER Montana Levi Blanco
SOUND DESIGNER Emily Auciello
HAIR, WIG, MAKEUP DESIGNER Cookie Jordan
FIGHT DIRECTOR Thomas Schall
PHOTOGRAPHER Kimie Nishikawa

Gnit
PAGE 74
PLAYWRIGHT Will Eno
VENUE Theatre For A New Audience
YEAR 2020
DIRECTOR Oliver Butler
LIGHTING DESIGNER Amith Chandrashaker
COSTUME DESIGNER Ásta Bennie Hostetter
SOUND DESIGNER Lee Kinney
MUSIC Daniel Kluger
PHOTOGRAPHER Kimie Nishikawa

Indecent
PAGE 168
PLAYWRIGHT Paula Vogel
CREATED BY Paula Vogel, Rebecca Taichman
VENUE Weston Playhouse Theater (VT), Walker Farm
YEAR 2019
DIRECTOR Jordan Fein
SCENIC DESIGNER Kimie Nishikawa
LIGHTING DESIGNER Oona Curley
COSTUME DESIGNER Ásta Bennie Hostetter
PROJECTION DESIGNERS Rachel Liff, Group Effort
SOUND DESIGNER Jeff Aaron Bryant
CHOREOGRAPHER Katie Rose McLaughlin
PHOTOGRAPHER Oona Curley

Laura Jellinek

Marjorie Prime
PAGE 4
PLAYWRIGHT Jordan Harrison
VENUE Playwrights Horizons
YEAR 2015
DIRECTOR Anne Kauffman
LIGHTING DESIGNER Ben Stanton
COSTUME DESIGNER Jessica Pabst
SOUND DESIGNER Daniel Kluger
PHOTOGRAPHER Laura Jellinek

Owen Wingrave
PAGE 130
COMPOSER Benjamin Britten
LIBRETTIST Myfanwy Piper
VENUE Opera Philadelphia
YEAR 2013
DIRECTOR Daniel Fish
CONDUCTOR George Manahan
LIGHTING DESIGNER Mark Barton
COSTUME DESIGNER Tilly Grimes
VIDEO DESIGNER Andrew Lazarow
PHOTOGRAPHER Mark Barton

Linda Buchanan

Boleros for the Disenchanted
PAGE 44
PLAYWRIGHT José Rivera
VENUE Yale Repertory Theatre
YEAR 2008
DIRECTOR Henry Godinez
LIGHTING DESIGNER Joe Appelt
COSTUME DESIGNER Yuri Cataldo
PROJECTION DESIGNER Linda Buchanan
ORIGINAL MUSIC Gustavo Leone
SOUND DESIGNER Veronika Vorel

Miss Saigon
PAGE 48
COMPOSERS Claude-Michel Schönberg, Alain Boublil
LIBRETTISTS Alain Boublil, Richard Maltby Jr.
VENUE Paramount Theatre
YEAR 2013
DIRECTOR Jim Corti
MUSIC DIRECTOR/CONDUCTOR Shawn Stengel
LIGHTING DESIGNER Jesse Klug
COSTUME DESIGNER Linda Roethke
PROJECTION DESIGNER Mike Tutaj
SOUND DESIGNER Adam Rosenthal
CHOREOGRAPHER Jeffery Hancock
PHOTOGRAPHER Liz Lauren

Louisa Thompson

Blasted
PAGE 191
PLAYWRIGHT Sarah Kane
VENUE Soho Rep, NYC
YEAR 2008
DIRECTOR Sarah Benson
LIGHTING DESIGNER Tyler Micoleau
COSTUME DESIGNER Theresa Squire
SOUND DESIGNER Matt Tierney
FIGHT DIRECTOR J. David Brimmer
PHOTOGRAPHER Louisa Thompson

The Pursuit of Everything
PAGE 198
PRESENTED BY High Museum of Art
EXHIBITION NAME Maira Kalman The Pursuit of Everything
YEAR 2019
EXHIBITION DESIGNER Louisa Thompson
PHOTOGRAPHER Louisa Thompson

Washateria
PAGE 91
Production photos
WRITERS César Alvarez, Charise Castro Smith
CREATED BY Louisa Thompson
VENUE Soho Rep, NYC
YEAR 2015
LEAD ARTISTS Sarah Benson, Adrienne Kapstein, Louisa Thompson
DIRECTORS Tea Alagić, Anne Tippe, Adrienne Kapstein
LIGHTING DESIGNER Rachel Fae Szymanski
LIGHTING DESIGN CONSULTANT Matt Frey
COSTUME DESIGNERS Ásta Bennie Hostetter, Anne Kenney
SOUND DESIGNER Elisheba Ittoop
GRAPHICS Sarah Gephardt, mgmt.design
PHOTOGRAPHER Christopher Ash

Markéta Fantová

36Q
PAGE 28
CURATED BY Markéta Fantová, Jan Rolník
YEAR 2019
LEADING ARTIST Romain Tardy
LIGHT WORK GROUP LEADERS Pavla Beranová, Fereshteh Rostampour
LIGHT WORK GROUP PARTICIPANTS Ana Quintas, Tereza Bartůňková, Kelly Rudolph, Paula Castillo Tocornal, Zuzana Bottová, Mejah Balams, Jack Stoffel, Sarah Feyen, Dorian Stevens, Lara Van Bellingen, Sinan Poffin, Guust Sambaer, Casper Van Overschee, Thomas Maes, Yen-Min Tseng
SOUND WORK GROUP LEADER Robert Kaplowitz
EXPERIMENTAL SOUND WORK GROUP LEADER John Richards
VIDEO WORK GROUP LEADER Romain Tardy
TACTILE ENVIRONMENT WORK GROUP LEADER Tereza Stehlíková
VIRTUAL REALITY WORK GROUP LEADERS Paul Cegys, Joris Weijdom
SYSTEM INTEGRATION WORK GROUP LEADER Shannon Harvey
PHOTOGRAPHER Tomáš Brabec

Letter to the World II
PAGE 144
VENUE Hornell Elks Lodge
YEAR 2013
CHOREOGRAPHER/DIRECTOR D. Chase Angier
PHOTOGRAPHER Evelyne Leblanc-Roberge

Liminal
PAGE 146
VENUE Fosdick-Nelson Art Gallery
YEAR 2007
CHOREOGRAPHER/DIRECTOR D. Chase Angier
INSTALLATION DESIGNERS D. Chase Angier with Markéta Fantová
LIGHTING DESIGNERS Markéta Fantová, Sharon McConnell
COSTUME DESIGNER Markéta Fantová
COMPOSER/SOUND DESIGNER John Laprade
PHOTOGRAPHER Richard Fanta

Marsha Ginsberg

A Midsummer Night's Dream
PAGES 132, 134
COMPOSER Benjamin Britten
VENUE Deutsche Oper Berlin/Opéra National de Montpellier
YEAR 2019/2020
DIRECTOR Ted Huffman
CONDUCTOR Sir Donald Runnicles
LIGHTING DESIGNER D.M. Wood
COSTUME DESIGNER Annemarie Woods
CHOREOGRAPHER Sam Pinkleton
FIGHT DIRECTOR Ran Arthur Braun
CHOIRMASTER/CHORUS DIRECTOR Christian Lindhorst
ASSISTANT SET DESIGNER Perrine Villemur
PHOTOGRAPHER Marsha Ginsberg

Hauch – A Sonic Horror Show
PAGE 32
CREATED BY Marsha Ginsberg, Juliana Hodkinson, Katharina Schmitt
CREATED FOR The Disappearance of Music Festival, Haus der Kulturen der Welt, Berlin
YEAR 2020
PRODUCER HKW; Neue Vocalsolisten, Stuttgart
CINEMATOGRAPHERS Berlin Best Films Forever, Marsha Ginsberg
AUDIO MIX AND MASTERING Peter Weinsheimer
VIDEO EDITING Matěj Šenkýřík
ASSISTANT DIRECTOR Glen Sheppard

Jackie
PAGE 140
PLAYWRIGHT Elfriede Jelinek
VENUE Women's Project Theater, NYC
YEAR 2013
DIRECTOR Tea Alagić
LIGHTING DESIGNER Brian H. Scott
COSTUME DESIGNER Susan Hilferty
SOUND DESIGNER Jane Shaw
PHOTOGRAPHER Marsha Ginsberg

Kafeneion
PAGE 183
VENUE Athens Epidaurus Festival
YEAR 2008
CONCEIVED/DIRECTED BY Dimitri Kourtakis
LIGHTING DESIGNER Christopher Akerlind
COSTUME DESIGNER Eva Nathena
SOUND DESIGNER Studio 19
DRAMATURGS Dimitri Kourtakis, Nikos Flessas, Marialena Mamareli
ASSISTANT SET DESIGNERS Kyriaki Tsitsa, Jian Jung, Sibyl Wickersheimer
PHOTOGRAPHER Marsha Ginsberg

L'Orfeo
PAGE 176, back cover
COMPOSER Claudio Monteverdi
LIBRETTIST Alessandro Striggio the Younger
VENUE Konzerttheater Bern
YEAR 2015
DIRECTOR Lydia Steier
MUSICAL DIRECTORS Attilio Cremonesi, Camerata Bern
COSTUME DESIGNER Frank Lichtenberg
CHOIR Zsolt Czetner
DRAMATURG Katja Bury
ASSISTANT SET DESIGNER Meredith Ries
PHOTOGRAPHER Marsha Ginsberg

Methusalem Projekt
PAGE 54
VENUE Deutsches Nationaltheater und Staatskapelle Weimar
YEAR 2011
DIRECTOR Roy Rallo
MUSIC DIRECTOR Alan Bern
DESIGNER Marsha Ginsberg
DRAMATURG Michael Dißmeier
COSTUME DESIGNER Doey Lüthi
VIDEOGRAPHER Anke Trojan
PHOTOGRAPHER Marsha Ginsberg

Notes On My Mother's Decline
PAGE 112
PLAYWRIGHT Andy Bragen
VENUES The Play Company, Andy Bragen Theatre Projects, NYTW Next Door
YEAR 2019
DIRECTOR Knud Adams
LIGHTING DESIGNER Oona Curley
COSTUME DESIGNER Sophia Choi
SOUND DESIGNER Peter Mills Weiss
ACTORS Caroline Lagerfelt, Ari Fliakos
ASSISTANT SET DESIGNER Sam Vawter
PHOTOGRAPHER Marsha Ginsberg

Peter Pan
PAGE 63
ADAPTATION Peter Littlefield
MUSIC Leonard Bernstein
VENUE Fisher Center Summerscape Theater, Bard College
YEAR 2018
DIRECTOR Christopher Alden
CHOREOGRAPHER Jack Ferver
MUSICAL DIRECTOR Michael A. Ferrara
ORCHESTRATIONS Garth Edwin Sunderland
LIGHTING DESIGNER JAX Messenger
COSTUME DESIGNER Terese Wadden
SOUND DESIGNER Stowe Nelson
ASSISTANT SET DESIGNER Blake Palmer
PHOTOGRAPHER Marsha Ginsberg

Maureen Weiss

A Midsummer Night's Dream
PAGE 96
PLAYWRIGHT William Shakespeare
VENUE Shakespeare on the Bluff
YEAR 2018
DIRECTOR Nenad Pervan
LIGHTING DESIGNER Rob Hillig
COSTUME DESIGNER Maureen Weiss
SOUND DESIGNER Rob Hillig

Dirt Bird
PAGE 150
VENUE The PopWagon
YEAR 2012
CO-LEAD/PIANIST Claire McKeown
SINGER/DRUMMER Athena LeGrand
COSTUME DESIGNER Claire McKeown, Athena LeGrand
PHOTOGRAPHER Joshua Worth

Home Seige Home
PAGE 180
CREATED BY Ghost Road Company
YEAR 2009
DIRECTOR Katharine Noon
LIGHTING DESIGNER Dan Weingarten
COSTUME DESIGNER Pamela Shaw
SOUND DESIGNER Cricket Myers
STAGE MANAGER Nicole Rossi
PHOTOGRAPHERS Dan Weingarten, Maureen Weiss

Rabbit Hole
PAGE 202
PLAYWRIGHT David Lindsay-Abaire
VENUE Long Beach Playhouse
YEAR 2009
DIRECTOR Diane Benedict
LIGHTING DESIGNER Dan Weingarten
COSTUME DESIGNER Unknown
SOUND DESIGNER Nicole Rossi
STAGE MANAGER Nicole Rossi
PHOTOGRAPHER Dan Weingarten

The Subscription
PAGE 157
PLAYWRIGHT Joshua Worth
VENUE Trade City Warehouse
YEAR 2001
DIRECTOR Maureen Weiss
LIGHTING DESIGN Edison Park
COSTUME DESIGNER Maureen Weiss (skirt designed by Lindsay Krisel Rock)
SOUND AND VIDEO DESIGNER Joshua Worth
PHOTOGRAPHER Joshua Worth

Coda

Rooms: Tiny Openings
PAGE iv
VENUE Trade City PopWagon at 18th Street Arts Complex
YEAR 2021
CURATED BY Hollace Starr, Maureen Weiss
COLLABORATORS John Burton, Natalia Escobedo, Dong Jun Joon, Naomi Kasahara, Marcus Kuiland-Nazario, Maya Ordoñez, Hollace Starr, Alexis Tongue, Maureen Weiss, Sibyl Wickersheimer, Josh Worth, John Zalewski

Mimi Lien

Lost in the Meadow
PAGE 230
PLAYWRIGHT Lisa D'Amour
LOCATION Longwood Gardens, Kennett Square, PA
VENUE Collaboration with PearlDamour and People's Light and Theatre Co.
YEAR 2015
DIRECTOR Katie Pearl
COMPOSER Brendan Connelly
COSTUME DESIGNER Jill Keys
SOUND DESIGNER Nick Kourtides
PHOTOGRAPHER Mimi Lien

Moby-Dick
PAGE 225
Still from video of a shop visit with A.R.T. Charge Scenic Artist Jerry Vogt, Mimi Lien, You-Shin Chen
WRITER/COMPOSER/ORCHESTRATOR Dave Malloy
VENUE American Repertory Theater
YEAR 2019
DEVELOPED WITH/DIRECTED BY Rachel Chavkin
MUSIC DIRECTOR Or Matias
LIGHTING DESIGNER Bradley King
COSTUME DESIGNER Brenda Abbandandolo
HAIR, WIG, AND MAKE-UP DESIGNER Rachel Padula-Shufelt
SOUND DESIGNER Hidenori Nakajo
CHOREOGRAPHER Chanel DaSilva
PUPPET DESIGNER Eric F. Avery
VIDEOGRAPHER Johnathan Carr

Model Home
PAGES 92, 94
VENUE Without Walls Festival, La Jolla Playhouse
YEAR 2017
PHOTOGRAPHER Mimi Lien

Natasha, Pierre & the Great Comet of 1812
PAGE 222
COMPOSER/LYRICIST Dave Malloy
VENUE Imperial Theatre/A.R.T./Kazino/Ars Nova
YEAR 2012
DIRECTOR Rachel Chavkin
LIGHTING DESIGNER Bradley King
COSTUME DESIGNER Paloma Young
SOUND DESIGNER Nicholas Pope
CHOREOGRAPHER Sam Pinkleton
PHOTOGRAPHER Evgenia Eliseeva

Superterranean
PAGE 173
CONCEPT/SCENARIO/SET DESIGN Mimi Lien
VENUE Pig Iron Theatre Company at the Philadelphia Fringe Festival
YEAR 2011
SCENARIO/DIRECTOR Dan Rothenberg
LIGHTING DESIGNER Barbara Samuels
COSTUME DESIGNER Olivera Gajic
SOUND DESIGNER/ORIGINAL MUSIC Lea Bertucci
DRAMATURG Geoff Manaugh
PHOTOGRAPHER Mimi Lien

Naomi Kasahara

Leaf Journal
PAGE 78

Rooms: Tiny Openings
PAGE 72
VENUE Trade City PopWagon at 18th Street Arts Complex
YEAR 2021
CURATED BY Hollace Starr, Maureen Weiss

Narelle Sissons

All the Names
PAGE 110
NOVEL BY José Saramago
ADAPTATION/DIRECTOR Karla Boos
VENUE Quantum Theatre
YEAR 2015
SCENOGRAPHERS Barbara Luderowski, Narelle Sissons
LIGHTING DESIGNER Cindy Lamaro
COSTUME DESIGNER Narelle Sissons
SOUND DESIGNER Sartje Pickett, Chris Evans
DRAMATURG Megan Monaghan Rivas
MEDIA DESIGNER Joe Seamans
PHOTOGRAPHER Narelle Sissons

Bernhardt/Hamlet
PAGE 120
PLAYWRIGHT Theresa Rebeck
VENUE Goodman Theatre
YEAR 2019
DIRECTOR Donna Feore
LIGHTING DESIGNER Robert Wierzel
COSTUME DESIGNER Dana Osborne
SOUND DESIGNER Joanna Lynne Staub
DRAMATURG Neena Arndt
PHOTOGRAPHER Narelle Sissons

Halfway Bitches Go Straight to Heaven
PAGES 114, 116
PLAYWRIGHT Stephen Adly Guirgis
VENUE Atlantic Theatre and LAByrinth Theatre co-production
YEAR 2019-20
DIRECTOR John Ortiz
LIGHTING DESIGNER Mary Louise Geiger
COSTUME DESIGNER Alexis Forte
SOUND DESIGNER Elisheba Ittoop
PHOTOGRAPHER Monique Carboni

Mabou Mines DollHouse
PAGE 20
International tour
YEAR 2003
DIRECTOR Lee Breuer
LIGHTING DESIGNER Mary Louise Geiger
COSTUME DESIGNER Meganne George
SOUND DESIGNER Edward Cosla
CHOREOGRAPHER Eamonn Farrell
ADDITIONAL CHOREOGRAPHY Erik Liberman
ORIGINAL MUSIC Eve Beglarian
PUPPETRY DESIGNER Jane Catherine Shaw
PHOTOGRAPHER Narelle Sissons

Pride and Prejudice
PAGE 138
PLAYWRIGHT Kate Hamill
VENUE O'Reilly Theater, Pittsburgh Public Theater
YEAR 2018
DIRECTOR Desdemona Chiang
LIGHTING DESIGNER Masha Tsimring
COSTUME DESIGNER Christine Tschirgi
SOUND DESIGNER AND ORIGINAL MUSIC Andre Pluess
CHOREOGRAPHER Erika Chong Shuch
PHOTOGRAPHER Narelle Sissons

The Crucible
PAGE 111
PLAYWRIGHT Arthur Miller
VENUE Great Lakes Theater
YEAR 2008
DIRECTOR Drew Barr
LIGHTING DESIGNER Rick Martin
COSTUME DESIGNER Kim Krumm Sorenson
SOUND DESIGNER Fitz Patton
PHOTOGRAPHER Narelle Sissons

Nina Ball

A Midsummer Night's Dream
PAGE 210
PLAYWRIGHT William Shakespeare
VENUE California Shakespeare Theater
YEAR 2014
DIRECTOR Shana Cooper
LIGHTING DESIGNER Burke Brown
COSTUME DESIGNER Katherine O'Neill
SOUND DESIGNER Paul James Prendergast
CHOREOGRAPHER Erika Chong Shuch
PHOTOGRAPHERS Jay Yamada, Nina Ball

Blasted
PAGE 164
PLAYWRIGHT Sarah Kane
VENUE Shotgun Players at The Ashby Stage
YEAR 2017
DIRECTOR Jon Tracy
LIGHTING DESIGNER Heather Basarab
COSTUME DESIGNER Miyuki Bierlein
SOUND DESIGNER Matt Stines
PHOTOGRAPHER Cheshire Isaacs

Who's Afraid of Virginia Woolf?
PAGE 212
PLAYWRIGHT Edward Albee
VENUE Shotgun Players at The Ashby Stage
YEAR 2016
DIRECTOR Mark Jackson
LIGHTING DESIGNER Heather Basarab
COSTUME DESIGNER Ashley Holvick
SOUND DESIGNER Sara Witsch
PHOTOGRAPHER Jessica Palopoli

Rachel Hauck

Antlia Pneumatica
PAGE 204
PLAYWRIGHT Anne Washburn
COMPOSERS Anne Washburn, Daniel Kluger
VENUE Playwrights Horizons
YEAR 2016
DIRECTOR Ken Rus Schmoll
LIGHTING DESIGNER Tyler Micoleau
COSTUME DESIGNER Jessica Pabst
SOUND DESIGNER Leah Gelpe
PHOTOGRAPHER Joan Marcus

Hadestown
PAGE 200
MUSIC/LYRICS/BOOK BY Anaïs Mitchell
VENUE Broadway, Walter Kerr Theater
YEAR 2019
DIRECTOR/DEVELOPED WITH Rachel Chavkin
MUSIC DIRECTOR/VOCAL ARRANGEMENTS Liam Robinson
LIGHTING DESIGNER Bradley King
COSTUME DESIGNER Michael Krass
SOUND DESIGNERS Nevin Steinberg, Jessica Paz
CHOREOGRAPHER David Neumann
DRAMATURG Ken Cerniglia
PHOTOGRAPHER Matthew Murphy

The House of Bernarda Alba
PAGES 8, 234
PLAYWRIGHT Federico García Lorca
VENUE Mark Taper Forum
YEAR 2002
DIRECTOR Lisa Peterson
LIGHTING DESIGNER Christopher Akerlind
COSTUME DESIGNER Joyce Kim Lee
HAIR AND WIG DESIGN Carol F. Doran
SOUND DESIGNER/COMPOSER Mark Bennett
PHOTOGRAPHER Craig Schwartz

What the Constitution Means to Me
PAGE 100
VENUE New York Theatre Workshop
YEAR 2018
DIRECTOR Oliver Butler
LIGHTING DESIGNER Jen Schriever
COSTUME DESIGNER Michael Krass
SOUND DESIGNER Sinan Zafar
DRAMATURG Sarah Lunnie
PHOTOGRAPHER Joan Marcus

Regina García

American Mariachi
PAGE 119
PLAYWRIGHT José Cruz González
VENUE The Denver Center for the Performing Arts
YEAR 2018
DIRECTOR James Vásquez
MUSIC DIRECTOR Cynthia Reifler-Flores
LIGHTING DESIGNER Paul Miller
COSTUME DESIGNER Meghan Anderson Doyle
SOUND DESIGNER Ken Travis
CHOREOGRAPHER Shaun Taylor-Corbett
PHOTOGRAPHER Sam Adams

Between Two Knees
PAGE 6
PLAYWRIGHTS The 1491's (Dallas Goldtooth, Sterlin Harjo, Migizi Pensoneau, Ryan RedCorn, Bobby Wilson)
VENUE Oregon Shakespeare Festival's Thomas Theatre
YEAR 2019
DIRECTOR Eric Ting
LIGHTING DESIGNER Elizabeth Harper
COSTUME DESIGNER Lux Haac
PROJECTION DESIGNER Shawn Duan
SOUND DESIGNER Jake Rodriguez
CHOREOGRAPHER Shaun Taylor-Corbett
FIGHT DIRECTOR Rod Kinter
DRAMATURG Julie Dubiner
PHOTOGRAPHER Dallas Goldtooth

El Paso Blue
PAGE 215
PLAYWRIGHT Octavio Solís
VENUE GALA Hispanic Theatre
YEAR 2016
DIRECTOR José Carrasquillo
LIGHTING DESIGNER Christopher Annas-Lee
COSTUME DESIGNER Robert Croghan
SOUND DESIGNER Neil McFadden
MUSIC Michael "Hawkeye" Herman
FIGHT CHOREOGRAPHER Jonathan Ezra Rubin
CHOREOGRAPHER Ed Osheroff
PHOTOGRAPHERS Regina García, Stan Weinstein

The Rembrandt
PAGE 59
PLAYWRIGHT Jessica Dickey
VENUE Steppenwolf Theatre

YEAR 2017
DIRECTOR Hallie Gordon
LIGHTING DESIGNER Ann G. Wrightson
COSTUME DESIGNER Jenny Mannis
SOUND DESIGNER Elisheba Ittoop
PHOTOGRAPHERS Regina García, Michael Brosilow

The Yeomen of the Guard
PAGE 125
MUSIC Arthur Sullivan
LIBRETTIST W.S. Gilbert
ADAPTATION Sean Graney, Andra Velis Simon, Matt Kahler
VENUE Oregon Shakespeare Festival's Thomas Theatre
YEAR 2016
DIRECTOR Sean Graney
MUSIC DIRECTOR Andra Velis-Simon
LIGHTING DESIGNER Heather Gilbert
COSTUME DESIGNER Allison Siple
SOUND DESIGNER Ray Nardelli
CHOREOGRAPHER Jaclyn Miller
PHOTOGRAPHERS Jenny Graham, Regina García

Sara Outing

Gregor
PAGE 67
CREATED BY Will Steinberger, InVersion Theatre
VENUE The Access Theater, New York
YEAR 2016
DIRECTOR Will Steinberger
PUPPET DESIGNER Sara Outing
SCENIC DESIGNER Anthony Freitas
PHOTOGRAPHER David Slotnick

Tilda Swinton Adopt Me Please
PAGE 67
CO-CREATED BY Han(nah) Van Sciver, Nicholas Scheppard
VENUE The Greenfield Collective
YEAR 2017
DIRECTOR Maura Krause
PHOTOGRAPHER Kate Raines

Shannon Scrofano

House Music
PAGE 188
CREATED/PERFORMED BY Jennie Liu, Andrew Gilbert
VENUE The Mistake Room (2016), Live Arts Exchange/LAX Festival (2015)
PRODUCER Grand Lady Dance House
VIDEO DESIGNER Keith Skretch
CURATED BY Samara Kaplan

Islands of Milwaukee
PAGE 124
CREATED BY Anne Basting, Sojourn Theatre
VENUE Milwaukee City Hall
YEAR 2012–14
DIRECTOR Maureen Towey

Coda

Nuestro Lugar
PAGES 122, 242
CREATED WITH Kounkuey Design Initiative, Mutuo Architecture
VENUE Cooper Hewitt Smithsonian Design Museum
YEAR 2013–18
CO-ARTISTIC DIRECTORS Shannon Scrofano, Evelyn Serrano
PARTNERS Delicias Laguna Azul, Desert Recreation District, Desert Riderz, Evelyn Serrano, National Endowment for the Arts, Shannon Scrofano, The California Endowment

Shing Yin Khor

Hamlet-Mobile
PAGE 192
VENUE Capital W
YEAR 2016
DIRECTOR Lauren Ludwig
PRODUCER Monica Miklas
LIGHTING DESIGNER Brandon Baruch
COSTUME DESIGNER Rachel Weir
PROJECTION DESIGNER Shing Yin Khor
SOUND DESIGNER Dave McKeever
PHOTOGRAPHERS Trisha Harrison, Shing Yin Khor

The Gentle Oraclebird
PAGE 30
Production photos
VENUE Three Eyed Rat
YEAR 2017–present
CREATOR/DIRECTOR Shing Yin Khor
LIGHTING DESIGNER Shing Yin Khor
COSTUME DESIGNER Shing Yin Khor
PHOTOGRAPHER Shing Yin Khor

The Last Apothecary
PAGES 186, 187
VENUE Burning Man
YEAR 2016
DIRECTOR Shing Yin Khor
LIGHTING DESIGNER Shing Yin Khor
VIDEO/PROPS/PAINT DESIGNERS Carl Lucas, Lana Wolverton
SOUND DESIGNER/CARPENTER Chris Benton
LEAD LOGISTICS/PAINTER Carla Kaun
MASTER CARPENTER/CO-DESIGNER Scott Keeler
CARPENTER/PAINTER/WEAVER/COOK/ CO-DESIGNER Heather Hoxsey
INTERACTION DESIGNER Sasha Sklar

Sibyl Wickersheimer

Big Haul
PAGE 170
SERIES CONCEIVED BY Janne Larsen, Sibyl Wickersheimer
GALLERY RAID Gallery
ARTIST Sibyl Wickersheimer
YEAR 2012
LIGHTING DESIGNER Elizabeth Harper
SOUND DESIGNER Kari Rae Seekins
PHOTOGRAPHER Sibyl Wickersheimer

Black Diamond
PAGE 126
PLAYWRIGHT J. Nicole Brooks
VENUE Lookingglass Theatre
YEAR 2007
DIRECTORS J. Nicole Brooks, David Catlin
LIGHTING DESIGNER Brian Sidney Bembridge
COSTUME DESIGNER Allison Siple
SOUND DESIGNER Andre Pleuss
PHOTOGRAPHER Sibyl Wickersheimer

Elliot, A Soldier's Fugue
PAGE 166
PLAYWRIGHT Quiara Alegría Hudes
VENUE Center Theatre Group/Kirk Douglas Theatre
YEAR 2018
DIRECTOR Shishir Kurup
LIGHTING DESIGNER Geoff Korf
COSTUME DESIGNER Raquel Barreto
SOUND DESIGNER John Nobori
ASSISTANT SET DESIGNER Yuri Okahana
PHOTOGRAPHER Craig Schwartz

I Carry Your Heart
PAGE 158
PLAYWRIGHT Georgette Kelly
VENUE Bootleg Theatre
YEAR 2017
DIRECTOR Jessica Hanna
LIGHTING DESIGNER Brandon Baruch
COSTUME DESIGNERS Ann Closs Farley, Alyssa Gonzalez
SOUND DESIGNER John Zalewski
ASSISTANT SET DESIGNER Yuri Okahana
PHOTOGRAPHER Sibyl Wickersheimer

Indecent
PAGES 226, 228
PLAYWRIGHT Paula Vogel
CO-CREATED BY Rebecca Taichman
VENUE The Bowmer Theatre at the Oregon Shakespeare Festival
YEAR 2019
DIRECTOR Shana Cooper
MUSICAL DIRECTOR Cristina Crowder
LIGHTING DESIGNER Marcus Doshi
COSTUME DESIGNER Deborah M. Dryden
PROJECTION DESIGNER Rasean Davonte Johnson
SOUND DESIGNER Paul James Prendergast
CHOREOGRAPHER Erika Chong Such
ASSISTANT SET DESIGNER Yuri Okahana
PHOTOGRAPHER Sibyl Wickersheimer

The Happiest Song Plays Last
PAGE viii
PLAYWRIGHT Quiara Alegría Hudes
VENUE Thomas Theatre at the Oregon Shakespeare Festival
YEAR 2015
DIRECTOR Shishir Kurup
LIGHTING DESIGNER Geoff Korf
COSTUME DESIGNER Raquel Barreto

PROJECTION DESIGNER Geoff Korf, Sibyl Wickersheimer
SOUND DESIGNER John Nobori
ASSISTANT SET DESIGNER Rabbit AL Freidrich
PHOTOGRAPHER Sibyl Wickersheimer

The Unfortunates
PAGE 217
PLAYWRIGHTS Jon Beavers, Casey Hurt, Ian Merrigan, Ramiz Monsef, Kristoffer Diaz
VENUE American Conservatory Theatre/ The Strand
YEAR 2016
DIRECTOR Shana Cooper
ASSOCIATE DIRECTOR Paul James Prendergast
LIGHTING DESIGNER Russell Champa
COSTUME DESIGNER Katherine O'Neill
SOUND DESIGNER Brendan Aanes
CHOREOGRAPHER Erika Chong Such
ASSISTANT SET DESIGNER Yuri Okahana
PHOTOGRAPHER Sibyl Wickersheimer

Tanya Orellana

Angels in America (Mexico Premiere)
PAGE 18
PLAYWRIGHT/LYRICIST Tony Kushner
VENUE Teatro Juan Ruiz de Alarcón, Mexico City, Mexico
YEAR 2018
DIRECTOR Martín Acosta
LIGHTING DESIGNER Matias Gorlero
COSTUME DESIGNER Mario Marín
SOUND DESIGNER Xicoténcatl Reyes
PHOTOGRAPHER Tanya Orellana

Dry Powder
PAGE 35
PLAYWRIGHT Sarah Burgess
VENUE Aurora Theatre
YEAR 2018
DIRECTOR Jennifer King
LIGHTING DESIGNER Kurt Landisman
COSTUME DESIGNER Victoria Livingston-Hall
SOUND DESIGNER James Ard
PHOTOGRAPHER David Allen

Nogales
PAGE 160
PLAYWRIGHT Richard Montoya
VENUE Campo Santo/Magic Theater
YEAR 2016
DIRECTOR Sean San José
LIGHTING DESIGNER Alejandro Acosta
COSTUME DESIGNER Courtney Flores
PROJECTION DESIGNER Joan Osato
SOUND DESIGNER Juan Amador
PHOTOGRAPHER Alejandro D. Acosta

Point Fuga
PAGE 148
WRITER/DIRECTOR/CO-CHOREOGRAPHER/COSTUME DESIGNER Dany Naierman
VENUE CalArts Tennis Courts
YEAR 2017
LIGHTING DESIGNER Rose Malone
SOUND DESIGNER Daniel Gower
PHOTOGRAPHER Tanya Orellana

rasgos asiáticos
PAGE 236
PLAYWRIGHT Virginia Grise
VENUE CalArts Center for New Performance at Automata
YEAR 2020
DIRECTOR Alexis Macnab
LIGHTING DESIGNER Christine Ferriter
COSTUME DESIGNER Nan Zhou
SOUND DESIGNER Colin Yeo
PHOTOGRAPHER Tanya Orellana

Sweet Land
PAGES 208, 220
COMPOSERS Raven Chacon, Du Yun
LIBRETTISTS Aja Couchois Duncan, Douglas Kearney
VENUE The Industry/Los Angeles State Historic Park (site specific)
YEAR 2020
DIRECTORS Cannupa Hanska Luger, Yuval Sharon
LIGHTING DESIGNER Jeanette Oi-Suk Yew
COSTUME DESIGNERS Cannupa Hanska Luger, E.B. Brooks
SCENIC DESIGNERS Tanya Orellana, Carlo Maghirano
PROJECTION DESIGNER Hana Kim
SOUND DESIGNER Jody Elff
PHOTOGRAPHERS P. 208 Jay L. Clendenin/*Los Angeles Times* via Contour RA; P. 220 Casey Kringlen

You-Shin Chen

News of the Strange
PAGE 64
CONCEIVED/CREATED/DIRECTED BY Moe Yousuf
VENUE Target Margin Theatre Lab
YEAR 2019
MUSIC DIRECTOR/COMPOSER/SOUND DESIGNER Eamon Goodman
ADDITIONAL COMPOSITIONS/SOUND DESIGN Viniyata Pany
LIGHTING DESIGNER Reza Behjat
COSTUME DESIGNER Dina Abd El-Aziz
CHOREOGRAPHER Sarah Dahnke
PHOTOGRAPHER Maria Baranova

UGLY (Black Queer Zoo)
PAGE 22
PLAYWRIGHT/DIRECTOR/CHOREOGRAPHER Raja Feather Kelly
VENUE The Feather Theory, Washington Ensemble Theatre
YEAR 2020
LIGHTING DESIGNER Tuçe Yasek
SOUND DESIGNER Emily Auciello
CHOREOGRAPHIC ASSOCIATES Amy Gernux, Aaron Moses Robin
PHOTOGRAPHER You-Shin Chen

Yuri Okahana

Jupiter Moon
PAGE 77
PLAYWRIGHT Bob Valine
VENUE The Garage Theatre/Panndora Productions
YEAR 2018
DIRECTOR Sonja Berggren
LIGHTING/SOUND/PROJECTION DESIGNER McLeod Benson
SCENIC DESIGNER/CO-PROJECTION DESIGNER Yuri Okahana
PHOTOGRAPHER Yuri Okahana

Yvonne Miranda

Big Tex
PAGES 248, 249
VENUE Texas State Fair
YEAR 2019
PRODUCER Dickies
PHOTOGRAPHERS P. 248 Kevin Brown/State Fair of Texas®; P. 249 Yvonne Miranda

Così fan tutte
PAGE 24
COMPOSER Wolfgang Amadeus Mozart
YEAR 2020
DIRECTOR Hank Hammett
CONDUCTOR Paul Phillips
LIGHTING DESIGNER Rose Cobey
COSTUME DESIGNER Bri Tobin
PROJECTION DESIGNER Philip Vilar
PHOTOGRAPHER Yvonne Miranda

Coda

ACKNOWLEDGMENTS

Four years ago, a student asked us whether there were any famous women set designers. This question turned into a conversation that has now turned into a book. Without our students, our work would go unchallenged. We thank them for beginning this dialogue.

Our decision to open the conversation to the larger community of designers was welcomed with such open arms and positivity. We are deeply grateful to all who moved our small conversation into a larger arena. Their honesty and ability to enter difficult conversations was integral to the book.

We would also like to acknowledge all the people that have helped to create the work that went into this book. Our conversations were centered around set design, but the set designs do not stand alone, they are the product of collaboration and joint purpose. We acknowledge the importance of all the joint efforts between directors, writers, performers, dramaturgs, lighting, costume, sound, media designers, and, of course, technical directors, production staff and management. Our gratitude extends to all the voices that help to create live performances, not only those showcased here, but in our ongoing work.

The book conversations were inspired by many people and thoughts that were not directly included in the book but who provoked thought and inspiration. We are grateful to Porsche McGovern, Donyale Werle, Jiyoun Chang, Pat Weiss, Hollace Starr, Sharon Kagan, Kirsten Hudson, Zachary Hamm, D. Chase Angier, Mara De La Rosa, Chris Akerlind, Tak Kata, Shana Cooper, Jared Mezzocchi, Jennifer Revit, Julie Dubiner and Elizabeth Thinnes.

During the process of writing we found inspiration and guidance in the work of Tibor Kalman and many books, including Spatial Practices by Melanie Dodd, *The Art of Gathering* by Priya Parker, *More Art in the Public Eye* edited by Micaela Martegani, Jeff Kasper, and Emma Drew, *Give it or Leave it* by Cauleen Smith, and *One to Twenty Five* edited by Judith Gerstenberg and Ute Muller-Tischler, to mention only a few. Books we held in our hands and hearts as guides.

Special thanks to our editor, Laura Hussey, who sought us out and kept us on track with warmth and kindness. Additional thanks to Swati Hindwan and Ronnie Morgan for their diligence and support.

And lastly, thank you to our families. They acted as sounding board and support throughout the process. Theatre work starts from the personal, and for us it was no different. Our heartfelt thanks go to Josh, Talula, Stanley, Shane, Olive and Otto and all of our extended family who have encouraged us to follow our own path. Without them this journey would not have been possible. We dedicate this book to them.

T - #0074 - 280323 - C276 - 254/178/12 [14] - CB - 9780367708344 - Matt Lamination